SCULPTURE
The Art & the Practice

NIGEL KONSTAM

COLLINS

First published in the UK 1984
by William Collins Sons & Co Ltd
London · Glasgow · Sydney
Auckland · Johannesburg

ISBN 0 00 411 776 X

Editor: Jane Havell
Designer: Caroline Hill
Illustrator: Tig Sutton

Typeset in Goudy and Optima by Advanced Filmsetters (Glasgow) Ltd
Colour reproduction by Dot Gradations, Ltd
Printed and bound in Hong Kong by South China Printing Co.

To R.V.R. who has taught me much and delighted me most

I would like to thank my wife Janet,
and also Jane Havell, Caroline Hill, David Ridge
and the staff at Collins
for the invaluable help and advice I have received
in preparing this book.

CONTENTS

PREFACE

The art of sculpture is primarily concerned with the enjoyment of the three-dimensional world about us. If you are the practical type—a person who enjoys toymaking or carpentry, arranging furniture in a room, laying out a garden or converting a house—then sculpture is almost certainly for you.

Sculpture is about making and arranging things to satisfy a desire for three-dimensional harmony and order. People's ability to think three-dimensionally varies enormously. It is a faculty which is very seldom asked for in the course of a formal education, nor is it needed in many of the professions. As a result, many people reach adulthood or even retirement without realising that they possess a strong natural talent for sculpture which could flourish if given a little encouragement.

This is a book designed primarily for the novice who wishes to learn not only the techniques but the processes of thought and the design considerations involved in the art of sculpture. But I hope it will also engage the interest of laymen, artists and art teachers.

It is my hope that the book covers every branch of sculpture essential to the aesthetic understanding of the art. Whole volumes have been written on subjects which can occupy only a single chapter in a general introduction such as this: my coverage of certain aspects is necessarily brief. Besides the better-known techniques of modelling, carving and construction in various materials, there are short descriptions of metal casting, chasing and repoussé work. The demonstrations are of techniques best adapted to the limited resources of the student or serious amateur who may have no more than a garage, garden or even bedsitting room in which to work. The materials used are, as far as possible, those easily available from artists' suppliers, builders' merchants or ironmongers. Many of the tools required will already be in the modest collection of the D.I.Y. handyman.

The work-space necessary will, of course, vary according to the scale of the work undertaken or the materials used. However, there are sculptural techniques so clean, neat and small in scale that one can practise them in places where even oil painting may be ruled out. And many of the rougher techniques, such as stone carving, are commonly practised by professionals outdoors in the kind of yard that can usually be found in town or country.

There are many colleges of further education, institutes and evening classes which provide space, tools and often excellent tuition. I hope this book will prove a useful adjunct to such teachings, as well as providing for those who cannot reach a class. But I cannot stress too often the advisability of getting live teaching if it is at all possible. In the case of metal casting, for

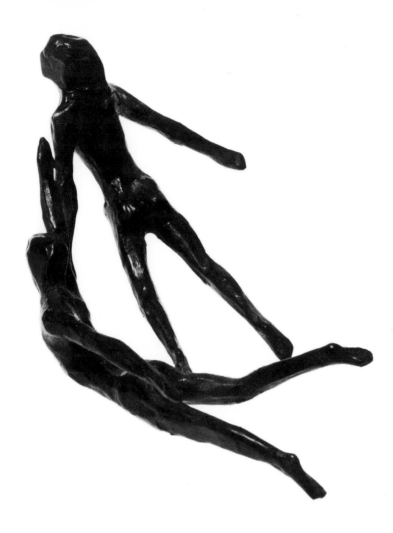

instance, I give the principles so that the process can be understood, but so much depends on the judgement and experience of the foundryman that it would be courting trouble, even danger, to attempt casting metal on your own.

In sculpture, ends and means are so intertwined that to describe the technique without reference to the artistic goal would be a disservice. Masters such as Pisano, Michelangelo or Moore have all evolved individual techniques which serve their own particular artistic purposes. So before going into the details of practical guidance, I have provided in the first half of the book a cultural background against which your own particular goals may be formulated.

Whether your talent be great or small, one benefit which can be more or less guaranteed by this approach is a richer understanding of the art of sculpture. Because of its enduring nature, sculpture has a well-documented and abundantly illustrated past going back deep into pre-history. It provides a vivid record of man's endeavours, his sensibility, his self-image and his image of the world about him, not to mention the technology with which those images were given physical being. A history nearly as old as man himself, it is a splendid subject for study.

Nigel Konstam, *Swimmers,* a small mobile in bronze—length 5½ inches (14 cm).

7

1. INTRODUCTION

As the desire to make sculpture most frequently grows from a love of the art, my first chapter is devoted to extending the understanding of the great achievements in sculpture. This brief canter is not intended as a complete chronological survey. The evolution of sculpture was probably not the neat step-by-step process that hindsight would like to make it. In choosing examples from widely different cultures and epochs to make points about sculptural design, my primary aim is clarity, not historical continuity.

Later in the chapter I will be presenting major design considerations as pairs of opposites: we could see them as poles of different axes (see diagram, *p. 14*). At first they may appear contradictory, but do not be confused. There are no right and wrong answers in art. Tastes vary, fashions come and go. We live in an era which prefers to see the working methods, even the fumblings and erasures, of the individual artist—look at the drawing *Caroline* by Giacometti (*pl. 1*). But many previous generations preferred an anonymous skilled craftsmanship, such as that of Leonhard Kern (*pl. 2*), which obliterated all trace of how the artifact was achieved.

As you examine the different pairs of concepts you may well decide where your own taste lies, but it would be unwise to get too fixed on any one sculptural dogma, for we can be reasonably sure that what is 'right' for this generation will be 'wrong' for the next. Your sculpture should reflect your own feelings and ideas. This does not mean, however, that you should not listen carefully to the criticisms of friends or teachers, who will all come to your work with the advantage of a fresh eye, and some with more experience as well. My own tastes are bound to obtrude here from time to time but you do not have to accept them. The important thing is that you should work in tune with your own tastes and aspirations.

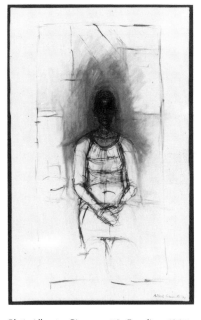

Pl. 1. Alberto Giacometti, *Caroline*, 1965 (Tate Gallery). The erasures and over-drawing in this painting testify to the struggle Giacometti had to arrive at his final forms and are immediately recognisable as his individual handwriting. They also illustrate the view of art as a means to experience as opposed to art as decoration.

NATURE AND ABSTRACTION

Perhaps the most dominating pair of opposites in our culture are those at either end of the axis which runs from nature to abstraction. The discussion as to whether art should hold a mirror up to nature or, on the other hand, "aspire to the [abstract] condition of music" has absorbed almost all our energy, leaving little room for the much more interesting question as to what constitutes quality in art. My guess is that most previous civilisations chose to imitate nature and were probably fairly satisfied with their achievements. Their success may appear very varied to our eyes, but then we have the benefit of hindsight.

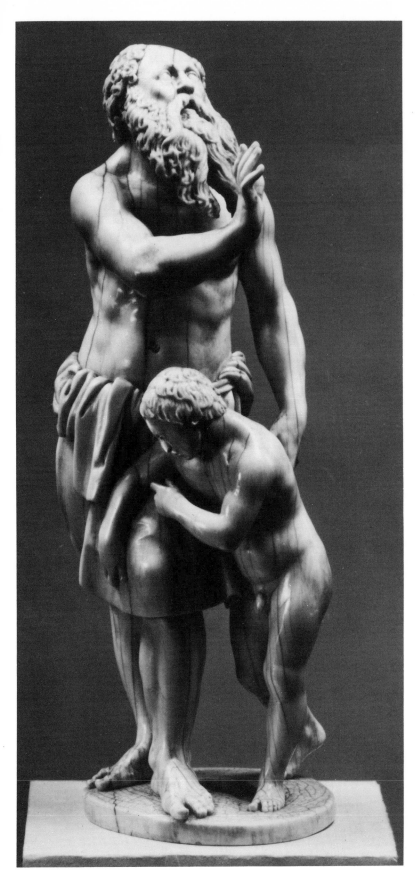

Pl. 2. Leonhard Kern, *Abraham and Isaac*, 17th century (Hilderbrandt Collection, Victoria & Albert Museum). Here the struggle of the artist with his material is polished away and we are left with a perfect, anonymous object in ivory.

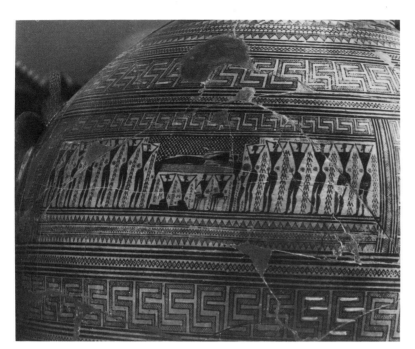

Pl. 3. Attic amphora, Greek, c. 750 B.C.
(Dipylon Cemetery, Athens).

One can view the development of Greek art as moving from a
severe abstract symbolic representation of life towards a repre-
sentation that grew steadily fuller in understanding and richer in
natural detail. The Attic amphora (*detail, pl. 3*) was made in about
750 B.C. and tells us about the lying-in-state of some important
person. We can safely say that there were eighteen mourners:
two kneeling, two sitting and the rest standing. We guess that
they are mourners because of the context of the prone person on
the litter and because they may be tearing their hair. But for that,
they might equally be members of a chorus-line: their number
and gender can be read but little more. The scene, represented
symbolically, is very close to a hieroglyph. It is almost as bald as
a check list of those present. I say almost because, like typo-
graphy, the drawing has a certain attractive patterning that has
nothing to do with the subject matter. As drawing becomes more
sophisticated we expect the pattern to become more intimately
connected with a greater variety of the qualities of the subject.
(See the analysis of Holbein's portrait of Elyot, *pp. 146–47*).

Christian art goes through a similar evolution, from early
Christian through Romanesque, Gothic and Renaissance to later
art, some of which was so close to nature that Rodin, for
instance, was accused of taking plaster casts from life. One might
see this century's art as a reaction against three or four millennia
in which closeness to nature was the general, if not the only,
criterion. There were, of course, variations on the theme as
tastes moved from classical restraint and harmony to the more
romantic or dramatic. One period will want to conform to
tradition, another will prefer innovation and novelty; one will
concentrate on intellectually controlled observation, another on
heightened spiritual expression.

My own view is that this century's focus on the abstract in art
has righted the balance and provided us with a very valuable in-

sight with which to survey our artistic inheritance. For abstract qualities have always been present in works of art, but they had become increasingly obscured as art became overburdened by surface virtuosity or by narrative content, a tendency which came to a climax in the middle and late 19th century.

20th-century art is in strong reaction to this. Now we have at our disposal a complete lexicon of abstract forms to compare with the art of the past which can immensely broaden our understanding of it. The disadvantage is that we inherit a position whose experience of art is so wide that students may be forgiven for becoming confused. How do you decide whether to take the active path as a disciple of Christo who wrapped up miles of the Australian coastline in polythene sheets in the 1970s, or more passively to seek Nirvana in front of a blank canvas? I hope to provide some guidance through these knotty problems by proposing a new attitude to our artistic inheritance, which could lead you to a clearer sense of direction to guide your own endeavours.

PERCEPTION

The profound respect we have for the arts is based on the recognition that, at their best, they are capable of expanding our perception and sharpening our responses to life. It would be sensible therefore to look briefly at the mechanism of perception itself.

Our eyes see light. But we *perceive* only those things that our brains are capable of receiving. The light is first transformed into nerve impulses, which then have to be interpreted by the brain. It seems to me that the brain is capable of sorting and storing these signals in two distinct ways. It can analyse them and break them up into their various components and shapes, an abstracting activity of our minds which is very clearly demonstrated in the drawing of children, where the object—a figure, for example—is represented by its attributes rather than by its appearance. The chief obstacle to drawing is that what you *know* gets in the way of what you *see*. And this obstacle remains, however much or little you know. Being true to what you see in front of you is surprisingly difficult. But if you find drawing hard do not despair: it is less of a problem in sculpture which is three-dimensional.

The brain also seems capable of storing sense data unedited. It puts whole images away into their various garages or kennels where they seem to live lives of their own, often emerging unbidden to play in our dreams. Cave men were probably rather better than we are at recalling their direct visual experience because they were less prone to analyse it. I guess that their daily thoughts were not the verbal chatter to which we are accustomed, but direct memories of visual experience, such as we enjoy only in dreams and day-dreams—visions of reality that convince as reality itself convinces, perhaps because it is derived from the same nerve impulses.

Unlike symbolic memories, these images are not subject to the

11

ordering principles by which our rational lives are ruled. They are beyond rational control, they live in our imagination. The cave man seems to have been capable of projecting this vital inner world onto the walls of his cave in a way that we more sophisticated artists are unable to emulate, perhaps because our minds have become too complex. Cave art has a random disorderliness about it that is not found in subsequent eras.

Our desire for order and pattern seems to have grown with the development of language, perhaps as part of the same ambition to order and name the natural world. We automatically tabulate and codify our experiences, turning sensation into a collection of attributes to be numbered and qualities to be named. The convenience of this symbolic method to everyday commerce seems to have caused it to dominate our minds, drowning out the swarming vision of the more primitive part of our brain. In the process of trimming our sensations so that they fit into abstract pigeon-holes we necessarily exclude some of their aesthetic richness.

One of the aims of an art education is to help us regain a lost innocence, so that we see things more truly, more wholly, and get back in touch with the light that first comes to our eyes. Art can remove the blinkers with which history and education have accidentally equipped us, enabling us to glimpse again the richness of nature that lies behind our symbol-ridden perception of her.

But another of the functions of art is to enrich the language of symbols, gradually developing and refining the way in which symbolic systems of thought can be woven together to strengthen each other so that the austere abstract patterns with which our minds have been etched can produce something that can be compared with the richness of nature. Art is another way of bridging the gap between what we actually perceive and what there is to be perceived.

The realism of more recent art cannot be compared with the naturalism of cave art because it is different in kind; it contains references to the accumulated knowledge of mankind which cave art does not contain. Our art has lost the spontaneous flow of cave art but gained in a sense of order.

ORDER, PATTERNING OR FORM

Our perceptions of the natural world are cramped and ordered whether we like it or not. All that art can do is to make us aware of the distorting effect of our mechanisms of perception, and help us develop some new mechanisms to ameliorate the deprivation. Modern art has made us 'form-conscious' in a new and helpful way. We are for the first time consciously aware of the strange spectacles we use.

The patterning of the world found by artists is described as 'form'. When we describe a work as formless, we mean that nature has not been mentally digested by the artist, but copied mindlessly. When a photographer takes a picture, his selection can make a pleasing photograph which reflects the beauties of

nature very well; a landscape by Cézanne, on the other hand, actually orders our responses by *organising* nature into a structure of advancing and receding planes. The word 'form' will always be used in this way here. Obviously, all sculpture has form in another sense—that is, it has a three-dimensional presence—but it might still be 'formless' in this special sense.

I will be describing the two main traditions of form-making in the following chapter; sufficient to say here that art, like every other discipline, teaches us to see the world in a particular way. Form is to the artist what the laws of physics are to the astronomer or the physicist, or what the Linean system of classification is to the biologist: it is a pattern we look for in nature. We look in order to test both nature and the pattern. Neither the laws of physics nor the laws of art are immutable.

Artistic patterning has evolved as human experience has evolved; it is both the expression of the experience and, importantly, the means of achieving it. It is essential not to forget the latter. Our attitudes to art tend to be too consumer-oriented, perhaps because writing about art is usually done by consumers. The artist seldom sees himself as either a maker of decorative objects or a purveyor of upliftment. It may come as a surprise, but communication is not his primary aim. He is on his own journey of discovery—his art is the means through which he seeks his own private experience. If, as a by-product, it enlarges the experience of others or has value as decoration or upliftment for them, very well and good. If not, that is not a disaster; it is an inconvenience because he will not be able to look to society for support.

IMAGINATION AND ORIGINALITY

The great artist or scientist is one who through some new insight is able to adjust our fixed laws or patterns of thought so as to improve and enrich our understanding of the world about us. The 16th-century astronomer Copernicus observed nothing new in the movements of the planets: they had been very accurately charted by Ptolemy 1,400 years earlier. He simply stepped outside the world-centred view of his contemporaries and saw the universe in a miraculously clear new *pattern*. What Copernicus saw was there to be seen even by the Meso-potamians; they had the necessary information but not the necessary flexibility of mind. The Copernican revolution was simply the result of seeing things from a new viewpoint—what Arthur Koestler has rightly called "a leap of the imagination".

The problem for artists and scientists alike is to approach both nature and their own inherited laws with an open mind. Up to the beginning of this century there was a simple and straight-forward relationship between art and nature. This century's concern with the other aspect of art—the abstract nature of our own minds—should not be allowed to obscure that primary relationship. Both aspects are necessary, and one can illuminate the other. My own enthusiasms range from Brancusi at the abstract end of our axis to Rodin at the other. Impartial and

liberal as I am, in the final resort I accept the old axiom, a little modified: art is not, in my view, simply to reflect nature, it is to help us understand her.

My own preference is for art which sees nature in terms of a repertoire of abstract forms which are either inherited from sculptors of the past or borrowed from other disciplines. This may sound traditionalist, even plagiarist to the uninitiated. But, if we take as an analogy the growth of language itself, I think you will agree that the invention of new sounds or groups of sounds requires little originality. Originality lies in perceiving something new and then finding a means of communicating that to others. Judge for yourselves: is this better done with a group of entirely new sounds, or by the juxtaposition of commonly understood words? The most usual sources for sculptural borrowings are the allied disciplines of pottery, architecture and engineering; mathematics and geometry have also made a major contribution.

THE PAIRS OF OPPOSITES

We have seen how the divisive polarisation that has occurred between naturalism on the one hand and abstraction on the other can be viewed more fruitfully as two aspects of the process of art: the shaping of a mental image which is then matched with observed phenomena. That axis is different in kind from the rest.

The following are axes of taste, not of process, and can best be seen in relation to particular works. Works of art are like puddings or pies: with the same ingredients each cook comes up

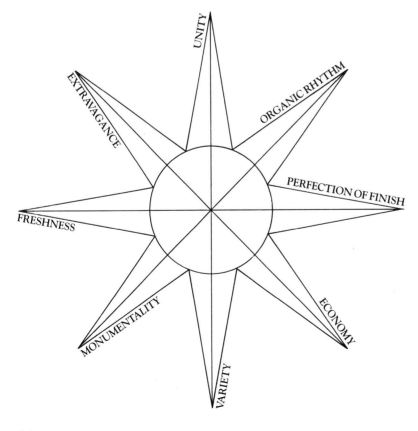

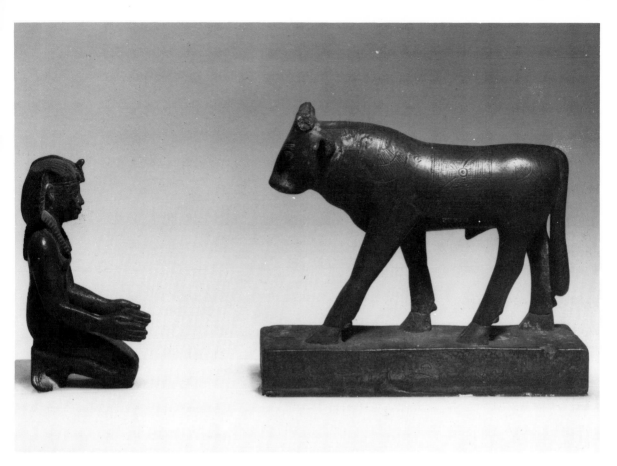

with a product that is distinctly his own. Art is an amalgam of seemingly contradictory qualities and attributes. The pairs in the diagram are not mutually exclusive; each may play a part in the whole. To describe an amalgam one must first describe the ingredients one by one, and then the method of mixing them together. But you cannot prove the pudding until it is mixed and cooked. Do not expect to understand every idea as it comes along—give it a chance to simmer.

Pl. 4. *Bull and Worshipper*, Egyptian, c. 600 B.C. (British Museum). This group is on the scale of a toy and has many of a toy's characteristics—the way the arms are modelled, for instance, suggests that they might pivot at the shoulders as on a tin soldier. These very features might, by their austerity alone, prompt the description 'monumental'.

Unity and Variety

One quality fundamental to a work of art is **Unity** and yet there must also be **Variety** within the unity. Unity is concerned with the initial impact. The visual equivalent of a headline in a newspaper, it must carry the message in the first instant. There is also unity of feeling and unity of design, yet rhythmic unity—like rhythm in poetry or music—needs to be varied or interrupted if it is not to become monotonous.

Monumentality and Organic Rhythm

When used in art criticism, **Monumentality** does not necessarily imply size; it can mean that a sculpture has the static grandeur of a monument, regardless of its actual size. When forms are arranged predominantly vertically and horizontally, they tend to have a static, monumental effect. **Flowing** or **Rhythmic** compositions would tend to have the opposite effect.

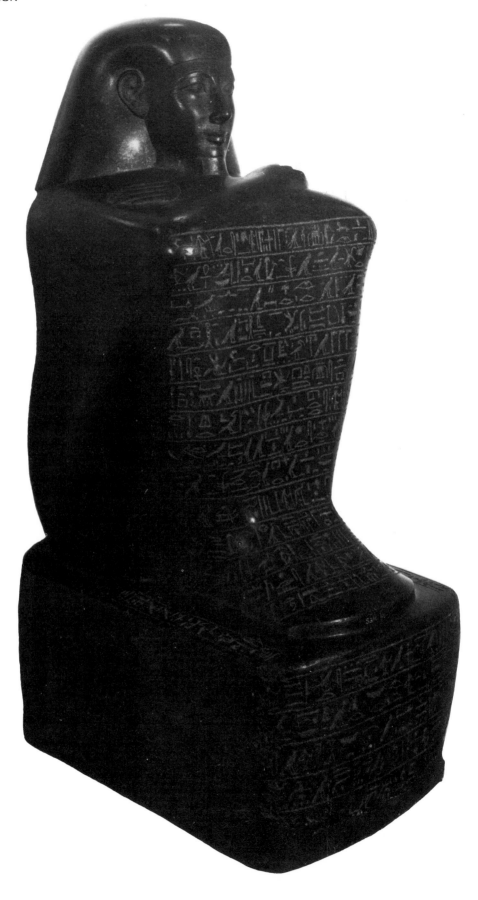

Pl. 6. *Baboon*, Egyptian, c. 1350 B.C. (British Museum). Like Sennefer, this ape is shaped within the block. Its clear sense of frontality makes it easy to place in an architectural setting.

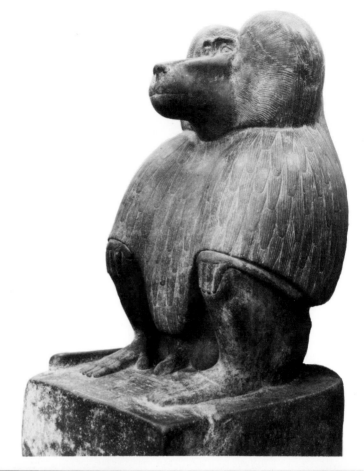

Pl. 7. Henry Moore, *Project for Family Group*, 1945 (Tate Gallery). This study for a monument combines the severe monumental qualities which we have seen in the Egyptian work with an organic, flowing rhythm, particularly evident in the way the parents' arms are woven together with the child.

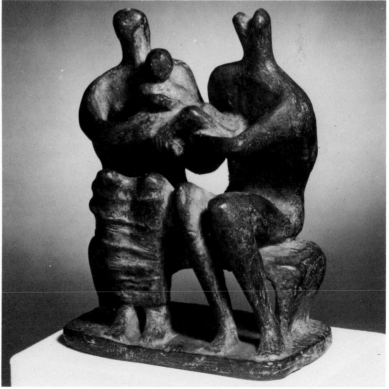

Pl. 5 (*opposite*). *Sennefer*, Egyptian, c. 1500 B.C. (British Museum). Although rather under life-size, this seated figure displays monumentality in its simplified rectilinear forms. It gives a very clear indication of the shape of the original block from which it was carved. There is economy in the amount of stone which has had to be removed and in the way it has been removed: one sees clearly the intermediate diagonal planes sawn from cheekbone to chin. Notice how the left hand is suppressed into relief in order to maintain the solid, block-like quality, balancing the demands of the figure and the nature of the stone.

17

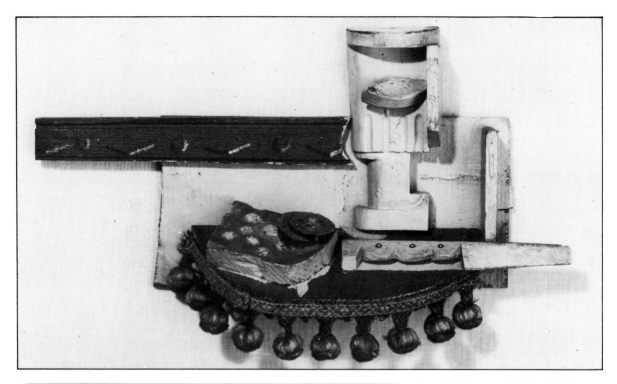

Pl. 8. Pablo Picasso, *Still Life*, 1914 (Tate Gallery). Picasso makes use of the sculptural qualities already created by the haberdasher, the cabinet-maker and the painter-decorator.

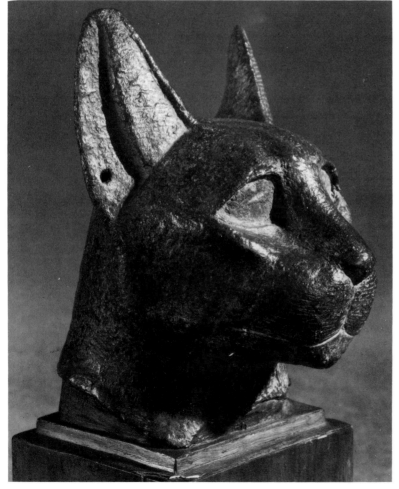

Pl. 9. *Cat*, Egyptian, c. 700 B.C. (British Museum). Although modelled originally in wax, this bronze has the same 'monumental' feeling about it that we have noted in Egyptian carving.

Economy and Extravagance

Brevity and directness would be the literary equivalent of **Economy** in the means of artistic communication, which is highly regarded today. But in the visual arts we also prize economy in the manipulation of the material—economy of effort, we might call it. Picasso's work often contains a virtuosity that relies for its effect on the outrageous ease with which it is made (see *pl. 8*). The ancient Egyptian who carved a jackal's head out of granite (*pl. 10*) can also impress us with the economy in the number of saw cuts he made in such a tough material. The simplicity of the means has an effect on the power of the final sculpture. One can feel the way in which the silhouette has been sawn out of the block, first in one dimension and then another, giving rise to a crystalline or geometric structure that is strong and interesting.

This geometric feeling is a feature of much Egyptian sculpture. Even the cat's head has it (*pl. 9*) and it is made of cast bronze, a medium which would not predispose the artist to any such forms. The patterning natural to stone carving has here been absorbed into a modelled work, a kind of cross-fertilising common in the development of art which I see as a major force in its evolution.

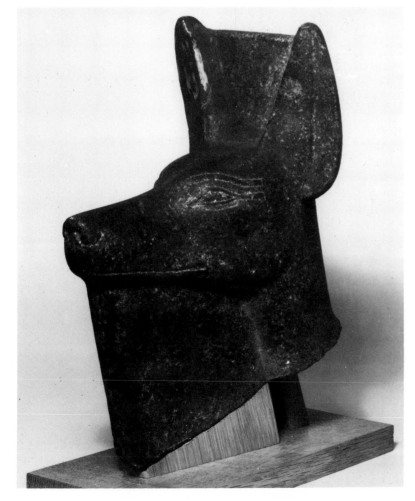

Pl. 10. *Jackal*, Egyptian, c. 700 B.C. (British Museum). A good three-quarters of the surface modelling of this jackal's head seems to have been created by the use of the saw. The resulting clarity is enjoyable partly because one feels that it would be easy to do oneself.

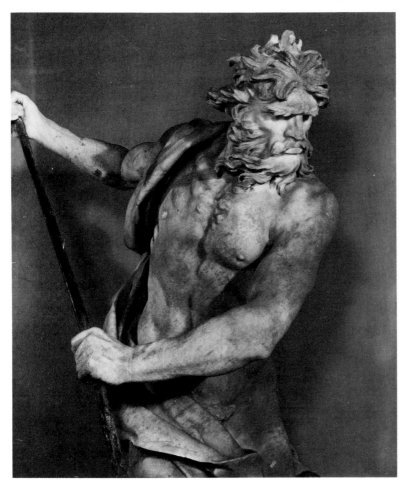

Pl. 11. Giovanni Bernini, detail from *Neptune and Glaucus*, c. 1622 (Victoria & Albert Museum). The earlier austerities of an architectural approach to stone are blown away in Bernini's commanding evocation of flesh and blood straining against the elements of wind and water. His compositions are held together by an enormous rhythmic vitality.

We tend on the whole to be too critical of art that is 'influenced' by other artists, feeling that influence demonstrates a lack of purpose or originality on the part of the borrower. But the contrary could be the case: much of the power of Picasso's work, for example, seems to me to be derived from the enormously wide range of influences to which he has responded and which he absorbed into his own art. Influences and borrowings which are the result of true love reflect glory back on the original source. They often throw an interesting new light on the source, as well as enriching the borrower by echoes from the past. They are the very fabric of art.

The mind of the artist reaches out and seeks to take hold of the object he observes with whatever hooks of mental valency there are available. The hooks of likeness—of metaphor—are very valuable. A likeness to pyramids, a likeness to musical rhythm, a likeness to a Renoir, a likeness to a beautiful girl are all equally valid as far as I am concerned.

The communion of artists is like Bertrand Russell's communion of mathematicians—a communion through time in which an individual alive today can develop the work of his immediate master or that of some master long since dead, in the hope of communicating something of value to his contemporaries or to individuals as yet unborn, individuals whose

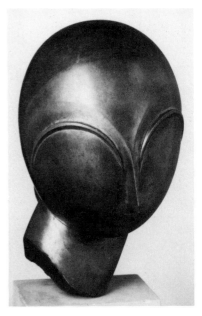

Pl. 12. Constantin Brancusi, *Danaide*, c. 1918 (Tate Gallery). This head is just one of the artist's many different versions of his 'egg'.

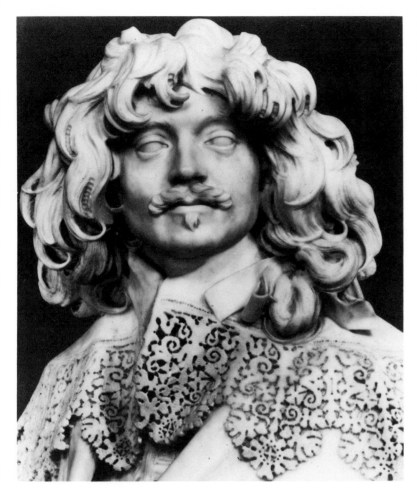

Pl. 13. Giovanni Bernini, *William Baker*, c. 1640 (Victoria & Albert Museum). Bernini is prepared to sacrifice the severe monumental qualities associated with the carving of stone for brilliance of effect. Under his virtuoso hand, marble can become lace or a lock of hair.

interests overlap with his own in a timeless but human network of communication.

At the extreme economy end of our axis we could put Brancusi's egg (*pl. 12*). In the early years of this century it brought about an extraordinary revolution, because it rang sculptural bells that reverberated back through history and opened our eyes to the achievements of the past in a new way, as well as opening a doorway to a bright future. Its significance rests in the fact that it was there through all history. The Greeks used it, academic artists used it, sculptors naturally arrived at the egg whenever they shaped an object by grinding and polishing.

The converse of economy is extravagance, and this is a quality that can be very appealing on occasion. We could put Bernini at the extravagant end of our axis. Extravagance can express itself in an abundance of detail, as in Mr Baker's collar where stone becomes lace (*pl. 13*) or, as Bernini pursues it in Neptune (*pl. 11*), where animation, drama and verisimilitude override the austere demands of the stone. Bernini stops at nothing (short of colour and actual movement) to imitate life. He is prepared to polish, cajole or manipulate the marble in any way he can in order to make it give out the very texture of life. The magically skilful evocation of Neptune's storm-tossed hair may be very far from Brancusi's austere idea of the right way to handle stone.

Brought up in the 1950s, I still feel a pang of guilt when I admire such things. But must we limit our enjoyment of a miracle in another idiom, even if at bottom we may agree with Brancusi that it is a good thing to be true to the materials? That dogma was a reaction to the 19th century when sculptors seldom, if ever, touched the mason's tools. They simply modelled their figures and sent them off to the stone quarries at Carrara where their carvings were done for them by specialists. This practice led to a steady decline in the understanding of the nature of carving. Design for stone was no longer informed by the interaction between the artist and the stone. But Henry Moore has wisely said of this dogma of truth to materials (and he was one of its chief exponents): "... many of us tended to make a fetish of it. I think it is important, but it should not be a criterion of the value of a work—otherwise a snowman made by a child would have to be praised at the expense of a Rodin or a Bernini ... The sculptor ought to be master of his material. Only not a cruel master."

Freshness and Perfection of Finish

A painter like Velasquez is admired for his 'handling' of paint because one can see the way his fully-charged brush has moved

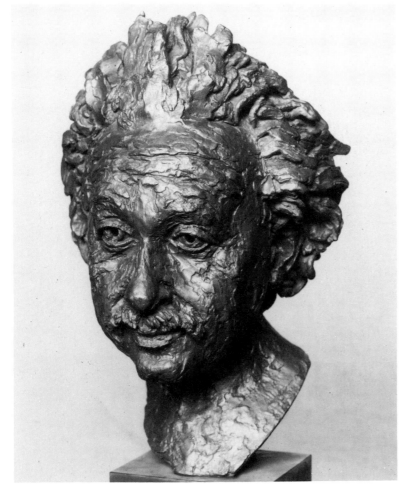

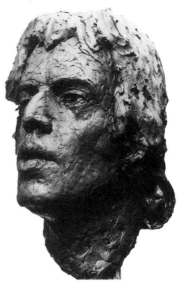

Pl. 15. Alan Thornhill, *Tom Stoppard*, c. 1980 (private collection). This portrait provides another demonstration of the strong effect of the fresh handling of clay.

Pl. 14. Jacob Epstein, *Albert Einstein*, 1933 (Tate Gallery). Epstein's handling of clay (here cast into bronze) is reminiscent of the fresh way that Rembrandt or Velasquez handled paint. As with many great artists, Epstein's work is very variable in quality; he is often at his best in portraiture.

across the canvas—it makes the art of painting appear incredibly swift and easy, although in fact Velasquez is known to have been a slow worker. The sculptural equivalent of this **Freshness** in handling paint may be seen in the way Epstein's fingers travel through the soft clay (*pl. 14*) or, very differently, in the way Donatello handles bronze, his chisel leaving a very clear mark of its passage (*pl. 16*). Both artists in their different ways leave clear evidence of their individual methods of work, often referred to as 'handwriting'. Such work has a liveliness about it that adds to its interest in my view. But that view has not always been shared: Rembrandt, for example, was constantly criticised by his contemporaries for failing to 'finish' his work.

Pl. 16. Donatello, *Pieta*, c. 1422 (Victoria & Albert Museum). This bronze was badly cast and Donatello had to make the best of it by very extensive chasing of the metal, a practice which was not at all unusual at this period. We see the marks of his chisel very clearly in the hair of St John (*extreme right*), and signs of extensive hammering on the halos and under the right arm of the woman standing behind Christ. It was typical of Donatello to make form and texture as he chased, so that one still feels very strongly the artist's hand at work on the bronze. The Epstein, by comparison, would have been cast and chased by someone else and therefore the working of the metal is as anonymous as possible.

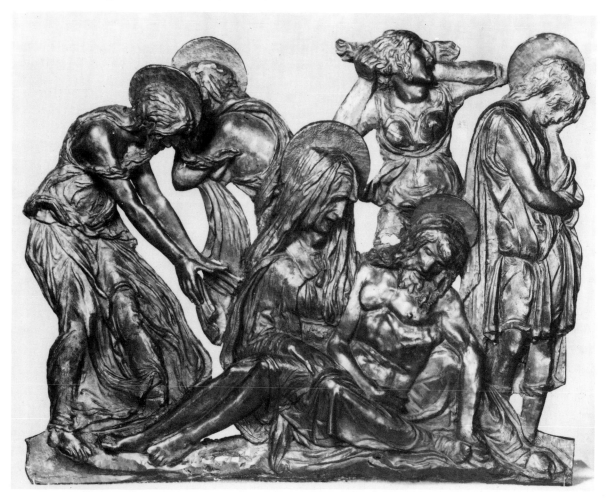

The opposite of this 'fresh' approach is the work of the meticulous craftsman who carefully eradicates all traces of his personality or his methods so that one is scarcely aware that the material has been worked by human hand. Busti has worked his marble to within a stone's throw of looking like porcelain (*pl. 17*). Such 'over-working' is frowned on nowadays. Obviously the machine age has contributed to a decline in interest in this kind of **Perfectionism**, though the comparative anonymity of the machine finish has also had an appeal to artists who worry about the cult of individuality (see *pl. 18*).

I hope that it is clear by now that these pairs of opposites are not being used to indicate hard-and-fast watertight categories, but qualities that, blended together, will give a variety of flavours according to their proportions. Like the cook, the artist is there to judge the appropriate balance and to decide to go for this quality or that. It is the quality of the decisions rather than deftness of hand that is the crucial factor in a work of art. You must not be afraid of making errors: they are the road to experience, and with experience they become fewer.

Pl. 17. Agostino Busti, *Triumph*, early 16th century (Victoria & Albert Museum). On this very small-scale marble carving (approximately 14½ inches/37 cm in height), ingenuity and patience are more in evidence than a good sense of design for stone. The result is very fragile, and looks it.

Pl. 18 (*opposite*). William Tucker, *Anabasis I*, 1964 (Tate Gallery). Many modern sculptors prefer the anonymity of a product that is finished by machine. Here we have a sculpture about the transformations that take place between the two- and the three-dimensional worlds. The way in which the jig-saw shapes fit together gives one confidence in the state of balance between the three pieces.

2. THE TWO TRADITIONS

In the main, art historical criticism really only recognises one set of forms—the 'classical' tradition. But I detect two distinct traditions of European form-making, both of which are necessary to the understanding of art, ancient and modern. In this chapter I will be describing the two traditions and the form-structure-systems which operate within each of them. The advantage of this new pattern of criticism is that once you have grasped the principles you will be able to understand easily what I am talking about. There is no mystery.

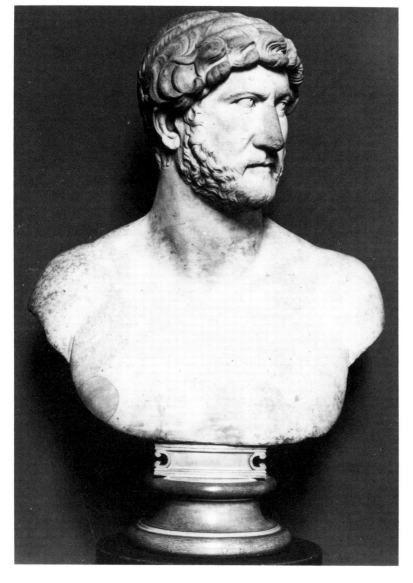

Pl. 1. *Hadrian*, Roman, 2nd century (British Museum). This particular example is one of perhaps thirty or forty similar busts which would have been made during Hadrian's reign as Emperor (117–138 A.D.); it is one of three in the collection of the British Museum.

THE ALTERNATIVE TRADITION

In chapter 9 I will be demonstrating for you methods of drawing and modelling which lead naturally to what I call the alternative school of form. To show you exactly what it is—and how it differs from the classical school—let us analyse a typical Roman portrait, that of Hadrian (*pl. 1*).

It may not be a masterpiece but it is a good example of a genre that used to be very much more highly regarded than it is today. Rembrandt owned no fewer than thirty Roman portraits, and his work leaves no doubt that he learned a great deal from them. His drawings can be read with complete confidence, in spite of their apparent coarseness of technique, because of their firm foundation in geometric form.

The sculptor of Hadrian strikes a balance between the naturalistic requirements of portraiture on one hand and a desire for formal clarity on the other. My analysis shows the link between the survey techniques used by the sculptor in finding his way through the block of stone, and the resulting geometric mode of thought.

By measuring the final sculpture we can arrive at the size of the most economic block of stone required. Fig. 1 shows the sculpture inside this block after it has had the unnecessary stone removed from above the shoulders. We see the small block **A** with the side surface drawn in (**a2**, **a3**, **a4**) as a kind of box which contains the head. The relationships between this box and the head inside are many and remarkable. The head fits inside the box most neatly; the front right edge **a1** forms the axis of symmetry of the features, and the diagonal **D** between this edge and the back left forms the axis of symmetry in depth. In other words, the geometry of the original block is reflected in the geometry of the head. With the actual sculpture rather than a

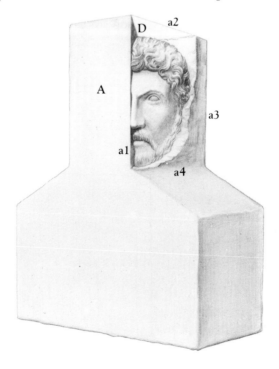

Fig. 1. The bust of Hadrian is shown here inside the original block of marble from which it was carved. The first stage would have been completed by an apprentice mason, who would have removed the unwanted stone from above the shoulders, leaving a smaller block within which the master carved the head.

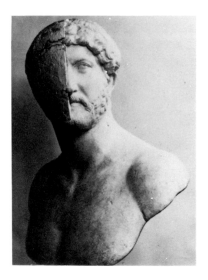 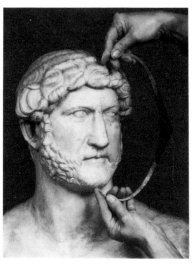 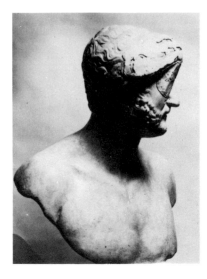

photograph to refer to, one can see that even the sides of the face reflect very clearly the sides of the block from which it was carved. When we come to analyse the carving of the features we find the same close relationship between the shape of the original and the process of removing the unwanted stone.

Figs. 2, 3, 4 (*left to right, above*).

Fig. 5 (*below*).

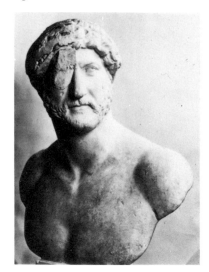

In fig. 2 we see on the right side of the face the rough egg shape of stone before the features were carved into it: note how the shape of the chin, the ear and the curls all fit into this shape. When finding his way through the stone, the carver would have taken a series of measurements from a single measuring boss. In this case, the curl in the middle of the forehead was probably the fixed point from which all the other major points were measured (*fig. 3*). The distance from the curl to the chin, for example, equals that from the curl to the rim of the ears. And the widest curl, the widest point of the beard and the chin all fall on the same arc of measurement. These points are used as guides for the next stage.

Looking at fig. 4, we see how the sculptor carved three planes into the egg—one to form the underside of the curls; a second, coming up to meet the first, to form the side of the forehead and the cheek, and a third to push the front of the cheek back to leave enough stone for the nose and chin. So confident was the carver that he took nicks out of both ears as he cut the first plane on either side. Fig. 5 shows the same stage in the carving from another view: note how the upward thrusting wedge shape formed by these planes is echoed in the shape of the nose, and again in the ripples of curls in the beard at the corners of the jaw. The planes on the side of the nose are continued in the frown, and touched on again in the corners of the mouth.

The original from which the artist worked is much more likely to have been a portrait modelled by some famous sculptor than the live Emperor Hadrian himself. The carver has had the advantage of time to plan and he has been very methodical. He would have selected various essential features on the outer surface—the central curl, the chin, etc.—and, using callipers and chalk, marked these off on the stone egg. He would then have

carved the intermediate planes to fix these and other salient features in their relative positions.

The process requires a geometric mode of thought that this sculptor obviously enjoyed: he leans on the planes round the nose. He plays the same kind of game with the ears and eyes, emphasising the geometry by taking up directions suggested in one place, and restating them in another: for instance, the direction taken by the line of the frown as it turns under the brow is precisely echoed in the line of the top of the ear lobe.

These compositional echoes or parallels are as important to the art of sculpture as they are to music; they give a sense of unity and completeness. They are also frequently used in drawing: Titian, for example, used them for dramatic emphasis in his painting.

In the chapter on carving (chapter 7), I discuss further the influence of the shape of the starting form on the finished work.

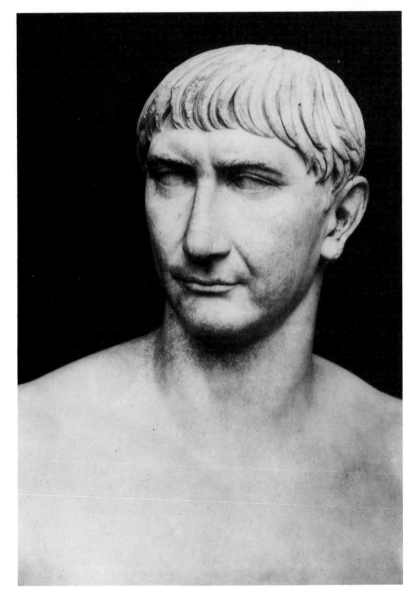

Pl. 2. *Trajan*, Roman, c. 110 A.D. (British Museum). This portrait displays many of the characteristics we have seen in *Hadrian*, including the posing of the head to fit the stone.

A block of stone, a tusk or a tree-trunk becomes the containing shape of the finished sculpture, which is very important to the sculptor. So much so, in fact, that the modeller, who has no shape to start from, tends to invent a containing shape in the course of work.

What I am suggesting is that sensible economies of stone and effort have led to a technical tradition that carried with it a geometric patterning of form, and that delight in this geometry then caused it to be pursued for its own sake. You will find the same or similar things happening in many Roman busts, and in drawings through the centuries in every country in Europe. Sculpture has always had this geometric element; draughtsmen and painters adopted it as soon as the invention of perspective made it possible for them to depict the third dimension with precision. As well as playing a major part in the work of Rembrandt and Holbein, it is the cornerstone of the art of Masaccio and Mantegna and underpins the portraits of Titian and Tintoretto as well as the vast majority of the work produced north of the Alps.

Pl. 3. Giovanni Rosselino, *Giovanni Chellini*, c. 1456 (Victoria & Albert Museum). The early Renaissance sculptors were very clearly influenced by their Roman predecessors.

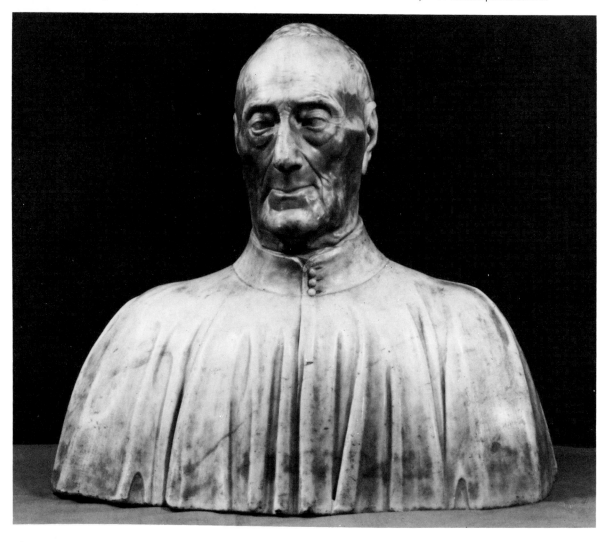

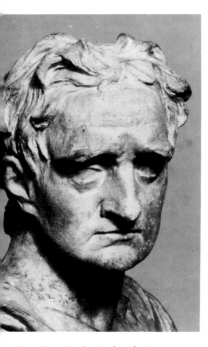

Pl. 4 (*above*). John Rysbrack, *Isaac Newton*, c. 1736 (Victoria & Albert Museum). The Roman influence is clearly felt here, although the forms around the eyes, for instance, are somewhat overblown compared with the austerity of Roman work.

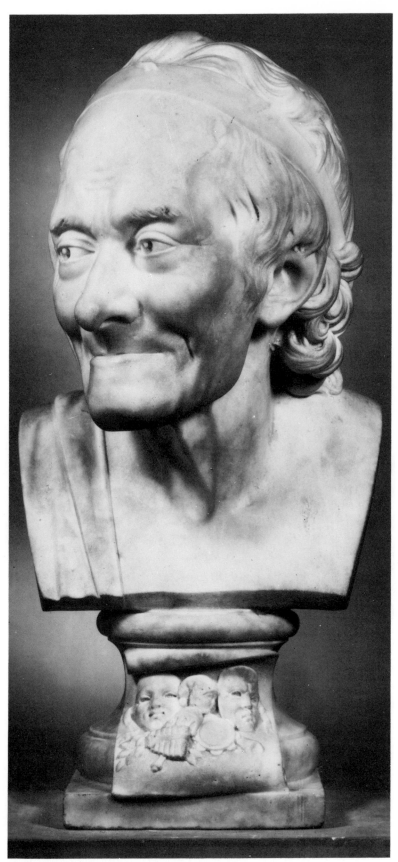

Pl. 5. Houdon, *Voltaire*, 1781 (Victoria & Albert Museum). Neoclassicism tends to look towards the Greek tradition, but in this brilliant portrait the Roman influence is very evident.

Roman portraits were the most respected and widely available prototypes of the antique in Europe. The Roman process of carving had a very distinct style which has had an immense and—in my view—beneficial influence on artists ever since. But modern critics have cultivated a disdain for Roman art. Roger Fry went so far as to say: "Rome, the one great culture of early times of which we can, I think, say that the loss of all her artistic creations would make scarcely any difference to our aesthetic inheritance." His description of Roman portraiture as "purely imitative and photographic" is much more than a limited blind-spot. It is blindness to a huge area of art and a blindness that we have inherited. As Wolfflin rightly said, "Beholding is not just a mirror that always remains the same, but a living power of apprehension which has its own history and has moved through many phases." In the most recent phase we have lost one of the cornerstones of European art.

The clear, simple geometric shapes that lie behind the complex surface of life are what hold observed phenomena together in a firm design. I maintain that this geometric patterning of form is equal in importance to the more generally understood classical tradition. We don't even have a name for it; I call it the 'alternative' tradition for want of another name.

Pl. 6. *Sir Gilbert Talbot*, English, 16th century (Victoria & Albert Museum). A severe, solid and geometrical portrait.

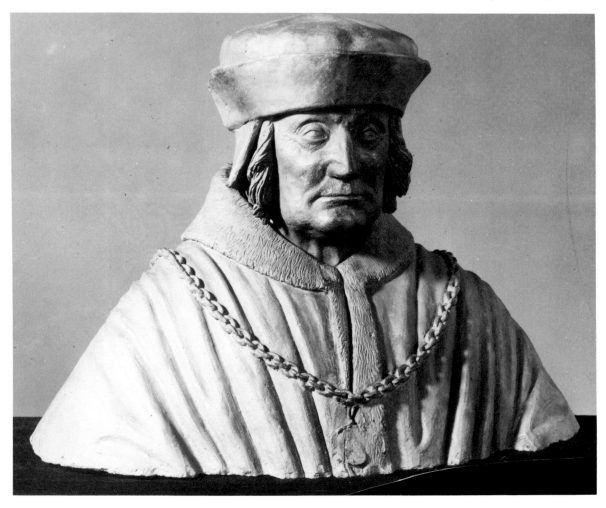

Pl. 7. Henri Gaudier-Brzeska, *Major R. H. Smythies*, 1912 (Tate Gallery). This excellent portrait borders on caricature.

A PORTRAIT IN THE
CLASSICAL TRADITION

In classical times, bronzes were probably made by modelling a core of terra cotta and then dipping it into molten wax several times. This wax would then have been modelled to the final finish in preparation for lost wax casting. As you see, the process produces a kind of instant classical unity without much intervention from the sculptor. It is difficult to believe that the Greeks and others did not avail themselves of this 'trick'. (Many works by Rodin combine arbitrary bumps with the fluid look: both could be the result of a quick dip in hot wax.) Techniques such as this might once have been closely guarded trade secrets, but they should not now be regarded as an open sesame to sculptural expression; I would advise against their use in general.

Fig. 6 (*above right*). Wooden tools are better for making classical forms as they tend to slide over the surface in a polishing action, whereas metal tools predispose the sculptor to cut.

Fig. 7. When you build up skin after skin with small pellets of clay, the difficulty is knowing when to stop.

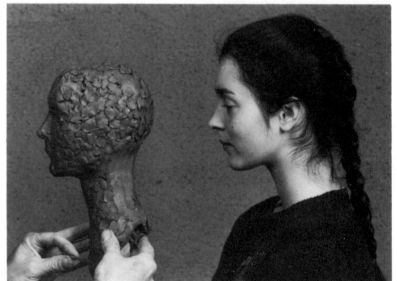

THE CLASSICAL TRADITION

The classical tradition finds its roots in Greek sculpture of the period between 500 and 300 B.C. In *Greek Sculptors at Work*, Carl Bluemel describes the effect of carving marble with tools made of bronze or iron rather than hard steel. To preserve the cutting edge on such soft tools it is necessary to go very slowly. The Greeks did not so much cut their stone as erode it; a more forceful attack would have spoilt their tools. After the initial blocking out which was done with a drill, they pecked gently away at the stone with their tools at right angles to the surface, removing layer after layer and finally smoothing the surface by rubbing it with another stone.

One can see that such a process predisposed the Greeks to soft rounded shapes as opposed to the firmer crystalline forms of the Romans. The idea that the head is an egg and the limbs cylinders

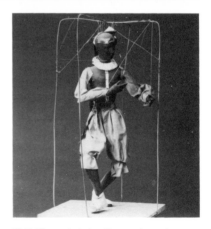

Pl. 8. The artist's lay-figure, draped and posed as a visual aid to composition.

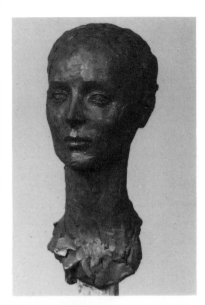

Fig. 8. Before treatment with wax.

Fig. 9 (*below left*). After treatment with wax. By repeatedly dipping the head into molten wax until a thickness of about $\frac{1}{8}$ inch (3 mm) is built up, I give the head an instant classical simplification and unity. Had I used a fired terra cotta core the wax could be re-worked in readiness for lost wax casting into bronze.

Fig. 10 (*below*). Drawing detailed features on the wax.

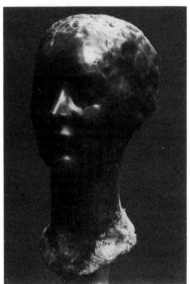

is derived from classical sculpture. The lay-figure—an articulated puppet so often used in the teaching and practice of academic drawing—is a diagrammatic expression of the same ideal (see *pl. 8*). Seeing the figure in these simple terms was fine for the Greeks, but it became a stale stereotype in time. Where sculpture based on the classical ideal is bound to see every head as an egg (modified to fit the individual), a portrait based on the Roman technique suffers from no such prejudice—every natural form can find its equivalent in three-dimensional geometry.

To give you an idea of how the classical technique works in action, I demonstrate it (*above*) using my daughter as a model. Using modelling clay, I build up the form gradually, adding layer after layer, just as the Greeks removed layer after layer of stone. If you wish to create a classical head it is necessary to maintain the egg shape at all costs; no idiosyncratic feature should be allowed to interrupt the simple unity of form.

For the sculptor this method has four distinct disadvantages. First, one is never quite certain when one has reached the final surface and therefore the egg tends to grow too big. Second, until one reaches the final surface all the relationships one makes are done by guesswork. Third, it takes a long time before one gets to the final surface, during which time one is becoming accustomed to forms and shapes in the work that are too distantly related to the model. Finally, as the forms grow steadily fatter they are likely to change in their relation to one another in an unforeseeable way. This last factor is less important when only the two forms of the head and neck are involved (*fig. 11*), but is more serious when one comes to deal with the entire figure.

Does it begin to sound as if I am not exactly recommending this classical method? Difficult as it may be for the sculptor, it is worse for the draughtsman, and this is because the egg is a form that cannot be pinned down by graphic means. It can be suggested, it can be rounded out with shading, but one cannot, for instance, make any precise statement about the movement of its axis within the depth dimension of the picture (see *fig. 14*). Given these severe limitations it is truly amazing that so many great artists have achieved so much within the classical tradition. Equally it is hardly surprising that the tradition itself is, if not dead, at least moribund. If you are brave enough to try to revive it, you cannot say you have not been warned of the pit-falls.

Once you have carved features on the egg, however, it does become a little more manageable. Most classical draughtsmen incorporate elements of the other tradition to give their work greater clarity of articulation. The two traditions are not exclusive, but few artists move confidently between the two.

The classical provides a very satisfactory vehicle for invention. The lay-figure is a simple schema that can be learnt by any schoolchild. You start with a pin-man to get the movement, then you create cylinders around the central pin armature. A student who has been equipped by a study of anatomy in the ancient academies would finally go on to delineate the muscles, etc.

The classical 'ideal' of beauty could be explained by this standardised approach to the figure, for the truth is that the method is incapable of producing anything other than the classical figure—it cannot produce the variety that one finds in life. As a method, therefore, it is ill-adapted to aiding observation. In order to refine one's powers of observation one needs a method that is capable of responding, without prejudice, to the vagaries of nature. The alternative tradition provides such a method; the classical tradition does not.

We have only to compare Roman portraits with Greek to see that this is so. The Greeks produced an 'ideal', the Romans produced characters, individuals. The classical Greek nose which runs in a continuous line from the forehead is a simple device for maintaining the profile of the egg. I doubt that it was any more common in life in classical times than it is today. There are heads in nature that conform to these exacting standards, but not many. That is why even classical artists like Raphael or Ingres use the alternative tradition for portraits of men.

Fig. 11. As the two large forms of the head and shoulders grow, the neck between them gets steadily shorter and thicker.

Fig. 12.

Fig. 13.

Pl. 9 (*below*). Henry Moore, *Pale Shelter Scene*, 1941 (Tate Gallery). We see here that the artist has followed Michelangelo's example in making shading which also draws sections round the form. With the aid of drapery in the lap of the closest figure he has managed to tell us, more or less, where the line indicating the upper thigh moves from describing its length and starts to describe its section; on the other hand, by no stretch of the imagination does that thigh connect with the stated position of the pelvis. The classical method is intrinsically imprecise no matter who the master.

DRAWING IN THE CLASSICAL CONVENTION

For this approach to sculpture the preparatory drawings should obviously be cast in the same classical mould. When we look at the egg shape (*fig. 12*) we can see that no step has been taken towards the individual sitter. Because of the evenness of the curve it does not tell us about the movement of the form in space; until features are placed on the surface (*fig. 13*) we have no means of ascertaining the height, depth and breadth axes of the head. The egg itself has an axis that is of very little use in establishing any head-like quality. A linear description of the cylinder of the neck is somewhat easier. We have the possibility of drawing round the section of the cylinder and along the length, but if a classical draughtsman loses sight of the distinction between length and section for a moment he is lost (see *pl. 9*).

Standing head and shoulders above any classical draughtsman, with the possible exception of Raphael, is Ingres—and his score in hits and misses does not encourage emulation. The number of Ingres drawings that maintain concentration from top to toe are very few. The high regard in which I hold his draughtsmanship rests on his paintings, where months of effort can make good a job that is, in all commonsense, beyond human reach.

Recent criticism would have us believe in some magic quality of 'line', but criticism would make more sense if it would concentrate attention on the areas between the lines—that is, after all, where we hope to find the form that the line seeks to describe. In chapter 8 (*pp. 146–47*) I analyse a drawing by Holbein. His hypersensitive line works by the relationships that line manages to create. It establishes those relationships across an area of paper that is read as a volume. Precisely the same happens in classical draughtsmanship, but whereas Holbein can work directly with form by shifting the planes and corners to establish the shape of his volumes, the classical draughtsman has to rely on sections and surface modelling, factors which Holbein uses merely as a supplement to his graphic vocabulary. Having established the structure, Holbein can manipulate the surface with a precision that is beyond the classical draughtsman, and he often achieves this without the aid of chiaroscuro.

The classical draughtsman is, in addition, hampered by another major disadvantage. It is easy to make a distinction between two-dimensional and three-dimensional rectilinear forms on paper, but next to impossible to distinguish clearly between a sphere and a circle. The third dimension of the sphere can only be hinted at by means of light and shade. True, it can be diagrammatically created by drawing meridians or sections (*fig. 14*), but these can only be read in relation to a known shape—they cannot describe a form that is not already in the mental repertoire of the artist or the audience. In other, crueller, words, classical draughtsmanship requires cliché as a foundation. We know the shapes of the human figure in a general way and the classical draughtsman conveys just that—generalisation.

With a draughtsman such as Raphael, who manipulated these clichés with the greatest skill, we apprehend his intention and tend uncritically to accept intention as achievement. But we have only to compare a Raphael drawing with one by Rembrandt, who followed Holbein's method, to see that Rembrandt is capable of describing a physical relationship in precise detail where Raphael has to be content with hints that we can read only because we recognise the various landmarks of human anatomy. Rembrandt's drawing can work without these landmarks.

I make this comparison because by comparing the best of both traditions we can fairly judge the advantages and disadvantages of the two methods. The study of Rembrandt's drawing is in my view a better training for sculptors than the study of Michelangelo. And this despite the fact that, as far as we know, Rembrandt never made a sculpture in his life, while Michelangelo's drawings are mainly directed towards that end. It is a fact that artists of this century have looked to Rembrandt rather

Pl. 10. Jean Auguste Dominique Ingres, *Study for the allegory of the City of Rhodes*, mid-19th century (Musée Ingres, Montauban). Above the arm, all is well. But below, the line is carried away by its momentum. The swinging line that Ingres uses to describe the pelvis makes no form at all because the relationship between the lines has been lost. In the calves and ankles he finds form again. Such a loss of concentration is entirely normal in the work of this great master of the classical method.

than to Raphael or Michelangelo for guidance in the art of drawing; by describing the grammar of drawing in a new way, I am merely suggesting a reason for that preference. The following criticism is aimed at Raphael's method not at his achievement, which is remarkable but, I would say, managed against the odds.

A COMPARISON OF THE TWO METHODS OF DRAWING

Rembrandt's drawing of Christ and the sick woman (*pl. 11*) may appear to the uninitiated to be a little clumsy, even messy. The hands, for instance, are not the clear statement we would expect in a Raphael. Even the drapery that covers 90 per cent of the drawn surface seems a bit scrappy. It is no good looking to Rembrandt for the well-drawn detail; his interests are elsewhere.

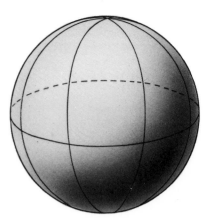

Fig. 14.

What Rembrandt gives us is a complete structure or, in this case more accurately, a complete machine for it is just about to go into action. It works not through the strength of the detail but because every part is so related to every other part that we can read the precise sequence of events before they unfold. Christ will rock backwards, muscular tension in the arms will bring the woman forward and then a push from her right leg will see her on her way. We can see that the miracle is going to work. Not only that, we can read the uncertainty of the patient and the quiet confidence of Christ—we read all this because Rembrandt is able to manoeuvre the details in space with such precision.

Examination of this or other Rembrandt drawings shows us that he did not achieve this by magic, but by the application of trial and error. The precise location of Christ's head has been

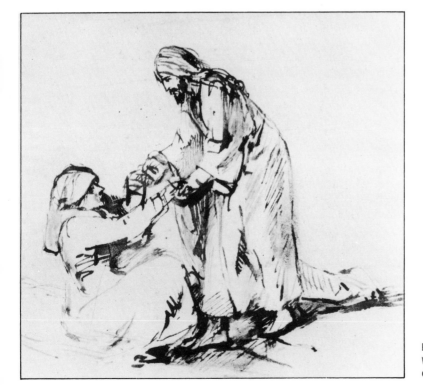

Pl. 11. Rembrandt, *Christ Raising a Sick Woman*, said to be 1659–60 (Lugt Collection, The Hague).

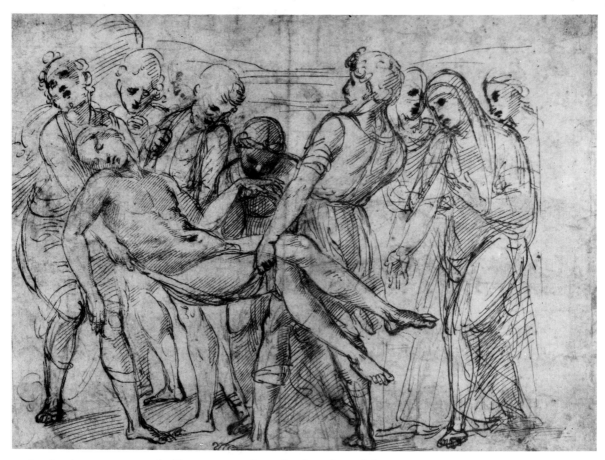

arrived at by a process of adjustment; so have his hands and feet. If, for instance, you cover the left foot with your finger so that you read the left foot in the position further back where it was first placed, you will see Christ using a much rougher approach to the job in hand. The movement of that left foot has done wonders for our assessment of his character. Rembrandt's drawing may on occasion appear crude because he is always prepared to sacrifice neatness where necessary to get the gesture right. His 'line' is often extremely scruffy, but his structure makes him the greatest master of drawing in my opinion.

Raphael, on the other hand, always draws very beautifully, and it may be that the priority he gives to an exquisite finish prevents him from seeing structure with Rembrandt's vivid clarity. The posture of the man at the extreme left of the group in the study for the Borghese Entombment (*pl. 12*) is not appropriate for someone carrying a great weight. The bearer supporting Christ's legs is much more convincing from that point of view, but is nowhere near the quality we saw in the Rembrandt. When we pause to consider the way these rather plump legs pass through the space between the bearer's arm and thigh, I think we have to concede that there just is not room for them. Because we recognise the legs as legs we tend to accept them without further question. We know what the bearers are meant to be doing and we have learnt to be satisfied with that.

The truth is that though every *part* of the Raphael is achieved,

the whole is ill-considered. It is true that this is only an early study for an early painting, but the structure of the painting itself is, if anything, even less well achieved: in the painting the two bearers appear to be heaving the corpse in opposite directions. The classical method is incapable of the refinement of structure achieved by Rembrandt.

It is my belief that the art of drawing is the art of dividing an area of paper into smaller areas; whether that division is made in areas of tone, of colour or by the use of lines is immaterial. We read a drawing (and the reading of drawing can and should be taught) by the relationship of areas to one another.

We stand in awe of classical draughtsmanship—perhaps because it was the predominant mode during the Renaissance —but, great and important as that movement may have been, it is unwise to saddle ourselves with a method so ill-suited to our needs. The classical mode has a usefulness for making up stories; it is a serious handicap when it is used to record observation. While we continue to believe that the art of drawing has to do with some magical property residing in the line itself the art of drawing will continue to decline. The study of Rembrandt's approach to form and structure in drawing is the best medicine I can recommend.

LEARNING FROM THE MASTERS

This brings me to the last point I want to make in this chapter. If you wish to become a chess-player you are obliged first to learn the moves; you would be wise to learn the gambits as well. When you have done that you may or may not become a good chess-player; but without it you won't become a chess-player at all. To learn the moves and gambits in art, as in chess, you are obliged to see how others have done it before you.

By far the quickest way of learning is from the great masters—by copying. Instant originality may fool many today but it is unlikely to amuse you, the artist, for long, let alone for a lifetime of study. The ancient practice of working from the antique has much to recommend it. First, you will see the problems of drawing and of sculpting against the unchanging object (working from life can be frustrating for the beginner since nature is always in flux). More important, by following the work of a master of your choice you come to understand more fully what it is you particularly like. Meanwhile you become acquainted with the language of form, almost without noticing. This is one of the most exciting aspects of art: you learn many things subconsciously simply by exposing yourself to good influences.

Finally, the interpretation of nature is a surprisingly difficult and confusing business; by using a work of art as a starting point you are making your task that much easier. This is sensible when you are just beginning to wrestle with the problems of the medium. Like the chess-player, the artist who earns the greatest respect is the one with the most originality, but if you are so original that you don't understand the rules, the best you can hope for is to be the inventor of a new game.

3. IMAGINATION AND CREATIVITY

Students of art frequently worry because they feel themselves to be lacking in imagination. This sense of inferiority is based on a very widespread misunderstanding of what can be expected of the visual imagination. We all dream; at one time or another most of us have experienced sensations of pleasure or terror of electrifying intensity which are purely the product of our own imagination. Do we need further proof of our capacity for an inner life, inner vision, inner feeling? The trouble begins when we try to make use of that inner vision.

The plain truth is that the riveting experiences of dreams or visions tend to look a bit incoherent, insubstantial and unsatisfactory in the cold light of day. Verbal descriptions of imaginative experience stand up well, but visual descriptions do not. This may be because visual descriptions have to vie with present reality while verbal descriptions are abstract and comparable only with remembered sensation. Verbal description matches like with like—the abstract quality of one mind with another. Historical criticism fails to recognise this crucial difference, perhaps because Vasari, the great 16th-century painter and art historian, was at pains to make them appear the same in order to build up the prestige of the painter in the eyes of scholars.

It is difficult enough to pin down the form of a head when you have the real head right there in front of you, so you can see that the problem of having the mere memory of a vision as reference should frighten the bravest. Mythology has led us to believe, although we cannot begin to do it ourselves, that the great can take such problems in their stride. The evidence leads to a very different conclusion.

All the evidence points to the conclusion that Rembrandt, Michelangelo, Leonardo, name who you will among the great (with the possible exceptions of Goya and Hogarth, for whom I have yet to find evidence), had precisely the same problem that we encounter today with the gap between the initial vision and the task of giving it substance. But instead of expecting miracles from their imaginations, the great masters fed theirs with a rich diet of reality. We vainly try to turn vision into reality; they set about the much more practical task of transforming reality into vision. The aim of both is the same; that is, to marry the inner and the outer worlds. One way works and the other does not, it is as simple as that. Art is difficult enough without attempting the impossible; why not follow their example?

The faculty we often mistake for imagination is little more than know-how, memory and a touch of invention. True imagination—what we actually admire in Rembrandt and Leonardo—is observation heightened by an act of sympathetic

Pl. 1. Auguste Rodin, *La Main Crispée*, 1884–86 (Victoria & Albert Museum). Part of the horror impact of this semi-life study is due to the likeness Rodin has seen between the hand and an old gnarled tree. A good part of what we recognise as imagination is based on visual metaphor of this kind.

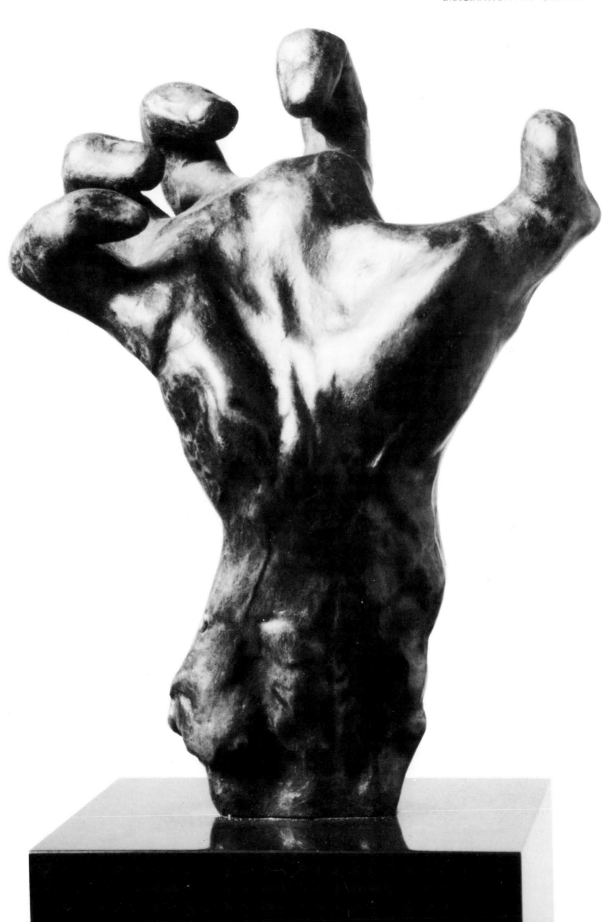

imagination which allows the artist to penetrate to the feeling beneath the appearance. Where lesser men tell stories by means of dramatic gestures, Rembrandt, for example, is able to take us to the very spot at the precise moment of the drama by the power of his imagination *working on reality*. His dramatis personae may in reality have been Dutch beggars in fancy dress, bearing no more resemblance to the historic truth than a nativity play, but we feel with him and are touched by the drama that he portrays because his reality, our reality and biblical reality overlap. The act of receiving Rembrandt's message is a similar act to that of creating it in the first place—both are based on a perception of reality held in common. Rembrandt's art can develop our perception of life, but our own perception is the starting point from which our art must grow.

There is a mythology of creativity and of the imagination that you would be wise to forget before you embark on your own creative endeavours. See your task as doing the best you can by the most convenient means available. Do not allow yourself to be inhibited by other people's fantasies about how 'true' artists should behave. Imagination seen as a store-house from which the very talented pluck images at will, fully developed and only awaiting a few strokes of the brush to bring them to life, is a myth; waste no more time pining for it than you would lamenting that you do not possess the strength of Hercules.

I give no guarantee that you possess as much genuine imagination as Rembrandt or Michelangelo, but I would suggest that the foundation of their art is observation, and if it has power to move you that is because you possess to some degree similar powers of observation and imagination yourself. Their art moves us by touching some chord of remembered experience which is our own. To put it another way, if we had not made similar observation for ourselves their art could not move us. All who can be moved by art are themselves potential creators.

One of the chief delights of art lies in its ability to sharpen our powers of observation and to open our consciousness to the infinite inspiration for invention that surrounds us in nature. And yet we have circumscribed ourselves with taboos that have all but strangled our creative endeavours. Men of science have made instruments to assist their limited vision: no-one thinks less of the astronomer because he uses a telescope. But the 'true' artist, according to popular belief, must produce everything from his own inmost being.

Mechanical aids are regarded as a bit of a cheat and definitely a sign of weakness. We are only truly creative when we draw from imagination and that, by common consent, means drawing without reference to the outside world. These are not simply the misapprehensions of the common man, they permeate the teachings and the theory of art at the highest levels. They are nonetheless absurd when compared with the actual practices of the old masters. The proportion of great artists who can be shown conclusively to have used mechanical aids may appear surprisingly high to the modern student: Holbein, Dürer, Vermeer, Velasquez—to name but a few.

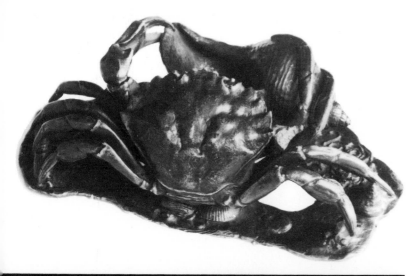

Pl. 2. *Crab with Shells*, school of Riccio, 16th century (Victoria & Albert Museum). In 16th-century Italy artists were very fond of making bronze still-lifes from actual objects.

Pl. 3. Nigel Konstam, *Floral Bauble*. I constructed this round a tree stump which had been incompletely burnt. The charred shape seemed to suggest some kind of organic propeller and was very attractive. Nature provided the form and style; my intervention was little more than a restoration job—I have developed what was suggested. This use of *objet trouvé*—whether bones, flints or junk of a man-made origin—is a very good way of getting started if you are in a rut.

If you are lucky enough to have an idea, try it out. If you think long enough you will be able to find twenty good reasons for laying it aside—our imaginations are infinitely fertile when harnessed to inaction. Start work—that is the only way to test the durability of an idea. If your inventive capacity functions as well in action as it does in inaction you will be all right. I have never in my life started work with a vision so complete that all I had to do was to put it down on paper or build it up in clay. Ideas tend to accumulate around a piece as work progresses.

The artist's first idea is usually the merest shadow of the final object. Leonardo surely did not lack imagination, and yet his preliminary sketch for the painting *The Virgin and St. Anne* makes him look like a fumbling amateur. Let other fumbling amateurs take courage, heed his example and learn to pursue their vision in reality. Put your trust in the processes of art; you will find they generate their own momentum.

STIMULUS AND INSPIRATION

My own creativity is often stimulated by other works of art. Sometimes the source is obvious, at others only the faintest echo of it is seen in the result. On one occasion I was so struck by a crucifix by Michelozzo which I saw in Venice that when I got home I had to make one for myself. In my mind, what I made was a direct replica of the Michelozzo. In fact, when I revisited the original some fifteen years later I did not even recognise it.

Sometimes the stimulus comes from life out there in the street; more often for me it comes from life posed in the studio. Stimulus can come from anywhere or anything—newspapers, television, photographs, landscape, literature, architecture, theatre, music; very often it comes from play. The section on carving a horse's head shows these factors in action (*pp. 138–41*).

Do not wait for inspiration—look for it. Keep a notebook about you and promise yourself to draw or describe the most inspiring thing of each day; however dull it may appear at first sight, the act of drawing or describing it will enhance it. You may even find that you have talked yourself into making something from it.

It is a great privilege to be inspired by a thunderbolt from Jove, but it does not automatically follow that the resulting work will strike others with equal force. Sometimes little or nothing comes from great experiences; conversely, experiences that at the time seem mundane may grow as you examine them sculpturally. Remember that, for the artist, the work of art is primarily a means of experience. If an experience is strong enough to make you pause, it could turn out to be just the inspiration you need. This description by George Fullard seems to me as accurate an account of a work of art and its genesis as one could hope for: "A complete work is not made, it emerges as a survivor out of a phase of action, struggling through the infinity of possibilities ... the quality of the survivor is ultimately dependent on the speed and vitality of the phantoms which precede it."

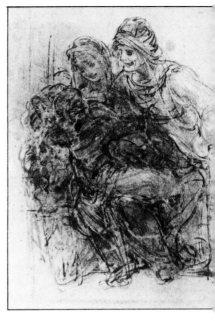

Pl. 4. Leonardo da Vinci, *Preliminary Sketches for the Virgin with St. Anne,* c. 1508 (The Louvre).

Pl. 5 (*opposite top*). Ernst Barlach, *The Avenger*, 1914 (Tate Gallery). I have long admired the way the arm and the sword frame the head of this figure. When I discovered that it was a direct quotation from a relief, *The Beheading of St. John the Baptist*, by the 13th-century Italian sculptor Pisano I did not feel cheated. On the contrary, I now feel I have even more in common with Barlach because we both enjoy the same things.

Pl. 6 (*opposite*). Barry Flanagan, *Four Casb 2 '67*, 1967 (Tate Gallery). Rope is lovely sculptural stuff—Turner framed a painting with it. A river meandering across a flood plain can be an inspiring sight, so why should this not be sculpture?

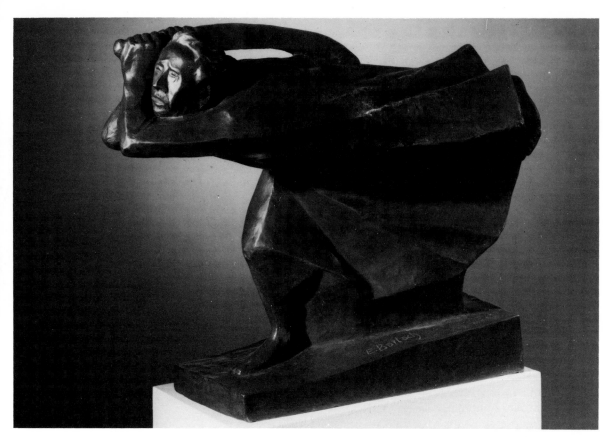

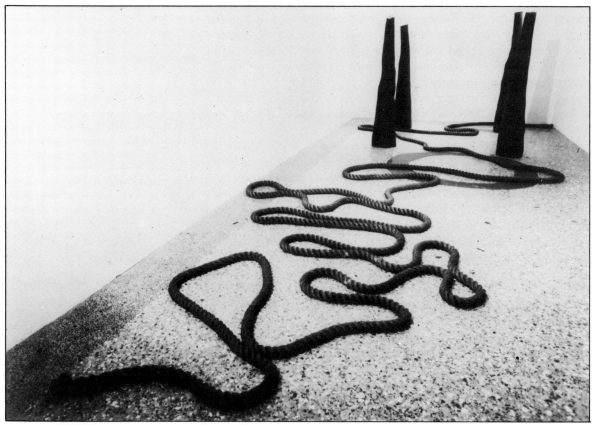

INSTINCT

Instinct is necessary to all visual achievements. Though the word implies some inborn quality that cannot be acquired, fortunately this is not the case in art: on the contrary, visual instinct is the result of cultivation. It is the instinctive obedience to unwritten laws, laws you have absorbed from the practice of the great masters without even realising it. Cultivating your instinct must become your top priority if you are to operate as an artist. This is done chiefly by exposing yourself to the best possible influences. It is not enough to sit at home looking at picture books, though that may help. Go to museums and art galleries, feast your eyes in the most expensive antique shops, surround yourself with beautiful things as far as you are able. It is a great advantage to have been brought up among such things, but it is never too late to start. Indulge your tastes and they will grow. Have no worries as to whether your taste is good or bad. The important thing is that it is yours; nourish what you have got.

Visual harmony is something that is experienced, but is very difficult to define. It comes in every shape and size; I know it when I see it. It is not something that can be analysed or taught like harmony in music. It is rather rare and special and the sensing of it is a great occasion. The same work of art will produce it in one person and not in another; it can be present for you on one occasion and gone on the next. Your job as an artist is to pursue what it means for you.

The poet Ted Hughes has advised writers, "Try to say what you really mean"; the same is true of the visual arts. The trouble is that we do not know what we really mean until we have succeeded in saying it. First we have to have a ranging shot at it, and then decide how close we have come to what we truly mean. Allow yourself as many ranging shots as you need. When you have come within striking distance, polish and refine the less satisfactory parts, pushing them closer and closer to what you really want to say.

Do not expect the clear precise expression to exist in the mind before you start. The process of art is a method of finding out what you really mean; it is a pathway towards meaning. The expectation of a clear message from the beginning is a great block to creativity. I know Mozart conceived music in his head and then just had to write down the notes, but he was exceptional in his field and his field was not the visual arts. As a visual artist you will need to be prepared to set out on a mere hunch and then to pursue it to a conclusion. It may be that you throw your work away and look for another hunch; that, alas, is part of the game.

Some of the examples illustrated in this chapter and through-out the book will speak to you, and my advice is not only to listen to what they say but analyse the way in which you receive their message. For each individual receives according to his own unique perceptions, and by analysing the essentials for *you*, you will begin to make contact with that perception. For what you give out in your art can never be other than what you receive. Train yourself as a receiver and your gifts will overflow.

Pl. 7. Anthony Caro, *Piece LXXXII*, 1969 (Tate Gallery). Like much architectural ornament, this piece eases the movement in stages from the horizontal to the vertical planes.

Pl. 8. Cesar, *Three Compressions*, 1968 (Tate Gallery). The action of a hydraulic press on old car wheels has something in common with the compositional technique of Michelangelo—both square the circle.

Pl. 9. Nigel Konstam, *Judo Throw I.*

As a culture we are frightened of receiving influence; it is part of our dottiness. The child would be unlikely to learn to walk or talk without walking and talking examples in front of him. If you have eyes you will receive influences whether you like them or not, whether you are aware of them or not; why not take charge and choose good ones? Your individuality will not be crushed by the masters unless you want it to be. Treat every work of art as a bearer of gifts. If it has nothing for you today then perhaps it will in a year or two; if not for you then for somebody else. If you will allow yourself, you will be naturally attracted to those that have gifts for you.

Art is for you. By studying art you are entering a brotherhood in which the giver and the receiver are one. If you cannot receive, you cannot give, because you have not understood the nature of the process to which you wish to contribute. There is a language of art which artists try to extend so that it can communicate new perceptions. But it can be over-extended: anyone can make something new, but to make something new and valuable is somewhat more difficult.

Pl. 10 (*opposite*). Kenneth Armitage, *People in a Wind*, 1950 (Tate Gallery). These figures have something in common with sailing boats in the wind and something in common with engineering. The artist often uses the structure of a folded screen to hold his figures up.

River God, Greek, c. 435 B.C. (from the west pediment of the Parthenon, Athens). Note how each part of the chest, hips and legs are clearly articulated against one another. All participate in one complete structure and in one movement which is stated in a form that is both man and stone (see *pp. 39–41*).

Evelyn Williams, *Woman on a Bed*, 1971. The materials—wax with string and cloth dipped in wax—give this piece an extra imaginative dimension that reminds one of the immediacy and the improvisory nature of the child's imaginative world.

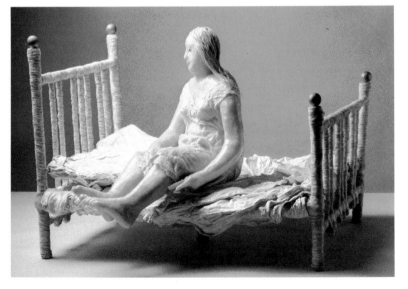

(*Opposite*) Nigel Konstam, *The Figure of Universal Laughter*. When I made the strange head of this over life-size figure I believed myself to be under the direct influence of some divine power. It is the only time I have worked under inspiration of this sort. In retrospect, I am quite pleased with the result. The funnel shape which leads to the open throat is a visual expression of my ideas about giving and receiving; the expression came before the thought.

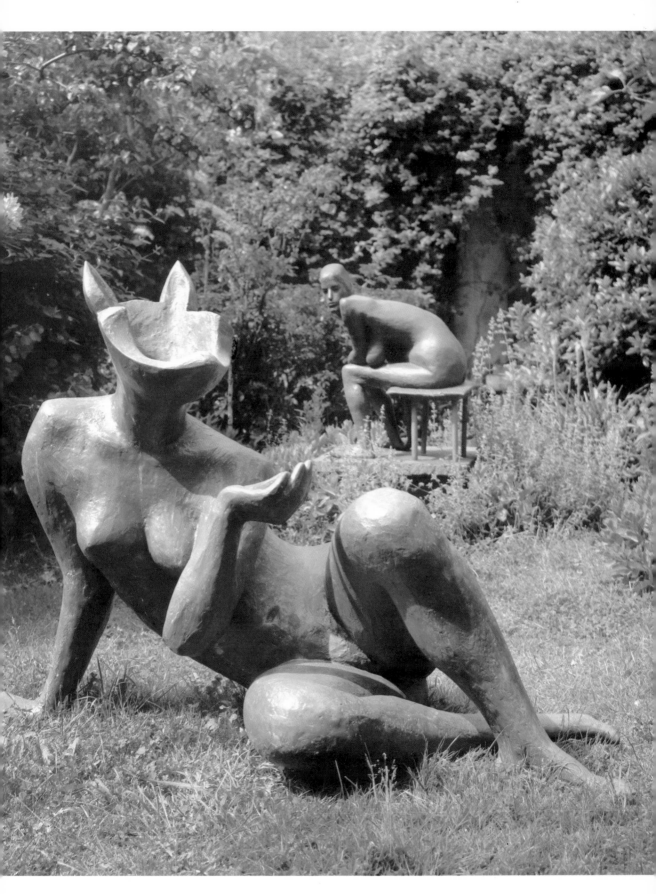

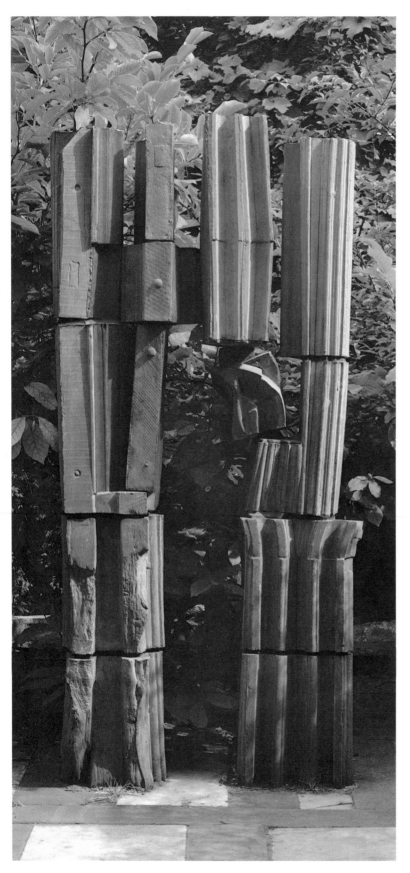

Peter Startup, *Separation*, 1965. The original model for this work was made out of bits of furniture and other man-made mouldings. Startup went on to cast the piece into terra cotta which unified the colour and to some extent disguised the collage origins.

(*Opposite*) Ursula Pitt, *Sky Parcel*, 1981. The structure was built round a balloon filled with water and air and tied with string. The artist writes: 'After a period of research and observation, contact with the materials informs, enriches and refines the project.'

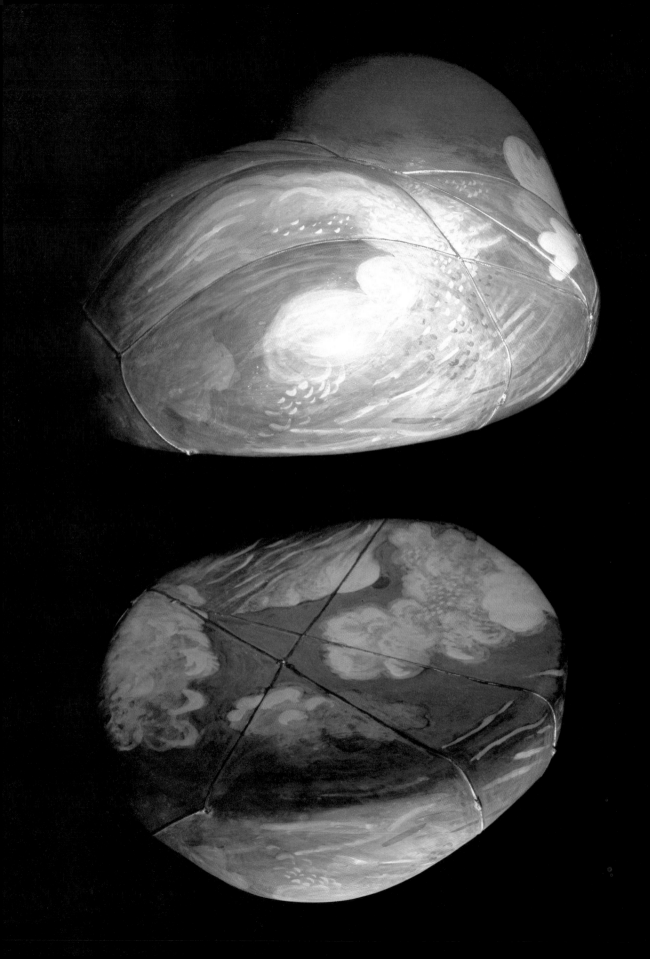

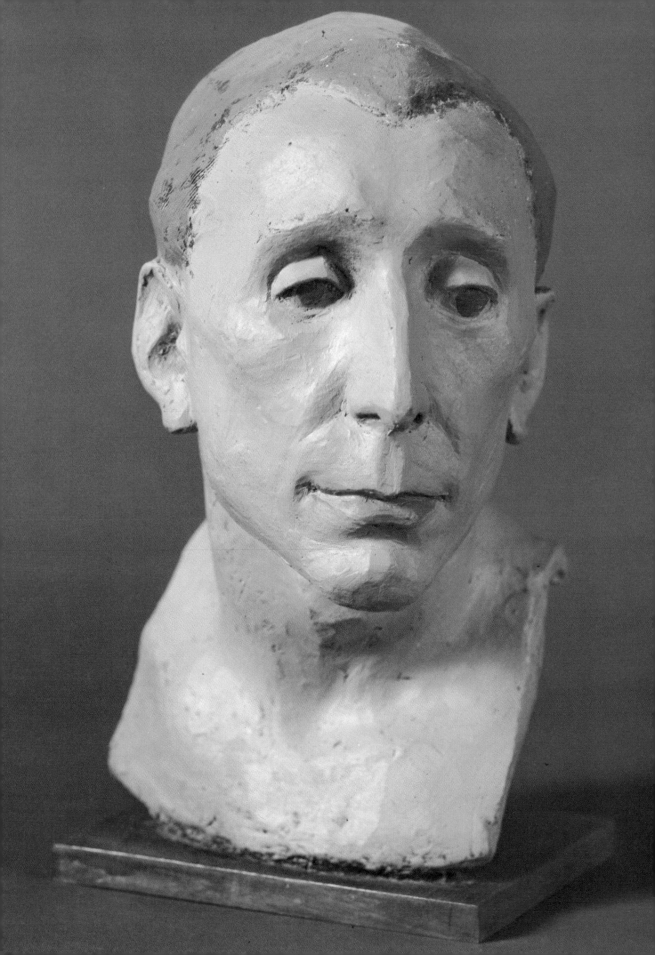

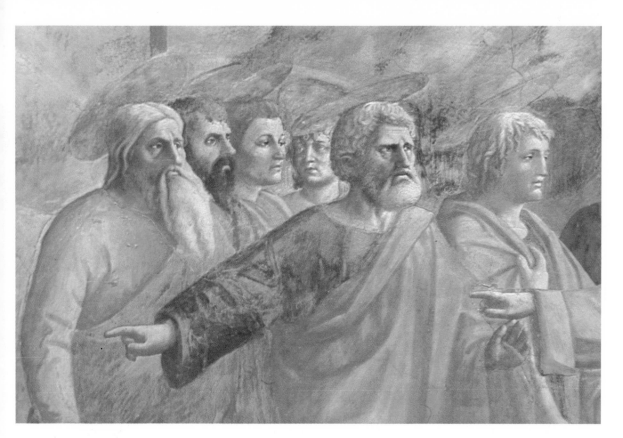

Masaccio, detail from *The Tribute Money*, c. 1426 (see *pp. 86–90*).

(*Opposite*) Nigel Konstam, copy of Uzano in painted terra cotta (see *pp. 90–92*) — life-size.

Final composition of *Running Figures* (see *pp. 102–4*)—length 14 inches (35 cm).

(*Opposite*) Final composition of *The Three Graces* (see *pp. 92–94*)—height 4 inches (10 cm).

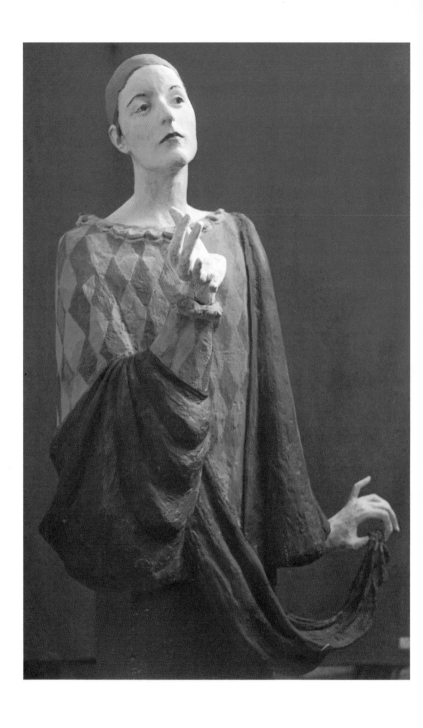

Nigel Konstam, *Pierrot* (see *p. 108*).

(*Opposite*) Stephen Cohn, *Monk Wall*, 1970 (artist's collection). This sculpture is made of papier-mâché finished with laminated paper and artist's oil paint.

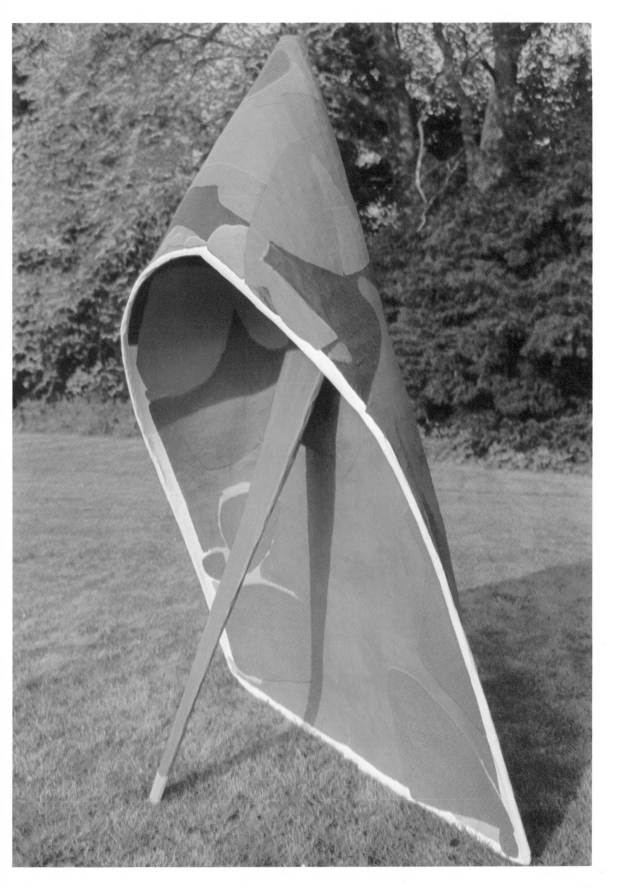

4. STRUCTURE AND COMPOSITON

When we arrange a room, lay out a bowl of fruit, or decide where in the garden to put a new sundial we are engaging in sculptural composition (see *pl. 2*). The decisions involved are not ones that can be settled without action. We must first try the cupboard here, the table there and the rug over there before we can know whether they are going to look good in those positions. Only when they are in position can we tell whether they look exactly right, temporarily acceptable, or perhaps quite wrong. Before you act, all you can do is guess. The professional is not the one who guesses right first time, but the one who is prepared to go on moving or changing the furniture until it does look exactly right. Because he is a professional, experience has taught him that the process will take time—it may take a long time. If you are prepared to go on perfecting and refining for a lifetime you are more than a professional, you are an artist.

Fundamental to all fine art is structure; in its largest sense it is the quality of the structure that separates the good from the great

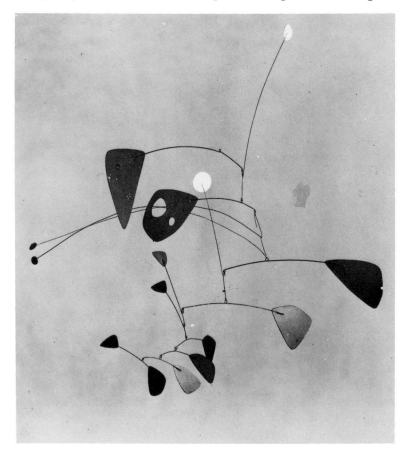

Pl. 1. Alexander Calder, *Antennae with Red and Blue Dots*, c. 1960 (Tate Gallery).

artist. In sculpture it is very difficult to separate the idea of structure from the idea of composition in general. The omnipresent force of gravity is to the sculptor what light is to the painter: the force that can unite the many disparate elements with which the artist wrestles. The study of structure is the study of the different ways in which nature or the ingenuity of man have resisted or responded to the pull of gravity (see *pl. 1*). I would urge you to study it in the widest possible sense in nature and in the many means man has devised to fabricate artifacts of all sorts.

In the interests of clarity, in analysing works I use the word 'structure' to cover ideas about balance in the direct gravitational sense. The word 'composition' is used to cover all other ideas of visual balance, harmony or rhythm. In practice I do not think that the two ideas can be separated: composition is concerned with creating a unity which has its own logic and it strikes a balance between all the elements present.

COMPOSITION AND THE RULES

The question as to what exactly constitutes rightness presents a problem that can only be answered subjectively—"It looks all right to me." The artist's decision is final; without this axiom the game cannot even start. Nonetheless there are rules. It is often said that rules are made to be broken, and the history of art is

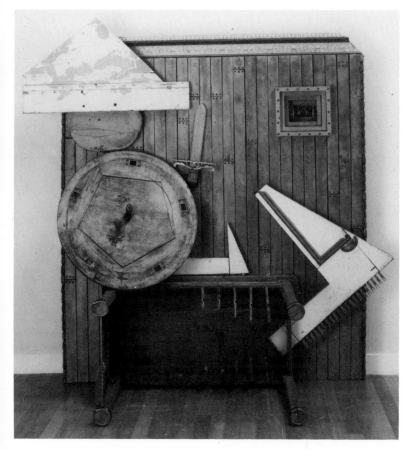

Pl. 2. George Fullard, *Death or Glory*, 1963–64 (Tate Gallery). 'There is no method and no intention to speak of; there is only imagination and the facts learned so far from work.'

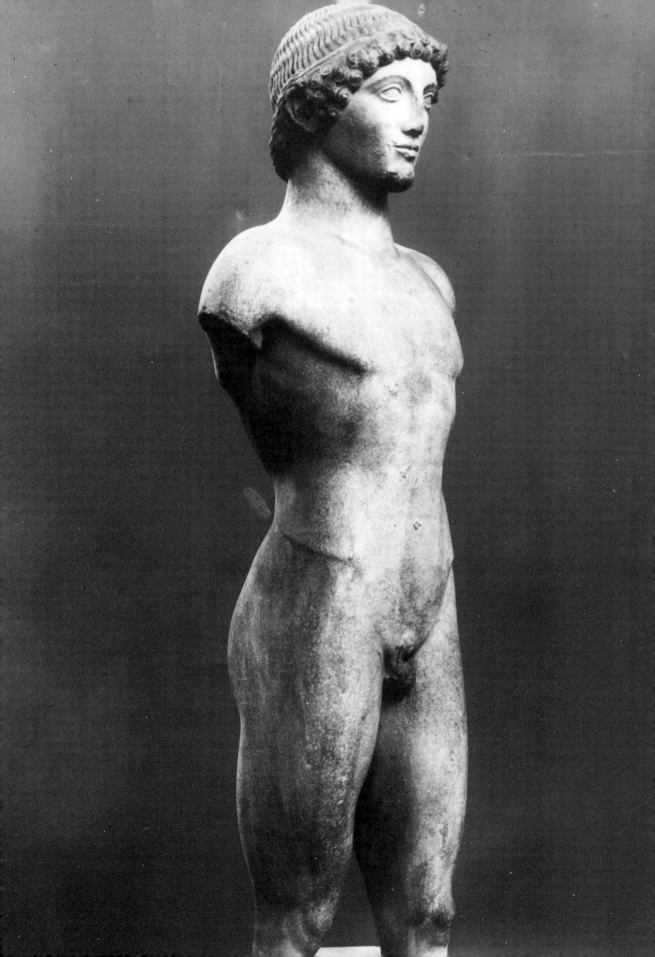

certainly a history of rules that have been bent, stretched, broken and reinstated. Under these circumstances it would be understandable if you were to question the good sense of learning the rules at all, but you would be gravely mistaken. The rules of art are wonderful, vague, super-rational, highly stimulating and absolutely central to the business of composition—one might say to the business of art altogether. Visual music can only be created in relation to the rules of art, not by obeying them slavishly, you understand—that can only produce a yawn or a pedestrian march—but by twisting them.

The rules of art are the grammar with which the sculptors of the past have expressed themselves. I would no more advise you to use their grammar than a teacher of English would advise you to write in the style of Shakespeare. But, as with writing, it is useful to have before you as a touchstone good examples of the way in which artists have expressed what they really mean.

By bending, twisting or standing the rules on their head, artists extend the language of art. A subtle change of emphasis can give new excitement to a time-worn cliché. But if this framework of art is stretched too far it disintegrates, and the games that were so pleasurable before become a riot. I have found the unruly behaviour of artists in recent years to be boring and destructive. I shall limit myself to describing work that seems to me to extend our understanding of the visible and tangible world. The psyche expresses itself in that world and in art if the artist attends to appearances with directed precision.

In talking about the rules of art I use words like framework, language, music. Composition is a word which suggests an amalgam of ideas. Words like rules, laws, canons of behaviour, canons of proportion, geometry, architecture, structure, framework, form, rhyme, rhythm, grammar, have all been used to try to pin down the illusive quality of the kind of patterning of nature that turns it into art. Many of the pairs of opposites outlined in chapter 1 are relevant here also.

Architecture has precise modular systems analogous to the Pythagorean scales in music. Scales are fundamental to the writing of music, but the use of architectural systems is more a matter of taste and convenience. Applying them is not a foolproof path to visual good manners, let alone visual harmony. Many great things have been achieved by instinct alone; conversely, the use of modular systems without instinct is a disaster. Composition is a matter of balance appropriate to the occasion.

CONSTRUCTION

The way in which materials have been used to make buildings has had a direct effect on sculptural thought, for the good reason that building materials are the same as sculptural materials. In early times, the builder and sculptor were probably one and the same person.

For example, the Strangford Apollo (*pl. 3*) shows the rectilinear front, back and sides that one finds in a building and in a building block. It is the direct result of approaching the job of

Pl. 3 (*opposite*). *The Strangford Apollo,* Greek, c. 490 B.C. (British Museum). This is an example of the archaic Greek Kouroi erected to commemorate victors at the Games (such as those at Olympia). The form reflects the method of carving seen in figures 1–4 overleaf.

making a figure in the same way as a stonemason might square up a block for building a wall. Figures 1 to 4 demonstrate this very simply. An outline is drawn on the front face and then driven through the block from front to back, just as if one was carving a moulding. The silhouette is then drawn on the side and again driven through to the other side. The resulting blocked figure is still very much present in the final work, giving it a very 'architectural' feeling. It is improbable that this figure was designed to go on a building as it is of a type that was erected in honour of an athlete, and is therefore likely to have been free-standing. The fact is that all these archaic Greek figures have a similar 'architectural' feel about them because they were roughed out in a similar way. The individual forms are stacked together, echoing the kind of post and lintel architecture that the Greeks were making at this period.

Fig. 1 (*below left*). A simplified silhouette is drawn on the front face of the stone.

Fig. 2. The unwanted stone is removed from the sides.

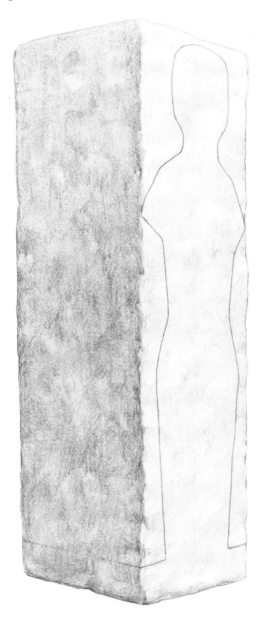

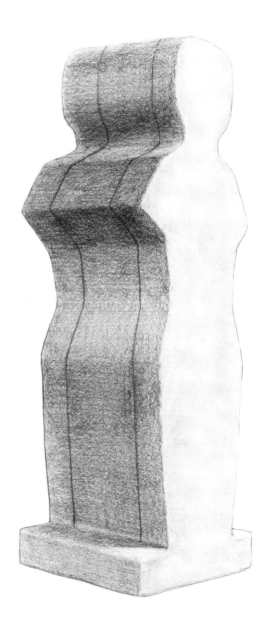

Fig. 3. A second profile is drawn on the side and the unwanted stone removed from the front and back.

Fig. 4. A diagrammatic representation of the post and lintel architecture.

Pl. 4. Unfinished Kouroi from Mt. Pentelicus, Greek, 6th century (British Museum). This figure gives a clear indication of the method of roughing out used at this time.

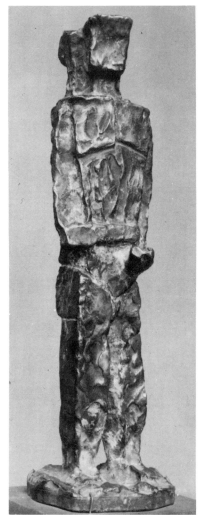

Pl. 5 (*below*). Fritz Wotruba, *Standing Figure*, 1949–50 (Tate Gallery). Wotruba is essentially a carver. Although this work is a bronze, the strong emphases on the front and the elevation hark back to the archaic Greek Kouroi.

Constructivism as a named movement in art—which started in Russia in about 1916—recognised an element that has always been present in sculpture. It drew our attention to the means and the thought-processes by which structures of any kind are made.

A piece of paper will hang limply from the fingers unless it is corrugated by holding it in a trough shape; it will then have considerable strength. Roll it into a cylinder and you can hold a brick up with it. The reason is that a skin that has little strength when it is in a single plane will gain enormously from being folded into the third dimension. Corrugated iron takes advantage of this phenomenon and creates out of a flexible material something that is remarkably rigid along the line of the corrugation. In building a terra cotta from rolled out sheets of clay this principle is brought out very clearly and absorbed into the way one creates a clay structure. It becomes a natural part of the way a sculptor plays with gravity.

Every material has its own particular strengths and weaknesses which can be described in terms of 'compressive' or 'tensile' strength. Wire or string are good in tension but useless in compression. They are good for building suspension bridges, but for building arches one needs brick or stone which have compressive strength. A clear awareness of what constitutes the main strength of the material used is essential to both the sculptor and the architect. Analogies can be taken from other disciplines too: pottery, for example, produces skin structures which have influenced architecture and which the sculptor should not neglect.

THE FIGURE AS STRUCTURE

One might think that because figurative sculpture is usually made in one material and cast into another these ideas of

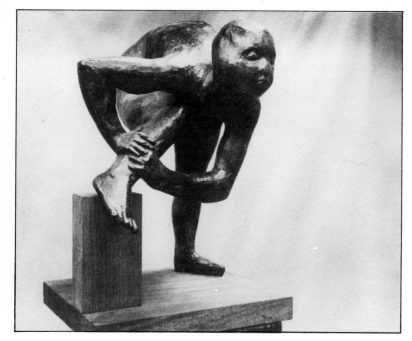

Pl. 6. Nigel Konstam, *Pillar and Flying Buttress Figure*. The mass of my figure is balanced between the flying buttress made by the arms and calf at one end and the pillar of the left leg (height 20 inches/50 cm).

structure do not apply, but it is useful to understand the articulation of the figure in structural terms to decide whether a leg is hanging in tension, or a knee locked, creating the sense of a pillar of separate parts in compression.

The study of the anatomical structure of the body is but one of the ways in which a sculptor studies structure. Anatomy was one of the main props of academic art; it is unfashionable now for good reason. By all means draw from the skeleton whenever possible: it is a very rewarding subject and will teach you a lot about structure in the larger sense of using the minimum material to get the maximum strength. The skull is particularly useful for this. But too much concentration on academic anatomy is likely to lead to stereotyped products that I would urge you to avoid. Once the recipe is learnt, anatomy can become the single principle to be applied without curiosity or enthusiasm to every human, or animal, eventuality. It works, but it is unchanging and therefore stultifying—it becomes a cliché.

Its main deficiency in my view is that it is incapable of forming imaginative links with other structures. Naturally artists are interested in ideas that have a high imaginative valency: ideas that are capable of forming imaginative links in the minds of the audience. For this reason it is wise to handle traditional artist's anatomy with caution. My advice is to turn to the anatomy books when you are confused, but not before.

In my own work I tend to play down anatomical structure. I pay more attention to the structure that results from a particular pose, treating variable abstract structure as more interesting than unchanging anatomical structure. This can most easily be seen in my *Pillar and Flying Buttress Figure* (*pl. 6*) where the arms and right calf work together to become the 'flying buttress', the left leg is the 'pillar', and both support aloft the single mass of the torso and right thigh.

Pl. 8 (*opposite*). Nigel Konstam, a group of rhythmic figures. The seated figure (extreme left) is contained within an overall pyramid. I also see a smaller pyramid which has the cushion and the woman's thighs as a base. The composition as a whole is a relationship between these two geometrical units and the much more organic rhythmic structure that is made by the arms, breasts and head. I have tried to combine the maximum serpentine pulse within a severe geometric framework. The head is turned into the front plane of the pyramid; its depth axis is lengthened by the bun on the back of the head and its width axis somewhat compressed in order to emphasise its relationship to the front plane. For me, the music of this composition is created by the pyramids, the planes and the rhythm of the limbs as they pass within the structure; though, of course, besides these abstract structures in my head there was a large pregnant girl out there in the studio who leant down to scratch her toe—that was the moment of inspiration. Behind her is a standing figure based on the same model and in the foreground a group, *The Three Graces*, based on a painting by Domenico Veneziano.

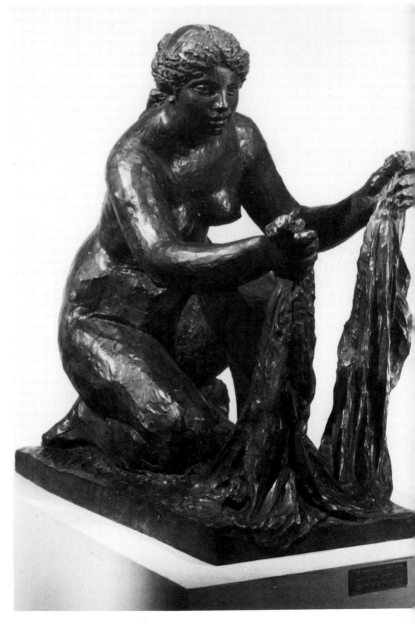

Pl. 7. Auguste Renoir, *The Washerwoman*. c. 1917–18 (Tate Gallery). This bronze, probably cast from a clay model, could be a design for a carving in stone, so neatly does the figure fit into a block. The material that hangs from the woman's outstretched arms defines the front plane of the block (in stone, the material would also function as a necessary support for the arms) and her thighs and arms define the sides. The relief quality of the side of the thigh emphasises its relation to the side plane. I very much admire this composition and the sides of the pyramid in my seated figure have a certain relief quality also.

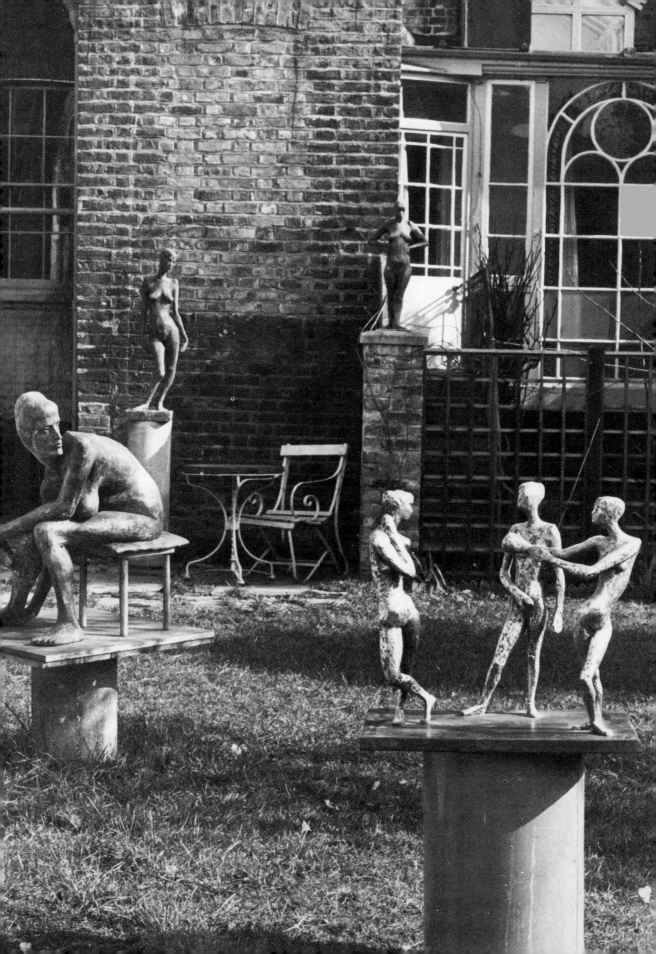

I regard myself primarily as a constructivist. Most constructivist work deals with an abstract language that allows the artist to use materials which are immediately recognisable for their structural significance, whereas the Strangford Apollo is uniformly stone in feeling and in fact. The figurative artist who is interested in the same ideas is obliged to treat the figure as if it is homogeneous in its substance. The 19th-century French painter Ingres had a supreme command of abstract structure. He tended to reduce his figures to a uniform rubbery consistency. The bony skeleton is not entirely denied, but it is subservient to the rhythmic demands. The interaction of forms of rubber can produce an oceanic symphony which flesh and bone cannot.

In his most constructivist mood Rodin recreates anatomy for his own convenience. In his *Prodigal Son* (*pl. 9*) we see a bow-like bend to the whole of the upper body, which is thrust forward by the compressed springs of the thighs and buttocks; the fists are inert weights which resist that thrust and therefore create the bowing. The ripple of muscles on the front creates an elastic surface which has only the loosest resemblance to human anatomy but which serves Rodin's structural needs very well. The calves are little more than the base from which this elastic superstructure springs. In this figure we see melodramatic despair allied to a structural drama in which two weighty fists are suspended in unstable equilibrium by equal and opposite forces. The melodrama interests me little; the structure I regard as the greatest piece of constructivism so far achieved in figurative art.

Rodin tends to be either belittled as a romantic who frequently went over the top, or lauded as a virtuoso sculptor of flesh; his real strength, his original perception of structure, is overlooked. As a portraitist, Rodin was the inheritor of a great tradition which sustained most of his other work as well. But it is in his new understanding of structure that his true originality lies.

The same can be said of many great artists. Michelangelo had an original sense of structure in that anatomical structure took a lower place in his priorities to the structure of the stone and the relief structure of the sculpture (see *The Slave, p. 125*). Verrocchio saw his figures as a kind of engineering: they hold together with analogies from card-houses, clock-work and mechanical toys, giving them a spacial clarity and strength of purpose which I very much admire.

Verrocchio's *David* (*pl. 10*), for example, is equipped with all the necessary anatomical trappings to hold him up, but besides that I see a clear abstract building structure that reminds me imaginatively of a card-house. The main planes of the limbs are stacked together at right angles to one another, like separate playing cards with which elaborate structures can be built. But like Gothic cathedrals they are not truly three-dimensional: they are more like two-dimensional structures which have been 'elaborated' into the third dimension. Verrocchio's sense of structure is remarkably consistent. The plane we see created by the right hand and the sword swinging from the shoulder like an angled pendulum, we see also on a monumental scale. *Colleoni* (*pl. 11*) holds his mace in the same way.

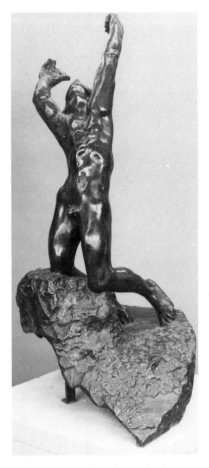

Pl. 9. Auguste Rodin, *The Prodigal Son*, 1885–87 (Victoria & Albert Museum).

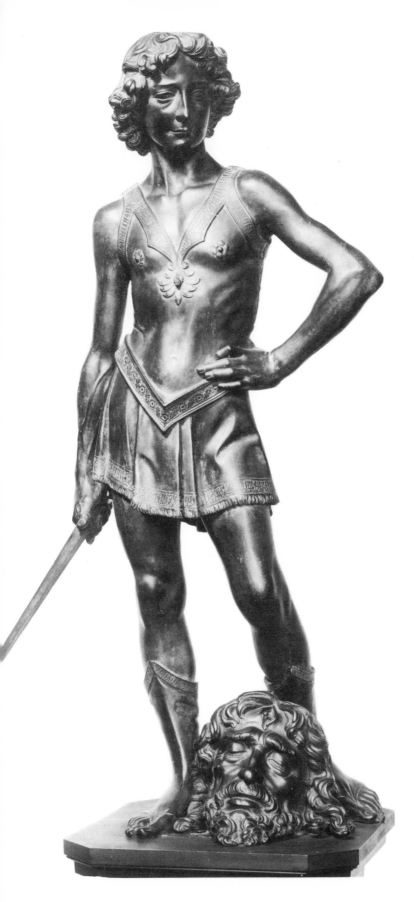

Pl. 10. Andrea Verrocchio, *David*, 1476 (National Museum, Florence). A plaster cast of this work may be seen in the Cast Court of the Victoria & Albert Museum.

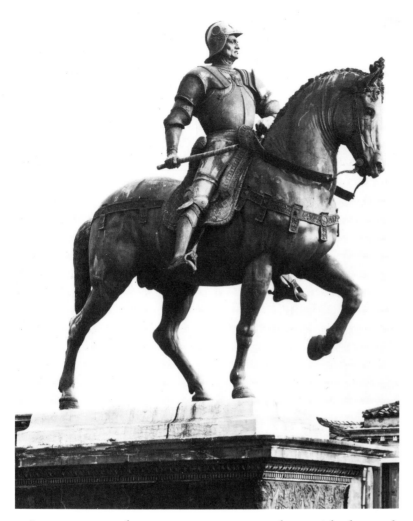

Pl. 11. Andrea Verrocchio, *Colleoni*, 1483–88 (Venice).

Let me return for a moment to my analogy with the card-house. Its natural growth is in a single plane. You can then set the same structure going at right-angles to the first. You can even put a third structure between the two, but essentially you are thinking structurally in planes. A pot from the potter's wheel, by comparison, is an early example of an artifact which uses a truly three-dimensional structure. Because of this it is more efficient: it can contain more space with less material.

These three-dimensional principles are only reappearing in architecture in the more advanced building of the 20th century, though the makers of the beehive hut must have seen the point. Rodin has used Gothic and modern structures with great originality, with the ironic result that his work is considered to be lacking in 'architectural' qualities, while 20th-century criticism has looked to the archaic Maillol for guidance in the principles of architecture as applied to figurative sculpture. Maillol uses the simple post and lintel architectural principles that I describe on pp. 65–67—entirely appropriate in conjunction with classical Greek architecture but less suitable today.

A comparison of Verrocchio's *Colleoni* (*pl. 11*) with *Marcus Aurelius* (*pl. 12*) will, I hope, demonstrate their two very different

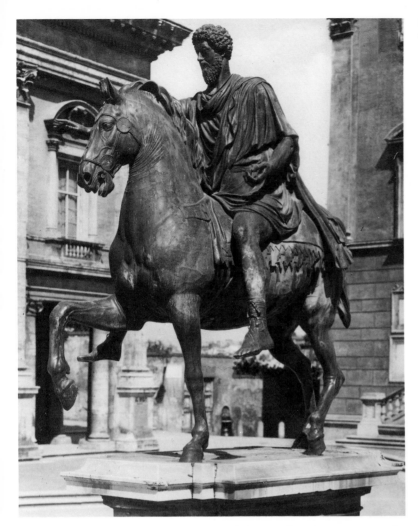

Pl. 12. *Marcus Aurelius*, Roman, c. 178 A.D. (Rome).

approaches to structure. The pose of the two horses is practically identical. In terms of clarity of form, the sculptures stand together at the very pinnacle of achievement.

Marcus Aurelius is the equestrian masterpiece of the Greco-Roman period. In its forms one still feels the distant echo of the toy soldier that can be removed from its mount leaving two separate and complete sculptures. The horse with all its naturalism and heroic posture still owes something to the toy horse—a cylinder or block with a leg at each corner. The poise of the rider seems to reflect the fact that he has been lifted on and off so often. The relaxed fall of the thighs across the horse's back holds him in position as sculpture-man on sculpture-horse; no muscle strains, the simple architecture of one shape placed upon another secures him sufficiently.

The difference of character between the benevolent Emperor and the aggressive soldier of Verrocchio is not the only thing that separates these two monuments. Verrocchio's *Colleoni* exists in the crisply defined space of the Gothic cathedral. The right arm and mace are treated as one continuous form: an angled pendulum which hangs from the shoulder at its natural point of rest and which would swing in a plane precisely at right

Pl. 13. Marino Marini, *Horseman*, 1947 (Tate Gallery). The bronze horseman appears to lift on and off and his arms function as a buttress in the same way as in *Colleoni*.

75

angles to the plane made by the legs. The head, chest and legs make together an inverted top-heavy 'Y'. Extra tautness is given to this erect form by the twist of the head and neck, but it needs the buttress of the left arm to stop it from toppling backwards or forwards. The stance of the horse is sharply angled—it makes a crisper impression in reality than shows in the photograph.

I have celebrated this structural sense in a figure I have called *Homage to Verrocchio* (*pl. 14*). Here I have created what I would like to think of as a clarified version of these principles. The locked right leg is buttressed by the left in the same way as we saw in the *David*; the right arm creates a triangle of forces which is wedged into the top of the hip for support. The weight of the head comes over to balance on top of this, creating a stable vertical column from which the torso hangs in a bow. The pendulum of the left arm seems to help to hold it stable.

This figure did not come direct from Verrocchio. I had a model who seemed to fall into that pose quite naturally but I recognise that the appeal of her structure to me was based on what I see in Verrocchio; much of my composition is. I would also describe the structure of *Regine* (chapter 11), made to demonstrate working from life, in much the same general way.

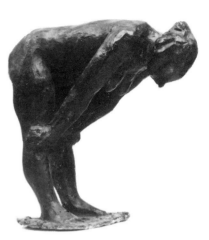

Pl. 15. Nigel Konstam, *Bracket Figure*. This is perhaps the most obviously structurally-inspired of my figures (height 9 inches/23 cm).

Pl. 14. Nigel Konstam, *Homage to Verrocchio* (height 3½ feet/1 m).

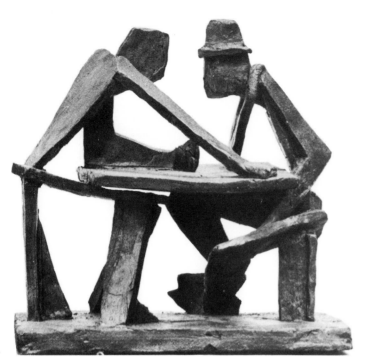

Pl. 16. Nigel Konstam, *Conspiracy*. This was made to demonstrate to students the principles of structure (height 4½ inches/12 cm).

Pl. 17 (*below*). Nigel Konstam, *Despair*, 1960. Here, I see the figure in terms of two buttress walls. The left forearm balanced across the thigh brings a flexibility into the card-house structure (see *p. 72*). At this period it was my ambition to re-make Rodin's architecture in the clear, formal language of the constructivists (height 23 inches/58 cm).

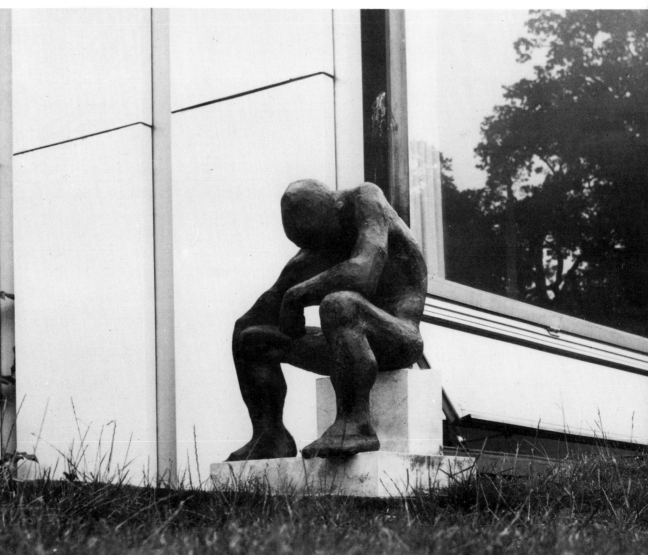

COLLAGE

Another type of sculpture that should be included under the general heading of construction is sculptural collage made from any kind of preformed parts, often man-made. The Picasso illustrated in chapter 1 (*pl. 8, p. 18*) is made from upholsterer's fringe. Picasso used bicycle parts, toys, cutlery, old wood—just about anything was grist to his mill. A good part of the enjoyment we get from these works is in seeing such common objects transformed into sculpture. Henry Moore is frequently inspired by some natural object such as a flint or a bone. He uses these as a starting point and adds to them in Plasticine or plaster.

Peter Startup uses old furniture and reshapes it to his own ends. He has a wonderful ability to put different materials together and make of them a kind of sculptural bouquet. He inlays wood with coloured plastics and uses casting to transform further materials that have been sculpted for some purpose other than art. In pl. 21 he has used the flongs made for printing

Pl. 18 (*above*). Victoria Bartlett, *Spectator*, 1979–80 (private collection). The structure of the head is here seen in terms of a beautifully tailored skin. The artist has said, 'Underlying the sculpture is a preconceived abstract vocabulary which I am interested in exploring.'

Pl. 19. Peter Startup, *Metamorphic II*, 1965.

newspapers as a sculptural equivalent to the use that collagists have made of newspapers themselves: the texture provides the tone that the printed page would have had. In his *Reflections* (*pl. 20*) he deals with other ephemera—passing shadows and reflections for which he has created sculptural equivalents. This piece typifies his interest in the transformation of shape—by projection in the case of the shadows, and by refraction in the case of the enlarged reflections beneath the table surface. The shapes made by cutting through a section on a diagonal like a table leg can be as surprising as the shape of a shadow.

Startup also has a good eye for structure, as is seen in his *Metamorphic II* (*pl. 19*). This is a metaphoric piece that can be fitted together in different ways. It has very much the same structural sense about it that I find in the work of Verrocchio: a precarious card-house balance in which the dark counter-weight angled down from the top acts in a similar way to David's sword and right arm. Good contemporary abstract art such as this often illuminates the art of the past.

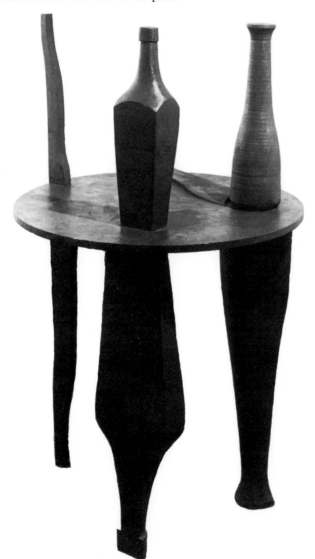

Pl. 20. Peter Startup, *Reflections*, 1967 (Chantry Bequest).

Pl. 21. Peter Startup, *Saturday October 22nd*, 1967.

5. RELIEF SCULPTURE

Relief sculpture is the art of depicting the three-dimensional world but with the depth axis greatly reduced. Sometimes the relief is no more than 2 or 3 mm in depth. The terms bas (low) relief and high relief refer to the depth from the front to the back. Some regard it as a bastard art—neither sculpture nor painting and therefore unworthy of study. On the other hand Michelangelo has been shown to have based his conception of sculptural composition largely on relief. Furthermore Hilde-brand, who wrote the most influential book on sculpture in the 19th century (*The Problem of Form*), followed Michelangelo's

Pl. 1. Stela showing Amen-Re, Mut, Harakhty and Isis, Egyptian, c. 1200 B.C. (British Museum). This relief looks as if it started life as little more than a graffitto scratched into soft stone. The edges of the lines were then softened and rounded to give a quilted appearance.

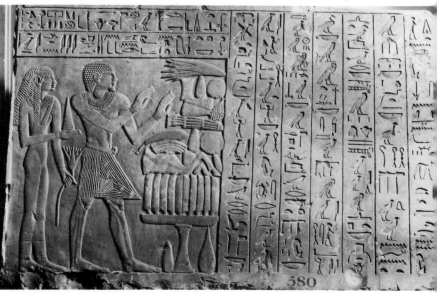

example in this, and neither should be lightly dismissed.

It is not all that easy to come to terms with the various conventions of relief sculpture, but very well worth the effort, particularly for painters. Relief sculpture is the basis of much great painting from Masaccio to Cézanne. Because it crosses the frontier between the three-dimensional and the two-dimensional worlds it played a crucial role in the development of Quattrocento painting and drawing. Respect for the surface, so essential to modern painting, has been central to relief sculpture for most of the last 4,000 years.

It is best to deal with the development of relief conventions in roughly chronological order, but imaginatively. If we look at the early Egyptian reliefs we can see them as a method of making more permanent messages that may have been painted on a stone and had started to fade. We can imagine a sculptor might have been employed to cut into the stone the shapes that had been painted. As he cut the lines around a form, he noticed that the sunlight suggested the roundness of an object depicted; with a little help the roundness could be filled out to perfection (see *pl. 1*). In these early reliefs, we see figures embedded in a matrix of stone—satisfactory in themselves, but without the necessary space in which to move freely. Phase two was to remove the surrounding matrix and leave the figures room to move (*pl. 2 and 3*).

The Egyptians remained within this simple two-plane format but what they achieved within it was far from simple. The quality of their best drawing has never been surpassed. The Mesopotamians and the Egyptians chose to operate within a very low 'bas relief', the front surface being separated from the back plane often by less than a centimetre. The effect of this very low relief is that the integrity of the wall as a mass of stone is kept intact. The problem of a depth greater than that required for one figure was generally avoided, but in more sophisticated works it was very adequately dealt with by offsetting the deeper space, as if each figure was cut in its own tile of space and the tiles were

Pl. 2 (*above left*). Stela of Nehebkhonsu, Egyptian, c. 1200 B.C. (British Museum). The figure on the left is completely embedded in the matrix of stone. The two on the right have been partially released. The sculptor seems to have made a kind of tent in negative of the woman's gown which gives her much greater apparent space in which to move. Her figure has the same degree of roundness as the first, but is more convincing because the background has been pushed back.

Pl. 3 (*above*). Stela of Sensobek, Egyptian, c. 1800 B.C. (British Museum). Here the couple have been completely freed from the background and exhibit considerable sophistication in the drawing, despite the early date of the relief. Note how the stripes on the front of the man's skirt manage to suggest a concavity with foreshortening on the panel closest to us. Each object in the pile of offerings in front of them is very beautifully drawn in itself, but as a pile they are less convincing—the top storey in particular looks very precarious. They are more of an inventory of gifts than a structure. Some of the hieroglyphics are no more than silhouettes in negative; some have details in low relief.

Pl. 4 (above). *Cock Fights*, Greek, 480 B.C. (British Museum). The Greeks used a deeper relief, allowing a greater sense of roundness to each form, but nonetheless maintained the surface of the stone over large areas of the subject. The format here is essentially the same as that used by the Egyptians.

then stacked to overlap one another. This method was used again to great effect by the Greek sculptor at Xanthos.

The Greeks tended to use a much greater depth of stone, even in their simplest reliefs. This produced a greater richness of decorative surface, but brought with it a number of problems which even their ingenuity was inadequate to solve. On the Parthenon frieze (*pl. 5*), for instance, the sculptor has been obliged to jump from one feeling for roundness when he sees the horse's belly against the back plane to quite another when he sees it against the hind-quarters of the neighbouring horse. However ingeniously the problem has been glossed over, at the accessible height we see the frieze today those jumps make me very uncomfortable.

In its purest form, relief sculpture respects the surface of the stone, and however many intermediate planes may be carved between it and the back plane the sculptor tries to reiterate the surface by creating large areas parallel to it at all depths. These parallel planes, receding one behind the other into the depths, have become a key feature of many great compositions in painting as well as sculpture.

Michelangelo sacrificed side views to create compositions which could be described as three-dimensional reliefs and which are best read from the front. He arranged planes that clearly proclaimed their relationship to the front. His method of carving

Pl. 5. Detail of the west frieze from the Parthenon, Greek, 448–43 B.C. (British Museum). The subject matter of horsemen riding three abreast strains even Phaidias's ingenuity: the near-horizontal horse's head second from right has to find an uncomfortable compromise position between the next rider's shoulder and the background, and its forelegs have to move from minimum to maximum roundness. The poor horse sticks out like a sore thumb in this majestic parade. The quality of the carving varies considerably. Compare the feeble wrinkles in this horse's skin and the drapery of its rider with that found on the far left, which is magnificent. This is probably the result of two different hands at work on the carving.

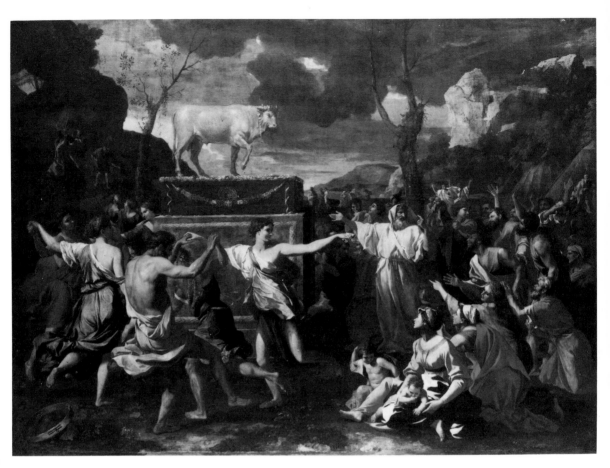

back from the front plane through layer after layer, often leaving the back of the stone untouched in his unfinished works, is both unusual and strongly indicative of his concern with the relief nature of his sculpture in the round.

Poussin was ever watchful to place his major actions in the picture plane, those that run into the depth being transitional to carry the eye from one relief plane to the next. As a sculptor I find it very difficult to see Cézanne as doing anything other than applying these same principles to landscape and still-life.

The ideal architectonic relief respects both the surface and the sculptural integrity of forms within the relief. To me the Parthenon frieze represents the beginning of a decline in relief design towards a greater concern for depth for its own sake, often at the expense of architectural unity and of the sculptural integrity of each form.

There can be no doubt about the brilliance with which Ghiberti articulated pictorial space. His method was to use forms which were little short of being fully in the round for the figures in the foreground and gradually to reduce the thickness as they recede, until the background—which might be half a mile away—in actual space is no more than a millimetre thick. The result is highly significant from the art historical point of view, and entirely successful pictorially, but in my view it should be regarded as a great technical feat rather than a method to be emulated. Aesthetically it is wise to limit the actual space to that

Pl. 6 (*above*). Nicolas Poussin, *The Adoration of the Golden Calf*, c. 1635–37 (National Gallery, London).

Pl. 7 (*opposite top*). Paul Cézanne, *Landscape in Provence*, 1886–90 (National Gallery, London).

Pl. 8 (*opposite*). Lorenzo Ghiberti, detail of a panel from the eastern doors to the Baptistry, 1430–36 (Florence).

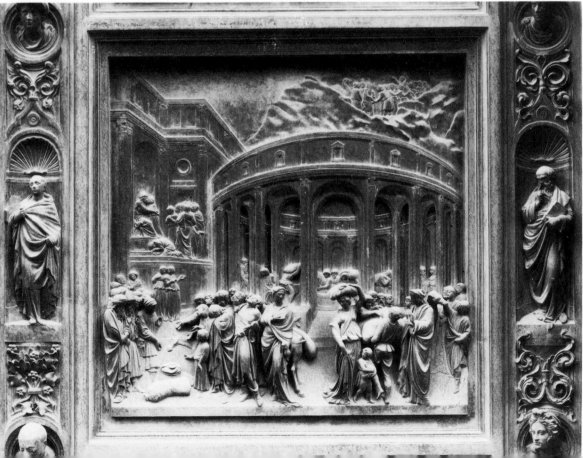

necessary for two figures to move in; beyond that complications are bound to arise which even the best artist cannot solve sculpturally.

It was Brunelleschi and Donatello who provided the springboard from which Masaccio jumped, fully armed, into perspective space. Brunelleschi was undoubtedly the scientific genius behind the rediscovery of perspective, but Donatello's conception of form, plus his practice of low relief carving, created a stepping-stone between the ability to depict the simple three-dimensional geometry of architecture and the much more complex geometrical ideas required to underpin a spacial conception of nature. We have only to compare the drawing of Donatello in his bas-reliefs with that of any artist before him, or with that of Masaccio himself before he met Donatello in 1427, to realise just how vital a role the activity of relief carving has played in the development of the art of drawing.

The perceptive abstract painter Kandinsky formulated the aphorism that, in drawing, 'line becomes plane'. In relief carving the opposite happens—plane becomes line. The chisel moves down the plane it is defining and, as it meets the back plane of the relief, it draws the line. Thus it physically creates the link between the sculptural conception and its linear representation. This link is necessary to the art of drawing, but in drawing the link is mental—as one draws across a surface, one explores volume. This is the miracle that took place for the first time in Masaccio's *The Tribute Money* (pl. 11).

The technical name for the very low relief used by Donatello at this period is 'relievo stiacciato' or flattened relief. It is characterised by minimal depth and a comparative disregard, by Donatello at least, of the actual depth of the back plane, which he allowed to billow forward where necessary to meet the form described. It is a no man's land between drawing and sculpture in which the cutting of the planes which describe the form precedes the creation of the line that divides solid from space. The resulting line necessarily describes the meeting of planes in a way which had not previously existed in the art of drawing. It became the substratum which underlies much of the best drawing since.

No drawing by Donatello survives, and he may never have drawn on paper. The nearest we can get to a Donatello drawing is a relievo stiacciato. A very apt example is to be found in his *Ascension* relief (detail, pl. 10). The incident of Christ giving the keys to St. Peter illustrates very well the similarity between the styles of Donatello and Masaccio. This relief is dated about 1432 by most authorities—that is, after *The Tribute Money*. I do not argue the date, but simply that Donatello's conception of form and his ability to give a near two-dimensional rendering of that conception had a very beneficial influence on Masaccio and through Masaccio on drawing ever since. There is a level of sophistication about the movement within each figure which, at that moment in history, could only be equalled by Masaccio. Notice how the drapery of the Madonna on the left is used to establish the main turning points from the back to the side, and how the section of the form is established behind her knees.

Pl. 9. Luca della Robbia, plaster cast after detail from the Cantoria Pulpit, early 1430s (Victoria & Albert Museum; original in Museo del Opera del Duomo, Florence). This work shows an immensely skilled use of relief space.

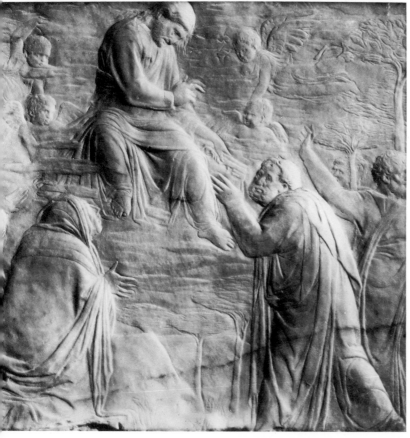

Pl. 10. Donatello, *Ascension with Christ giving the Keys to St. Peter*, c. 1432 (Victoria & Albert Museum).

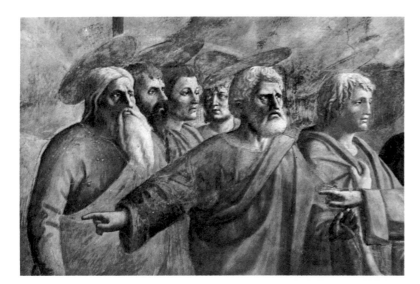

Pl. 11. Masaccio, detail from *The Tribute Money*, c. 1426 (Brancacci Chapel, Sta. Maria del Carmine, Florence).

Pl. 12. Masaccio, *Virgin and Child*, 1426 (National Gallery, London).

Though Masaccio achieves in *The Tribute Money* an unparalleled masterpiece, until that moment I would rate him as a good rather than a great painter. Donatello, however, 14 years his senior, had been making reliefs of this sort for ten years and had just returned from Rome where he had been studying antique art with Brunelleschi. One can point to a startling development in Masaccio's style within the short period in which he was working on the Brancacci Chapel, whereas Donatello was a master of forty-one with an established style. Compare the head of the Virgin (*pl. 12*) painted by Masaccio in 1426 with that of St. Peter, which may have been painted a matter of months afterwards; we see Masaccio has suddenly become a giant. The Virgin's head is a ball of cotton-wool when put beside the forcefully sculpted drawing found throughout *The Tribute Money*, but not before in Masaccio's work. The description of the Holbein in chapter 8 should help you to see what I mean.

Masaccio's form follows the pattern of Donatello, which in turn owes a great deal to Roman portrait sculpture such as I have described in the analysis of the bust of Hadrian in chapter 2. In his *Virgin*, Masaccio has mastered the perspective of the lutes and the throne, but the figures remain very much of their period. In *The Tribute Money* he has far surpassed Donatello in his complete mastery of perspective space. I am convinced that Donatello laid the foundations on which painters afterwards were able to build, though he himself was never quite able to match their achievement. The spacial structure of the *Ascension* relief is very similar to Masaccio's masterpiece, but inferior. In the central group Masaccio has achieved a flow of figures in space which, in spite of a few hiccups (such as the bodiless head that floats above the far shoulder of the disciple second from left), has remained the envy and admiration of painters ever since.

Donatello's command of pictorial space, however, always seems to me to be a bit shaky. If we examine the seated figure of Christ we cannot fail to be impressed by the skill with which the whole figure is moved in the relief space. The right leg in particular is articulated in depth with an assurance that Donatello may have learnt from his short apprenticeship with Ghiberti. The other leg is also impressive but its relationship to the arm of St. Peter is disappointing. The hand and head of St. Peter fail to make contact with the plane in which the handing over of the keys (the main action) takes place. The position of St. Peter's back foot leads me to guess that Donatello may have wished him to move diagonally into the depth, but this does not quite come off—perhaps because of Donatello's unprecedented ambition. He has attempted to show us the scene without the assistance of foreground or middle-distance, as if seen by an observer below the level of the ground on which figures are disposed. When we question Donatello's pictorial skill, we should not lose sight of the fact that his ambition is quite amazing for a moment in history when the science of perspective was still in its infancy. His special contribution to its growth lies

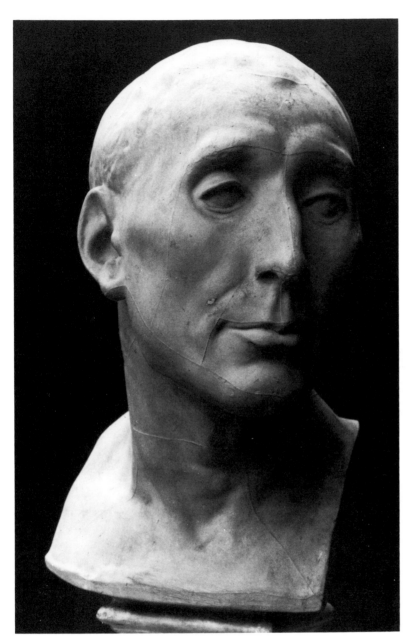

in his ability to find an accurate two-dimensional equivalent for the forms he used in sculpture.

The formative influence of the reliefs of Ghiberti and Donatello on painting and drawing should not be underestimated. In my view it constitutes a very good reason why all students of sculpture or painting should have the experience of making a relief. Their quality of drawing would improve beyond all expectation as a result.

To demonstrate this contribution I will go through the same process as Donatello did. I will carve a relief based on his portrait of Niccolo Uzano (*pl. 13*). As a preliminary I have made a copy of the head, slightly sharpened to underline the three-dimensional geometry of the original (*p. 56*).

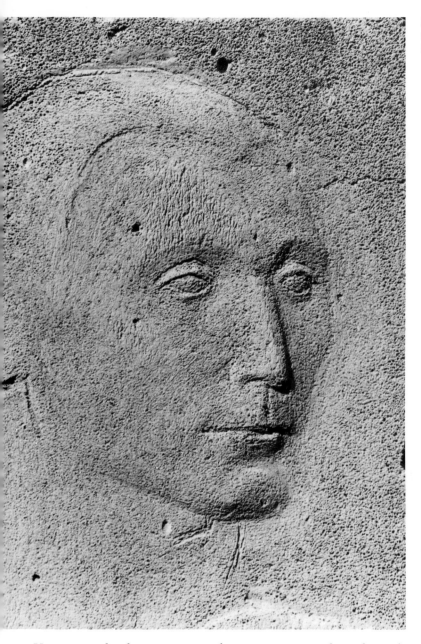

Pl. 14. Nigel Konstam, relief carving in expanded cement block, based on Uzano (height 14 inches/35 cm).

You see in the demonstration that as one cuts a plane through the surface, one also draws the line as one plane meets another. The continuity of movement of one plane to the next that one hopes to find in a drawing is a sine qua non for the relief carver: the relation between line and plane is a fact of life and if there is no sequence of movement in the planes themselves then there is no form. These very low reliefs of Donatello's require a technique that forces on the artist a recognition of the relationship between line and form that is a crucial stepping-stone to the mature art of Masaccio. One can well imagine the three friends —Brunelleschi, Donatello and Masaccio—each uniquely well-equipped in his own particular field, thrashing out between them the quantum leap in the art of drawing that was to be realized in the art of Masaccio.

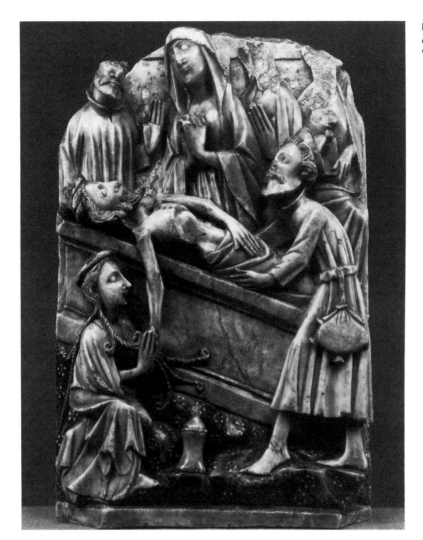

Pl. 15. Alabaster carving, English, 15th century (Hilderbrandt Collection, Victoria & Albert Museum).

I would advise the beginner to start by carving. The process of carving a relief in stone is likely to lead one to follow the severe classical pattern, because the stone starts with a surface. One draws the subject on the surface of the stone and then carves away the background, a technique that predisposes one to the classical pattern. Modelling starts with a back-plane and the front-plane has to be established by the discretion of the sculptor; a modelled relief is much more likely to develop along the lines of Ghiberti and can easily run out of control.

Rodin carried the pictorial approach to its most extreme expression in his Gates of Hell. There, figures in the round come and go through the ether of his back-plane with an abandon that it would be most unwise to emulate, even if you share with me a high regard for this wayward masterpiece.

REPOUSSÉ WORK

There is another technique of relief sculpture which predisposes the artist to a certain distinctive kind of form, and that is repoussé work. The word is the past tense of the French verb,

'to push back'. A sheet of malleable metal such as lead, gold, copper or bronze is beaten or pushed from behind into the rough shape required and then the more precise detail is worked from the front.

If you are using metal of a heavy gauge you will need hammers and round-nosed tools to move the metal without cutting it (*fig. 1*). In my demonstration of *The Three Graces* I have used a much more lightweight metal—a tomato purée tube opened out—which can be moved about easily with the end of a pencil. This is a good way of getting acquainted with the technique: all you need by way of equipment is a pencil (or some similar tool),

Fig. 1 (*above*). Working on *The Three Graces* repoussé, showing the scale of the work (height 4 inches/10 cm) and the tools.

Fig. 2. The final work from the back.

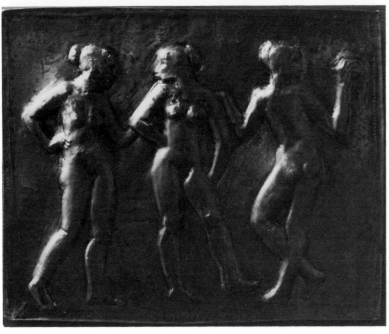

Fig. 3. The final work from the front.

Pl. 16. Nigel Konstam, drawing after Cranach, detail of *The Judgement of Paris*, 1533 (original in Karlsruhe Kunsthalle).

the empty tube, a pair of kitchen scissors to open it out and paint-stripper to clean the outside. In fig. 2 you can see I have folded over the edges of the metal to give extra strength.

The first stage in the work is to rough out the large shapes you want, by pushing gently on the back of the metal with the rounded end of the pencil. To work the metal, lay it out on some material that will give way slightly, such as two or three layers of felt. Do not be in too much of a hurry to define the edges of the shapes you want. Repoussé work is rather like drawing in pen and wash: first you sketch out the general way in which the masses are to be disposed, then you refine their shape. Only in the final stages do you make the sharp crease in the metal which will define where the figure ends and the background begins. I draw the sharp definitive lines with an old ball-point pen, working down onto a flat wooden surface.

Repoussé allows for a great deal of sketching and suggestion. The method gives you a vague version of what you are aiming at which can be very exciting. But once you start to define, it is difficult to change your mind since the metal becomes fatigued if you try to re-shape it radically. For instance, the higher foot of the central figure in my demonstration was once turned inward; I changed my mind and the metal has taken on a rather battered appearance. When working metal as thin and light as this, it is best to accept the fresh, right-first-time appearance of your figures rather than to be too finicky (compare the head of my central figure with the more detailed one on the left, fig. 3).

The method of work dictates that one form should grow out of another in an organic, rhythmic way: the work therefore constitutes an education in rhythmic composition. It is not the easiest way of starting to make sculpture, but it is one of the cleanest and simplest to set up.

6. MODELLING

wax, Plasticine, Das, plaster, polystyrene, papier-mâché

WAX

Wax is my own preferred modelling material. It has several advantages over other modelling materials, and few disadvantages. It is lighter and stronger than most and therefore requires less support from an armature. It changes its quality with changes of temperature; it is workable liquid or solid; it can be worked under hot water, which both softens it and at the same time supports it in its pliable state; it is workable at room temperature and modellable at blood heat, and can be stored safely for years. There is a wax attributed to Michelangelo, which may be seen in the Victoria & Albert Museum (*pl. 1, p. 124*).

You can polish or carve wax with such precision that it looks like metalwork; you can soften it by mixing it with turpentine or paraffin until it is soft enough to be applied with a paint brush if necessary; you can dip it in cloth and model drapery with it—in short, there is very little that you cannot do with wax. From a practical point of view there are two further considerations: it is very easy to cast, and it is halfway to bronze if you use the lost wax process.

Its only disadvantages that I can see are that it is fairly expensive (but it is re-usable) and that it melts if left in the sun. It is also hard work to change large volumes of it since it is so strong.

There are many different types of wax. The most convenient for a sculptor is micro-crystalline, a by-product of the petrochemical industry, which is in the middle range as far as price is concerned. At the cheaper end there are

Fig. 1. A bunsen burner flame is good for working wax because it can be directed downwards. Here I use it to soften the wax manikin so that I can bend it easily into position.

paraffin wax and earth wax. I personally will not touch either of these as a modelling material, though some sculptors can work with them blended with other waxes. Beeswax was the traditional wax used before micro-crystalline was available. It is expensive, it smells delicious but has no other major advantages over micro-crystalline that I can see. You can also get waxes specially blended for modelling; I use one to make a model from a Holbein drawing (chapter 8).

If you are going to use wax you will have to equip yourself with a heat source. I find a bunsen burner entirely satisfactory; a blow lamp would also be very good. A small gas ring is a bit cumbersome but

would do; a spirit lamp is all right for small work, but ideally you should have the kind of flame that is fierce enough to direct downwards on occasion (see *fig. 1*). An open fire is also an advantage in that the smell of burning wax, which is the usual consequence of reheating tools that have been used for wax, goes up the chimney.

You will also need an old saucepan to melt the wax in, and a metal tool of some kind with an insulated handle—such as a soldering iron, an old file or a screwdriver—that you can use as an iron to heat and then apply to the wax in places where you might want to join by welding.

For my demonstration, *The Three Graces*, I started from a painting by Cranach that delighted me. I had already made two groups from the same painting, and doubtless I could continue to make variations on this theme for years if I wished. Cranach has a very personal approach to form which is specially well adapted to sculptural composition: his forms seem to link themselves together without any effort on my part.

I began with three small pre-cast wax manikins (see *pp. 162–65* for the method of producing these manikins). Soon after these wax figures are taken warm from the mould they are very plastic, and at this stage it is wise to twist them roughly into the poses that you require (see *fig. 2*). You can then mount each on a thin base of wax sufficient to hold them upright and scoot them around to make a composition of them (*fig. 3*). Doubtless you will then have to modify the original pose that you gave each figure, but it is easier to get ideas for compositions from figures in movement than from lifeless poses taken from the mould. Give yourself the opportunity to play, make many such figures and arrange many groups, and keep swapping them round until your ideas gel (*fig. 4*).

Fig. 2. Put the manikin into some movement while it is still warm.

Fig. 3. Mount the manikins on separate bases so that you can move them round and interchange them to find an interesting composition.

Fig. 4 (*below*). The final composition in sketch form.

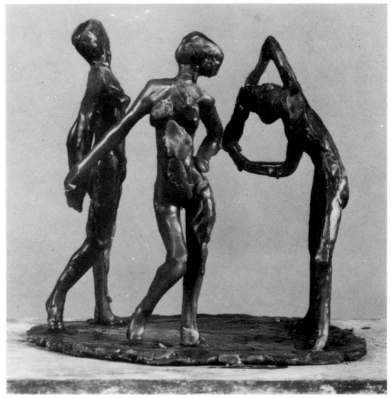

When making a composition one must be aware of the overall shape of the figures as they combine and of the spaces between them. The theme of *The Three Graces* suggests the kind of rivalry and preparation that goes on before the Miss World competition. I have arranged the figures around an oval; the girl on the right combing her hair has her limbs in an arc of that oval when seen in plan. The two rivals also fall into that general plan. I have tried to make the three form a kind of pierced bowl shape. The poses are exaggerated as in fashion photographs; it is a very light-hearted affair—the onlooker is not expected to get too worried by the goings on. There is a designed flow of directions between the movements of the figures and the variety in the shapes and spaces they make together.

Very little of the original Cranach is left, except the light rhythmic quality which has something to do with the relation of thicknesses and thinnesses in his work. His forms look almost as if they have been extruded from some maverick sausage machine. I have pushed my forms in that direction but I have not gone all the way; as a sculptor I like to play flat against round. Cranach uses forms which are just a little too continuously round for three dimensions—roundnesses can only lead the eye round; flatnesses can point from form to form and so create relationships which are beyond the reach of roundness.

Fig. 5 (*above*). I use a hot iron to soften the wax so that I can continue to work it after the basic positions of the figures have been decided.

Fig. 6 (*left above*). When the wax has been worked with a flame or hot tools, it can take on a translucent quality which makes it difficult to see the surface. A light spray with a cheap metallic paint (but not the kind used for cars) will combine well with the wax and show up defects in the surface very clearly. When the wax is complete it is fitted with runners and airs and cast into bronze (see chapter 10).

Pl. 1 (*left*). *Small Warriors*, Greek, 5th century B.C. (British Museum). These little models were presumably all made from the same mould.

PLASTICINE

Because Plasticine is something that we have all played with as children, there is a tendency to underrate it as a serious modelling material. This is a pity—it is extremely useful and in some circumstances indispensable. Lipschitz used it on a monumental scale and his forms have a distinctive rubbery quality that one is unlikely to achieve in any other material. Its great advantage over clay, on this scale, is that you do not have to cover it and keep it damp when you are not working on it (the business of keeping large amounts of clay in good working condition is a major difficulty). Alas, Plasticine is too expensive for most of us to use in great quantity.

When you have to work from a moving model on a small scale (at the zoo, for example), Plasticine really comes into its own. It is strong enough to travel in the back of the car; it keeps in good condition when you are working out of doors where sun and wind would dry out thin forms made of clay on an armature in no time at all. It is a very convenient material for small-scale work. It maintains its plasticity for years without drying out. It can be softened with Vaseline. It becomes softer when held in the hand, but is reasonably firm at room temperature.

I used Plasticine for my preliminary study of the singer Hans Hotter (*pl. 2 and 3*). I had the opportunity of attending his master classes before making his portrait, which gave me a chance to observe him in action and to see sides of his personality that were unlikely to show themselves during a sitting in the quiet of a studio. I armed myself with a sketch book, a very small armature and a packet of Plasticine. In the event I had to abandon all idea of drawing as the subject was not still for an instant. The Plasticine could be held on my lap and moved round to match whatever

Pl. 2. Study of Hans Hotter in Plasticine made during the singer's master class (height 5$\frac{1}{2}$ inches/14 cm).

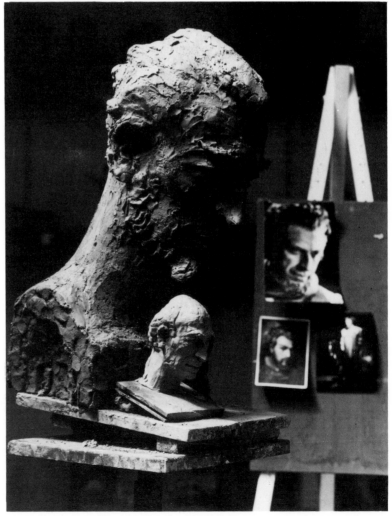

Pl. 3. The Plasticine model together with the over life-size clay head at an early stage of work.

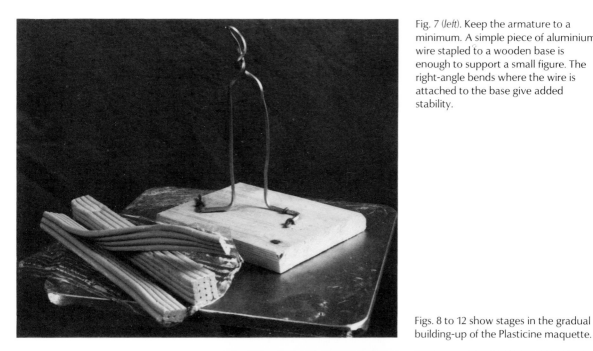

Figs. 8 to 12 show stages in the gradual building-up of the Plasticine maquette.

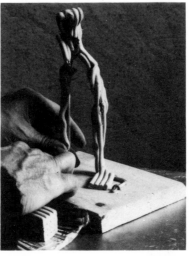

view presented itself to me. It proved a very satisfactory arrangement.

I also used Plasticine in preference to wax for a maquette based on a Rembrandt drawing, because it has a more plastic surface. With Plasticine I could suggest the surface of a Rembrandt drawing or painting, which seemed an amusing idea. I have made the handling of the face as fresh and expressive as I could to demonstrate the potential of Plasticine in this direction. The purpose of the maquette is to show the way Rembrandt posed his life models in front of a mirror (*fig. 13*). He used this technique on many occasions, sometimes to get two models for the price of one, sometimes to create a subtle three-dimensional symmetry that is there but not immediately apparent in the resulting painting or drawing. Many of these drawings are believed to have been done without reference to the outside world, from Rembrandt's 'imagination'. But my discovery of so many reflected images confirms the report of his contemporaries that "Rembrandt would not attempt a single brushstroke without a living model before his eyes".

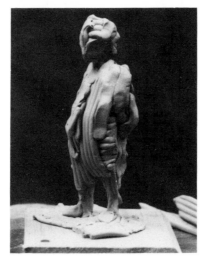

Fig. 13 (*below*). The completed maquette with a mirror and the drawing by Rembrandt. The maquette (height 6 inches/15 cm) represents the live model who posed for Rembrandt in fancy dress in front of his mirror.

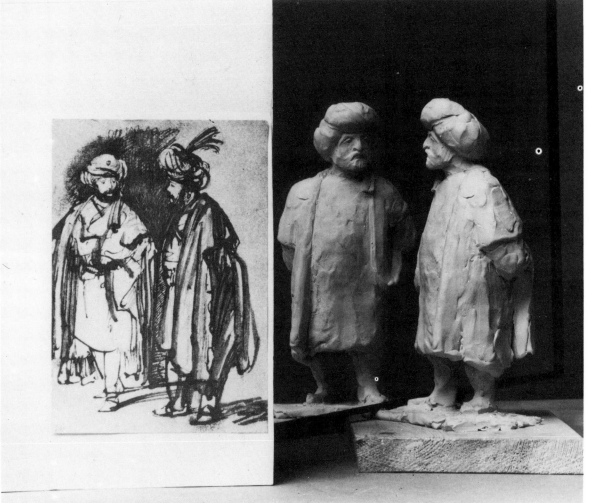

DAS

Das is a modelling material designed primarily to be used by children. It is not all that easy to handle, but it has the advantage of being fairly strong and light when dry. It will take poster paint and can be varnished with Varni-Das for a gloss finish. It is a good material to use for making such things as puppet heads and hands, masks or any other modelled object that needs to be light and reasonably durable. I would also recommend it for making a maquette which you intend to enlarge in direct plaster as it has many of the same characteristics (Polyfilla is also good for this purpose).

It is best used over a support of some kind. For a puppet head I would suggest screwed up paper and card, made firm with Sellotape. A mask could be made over a core modelled in clay or Plasticine and separated from the Das with cling-film.

For my group of revellers I have made an elaborate armature of wire (*figs. 14 and 15*). The Das is squeezed into the wire and left to dry (*fig. 16*). If one comes back the next day the whole structure will be firm and strong and can then be shaped (*figs. 17 and 18*). Das has a fine fibre in it which makes it difficult to model and difficult to cut cleanly except with a sharp knife—the finest surface is made

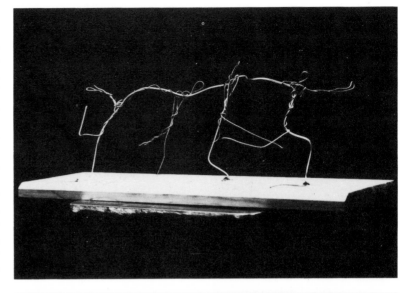

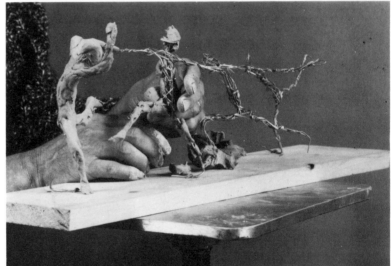

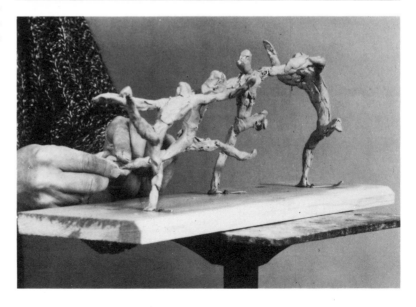

Fig. 14 (*top right*). Begin the armature by first sketching the movement in wire.

Fig. 15 (*middle right*). An elaborate wire armature allows the sculptor to feel the movement of the finished work from the beginning. It also provides good support for the modelling material.

Fig. 16 (*right*). Squeeze Das into the wire and allow it to dry overnight.

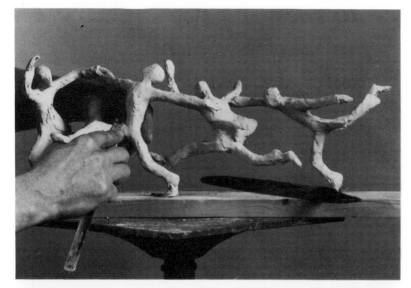

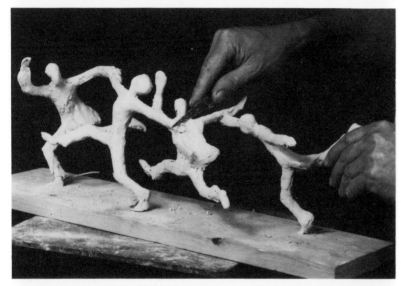

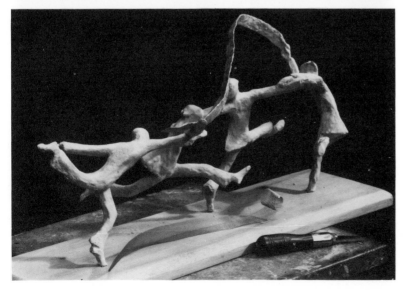

by cutting. You can also wet down Das so that it can be applied with a trowel, in which case you have more control. It is a good idea to give dry Das a coat of PVA glue before you try to stick new Das to it. If you have not got PVA, at least wet the surface.

If you can master the problems of working with it, Das is a durable and clean material to make sculpture with. It is generally available and modestly priced. My 14-inch (35-cm) long sculpture was made out of 14 oz (400 g).

I have finished it with Plas Dur, another self-hardening modelling clay, easier to use than Das because it has no fibre in it. It also dries without shrinking.

A new material with similar qualities is Cold Clay. It is based on a natural clay that can be fired to stoneware temperature (1280°C), at which it becomes a warm buff colour. If left unfired, it becomes fairly hard, and goes black if dried in light and silver-grey if dried in the dark. You can therefore decorate it by masking areas as it dries, or by scratching through from the black to the grey after it has dried. It does, however, shrink as it dries, so it is best worked without an armature. If an armature is needed it should be removed before drying or covered with wet newspaper to allow room for shrinkage. Cold clay

Figs. 17 and 18 (top and middle left). When dry the Das can be shaped with an old hacksaw blade or, best of all, a good, sharp knife.

Fig. 19 (left). A scarf made of Plas Dur spread on an aluminium mesh (seen on the base) creates a rhythmic counterpoint to the main movement of the composition.

works as easily as ordinary clay.

The wire armature used for the sculpture was quite elaborate—its advantage is that you have a lot of scope to move it around before you commit yourself. The more elaborate the armature, the easier it is to see, and therefore the easier it is to respond to sculpturally. The ideal armature should visibly occupy the space that will eventually be occupied by the sculpture, as well as provide firm support for it. Some sculptors work with wire only (see *pl. 4*).

Pl. 5 (opposite). Evelyn Williams, *Figures at a Window*, 1980 (private collection). This low relief is made of Das which has then been painted.

Pl. 4. F. E. McWilliam, *Cain and Abel*, 1952 (Tate Gallery). This sculpture is made of wire. The artist often uses plastic wood and wire.

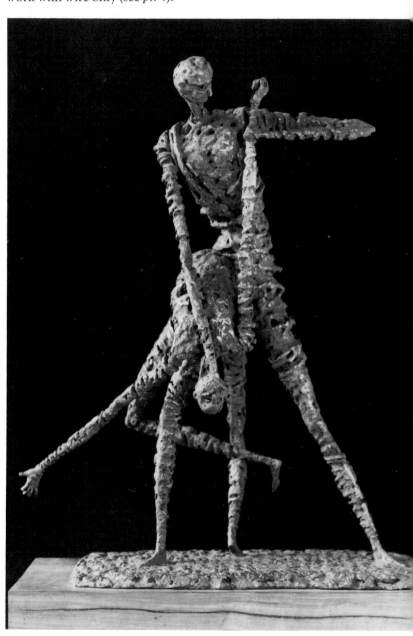

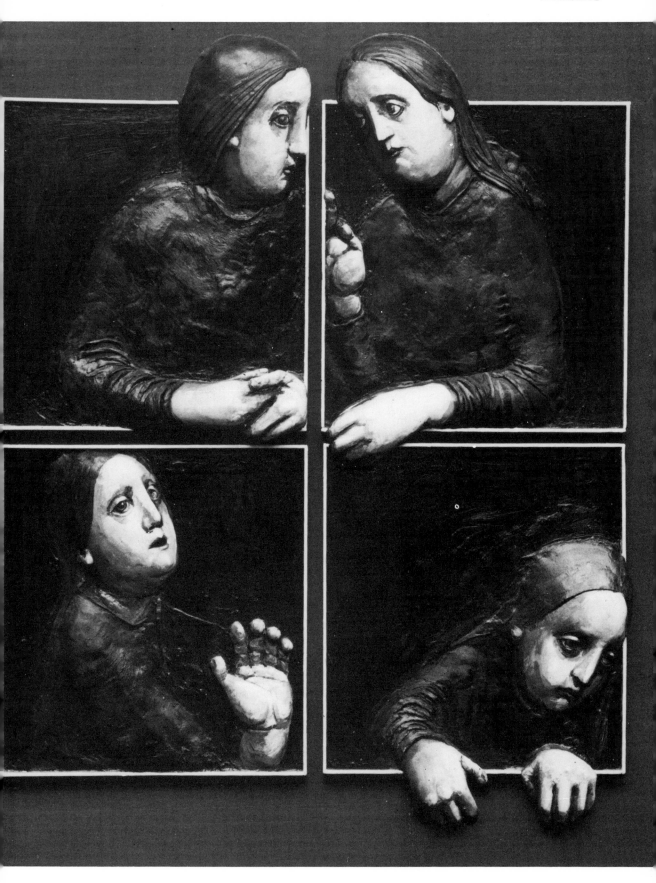

BUILDING IN DIRECT PLASTER

Plaster is frequently used as a material to build sculpture as well as to cast it. The normal plaster used in sculpture is plaster of Paris. This comes in various grades from coarse to superfine. The coarse is used in the lost wax process of casting bronze, but is not good to build sculpture with. Pottery plaster is easy to handle and though it is not as strong as dental plaster it may well be strong enough, particularly in the final stages. Dental plaster is the one most used by sculptors.

All these plasters set very quickly—in 10 to 20 minutes. They are excellent for building up a big, strong structure quickly, but it is difficult to adjust afterwards. The danger is that you might get landed with a big, strong 'snowman' that you don't much like.

There are many ways of fabricating in plaster. You can mould pieces and stick them together. You can use plaster-board as a basis for more abstract work. You can cast plaster against smooth flexible surfaces such as hardboard, polythene or vinylay and use the exciting shapes that result as a basis on which to build. You can build a 'snowman' and then carve it. You can build up slowly round a core or armature. And you can use a combination of all these techniques. I would not advise the use of direct plaster on small work until you have considerable experience of the medium. I will describe a method of making an over life-size figure which is as demanding a task for a sculptor as has yet been devised. The same technique can be used on any number of lesser tasks. (For a description of how to convert measurements to a different scale, see *p. 179*).

To avoid the pit-fall of building too fast and getting lumbered with something you do not care for, it is best to make very elaborate preparations in terms of an arma-ture. I favour fine chicken wire for this purpose. It can be rolled into cylinders to the approximate size of the limbs, then made firm by twisting the cut ends together, and further modelled to make an accurate outline of the form required. This may seem laborious but, as with most sculptural preparations, it pays off very quickly indeed.

The modelling is done primarily by a method of tailoring which is quick and strong, and easier than it sounds (*fig. 20*). The wire forms can then be mounted on a skeleton of steel or aluminium much like that shown as the armature of *Regine* (chapter 11). I favour $\frac{1}{4}$-inch (6-mm) mild steel, held up by a vertical steel tube of 1 inch (2.5 cm) or more in diameter. It is a good idea to arrange the supports as in the diagram (*fig. 21*), so that when the plaster figure is strong enough to be self-supporting the steel tube can be removed. If you spend a week perfecting the armature you will not regret it—the chances are

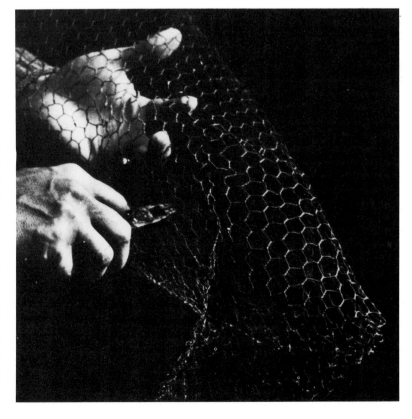

Fig. 20. Insert a pair of pliers at right angles to the surface of the chicken wire with the jaws on either side of one of the wire twists. Rotate the pliers half a turn to shrink the surface. Repeat the action until you have achieved the shape you want.

that you will save time in the long run. Normally I would expect to take at least a year to bring a life-size figure to completion.

Let it be said, however, that I would not choose to do a life-size figure in direct plaster, but in some material that is easier to change. To make *The Figure of Universal Laughter* (*p. 53*) I began with chicken wire as described. I then covered it with sheets of wax, rather than plaster, welded on with a flame, and built them up with further wax. The result was a strong and flexible figure that was so light that it could be rolled over, hung from the ceiling or cut into separate pieces in order to get a new view of it. These are things that I actually do in the course of making a figure and if I was unable to, I would feel deprived. Working in direct plaster would make such conditions difficult to fulfil.

Having completed your armature, you can cover it with plaster bandage or with scrim dipped in wet plaster. This will immediately give you a strong ridged figure which is easier to assess visually than a semi-transparent armature. Go slowly with this process so that you can correct any misjudgements that may have gone unnoticed in the armature. At the same time, be careful to see that the bandage and the chicken wire as well combined by pushing the fabric through the holes in the wire every 3 inches (8 cm) or so.

An alternative to this, which is rather more cautious, is to cover the wire with plasterer's hessian (*fig. 22*). This can be bought at a builder's merchant's and is normally used to secure the joints in plaster-board. Apply it to the armature as you would a bandage to a limb; tie it or even pin it where necessary. You can make minor modifications by bandaging in small shaped volumes of paper or rags. The advantage of this method is that the figure becomes completely visible before it becomes immovable: the more experienced you are with plaster the more cautious you are likely to

Fig. 21 (*below left*). Use $\frac{1}{4}$-inch (6-mm) mild steel for the armature, slotted into a steel tube of at least 1 inch (2.5 cm) diameter for firm support. Join the pieces of armature together with wire ties or plaster and scrim, rather than welding which is too inflexible. When the plaster build-up is strong enough, the tube can be withdrawn.

Fig. 22 (*below*). Further shape is given to the wire mesh by bandaging rolls of paper to it with plasterer's hessian. This gives an ideal surface for applying plaster.

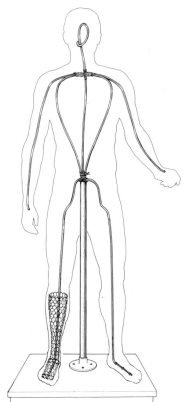

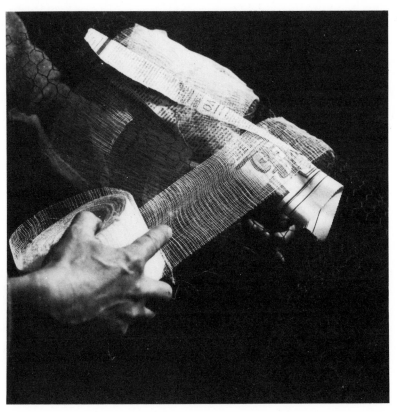

become. When you have completed this bandaging phase you can go on to apply the plaster to the sculpture by hand, or using a trowel or plaster scalpel.

The rapidity with which the plaster sets (or 'goes off') is likely to become an embarrassment at this stage. Plaster setting can be slowed down by adding gelatin to the water before you mix it. In any case mix only small quantities at a time. A good bowl for this can be made by cutting a plastic ball in half; it is smooth inside and old plaster can be broken out easily.

When the plaster begins to set do not try to empty it down the sink! Plaster bowls should only be washed out with water if your sink is equipped with a very adequate plaster trap. In all other cases allow the plaster to set in your plastic bowl and then dispose of it in a dustbin.

The sensible thing to do when you reach this slower phase of work is to prepare some gelatin by dissolving it in hot water so that it is a thin glue. Keep it handy in a polythene bottle, such as is used for washing-up liquid, and add it as necessary to the plaster in the proportion of approximately one tablespoon per litre. In this way you will slow the plaster down to a setting time of an hour or more. (Experience will show you how much plaster you can use in an hour.)

Warm water speeds the plaster up. Old damp plaster will go off in a minute; so will plaster that has been mixed with water that contains the remains of a previous mix. To avoid this it is always advisable to use two bowls. Put the old bowl aside when it is used and clean it later when the plaster is quite set. Keep a bucket of warm water to clean your hands, and the water from this can be emptied into ashes or down a toilet at the end of work. If you use the toilet flush it several times to dispose of the plaster water without endangering the drains.

I built the body of *Pierrot* (*p. 60*)

using builder's 'bonding'—a very coarse, sticky kind of plaster which is readily available. I put it over chicken wire and plaster bandage and found it very useful for modelling with. It goes off very slowly and is of a texture which is much easier to handle than plaster of Paris. I used builder's 'finish' for the same reason. The result is not so strong, but that too is an advantage when you come to work it with rasps, old saw blades and sandpaper. You can give considerable strength to the final sculpture by saturating it with PVA.

Working in plaster is a very messy business unless you are well organised. It splashes your clothes and your hair, and you tread the droppings round the house. It is best to work in a rough, secluded spot and in old clothes; wear boots or clogs that can be easily kicked off whenever you leave the plaster area.

POLYSTYRENE

Expanded polystyrene can also be used as a core round which you can build in plaster, preferably using scrim or plaster bandage for strength. It is incredibly light and strong, but unless you have a special reason for using plaster you might do better to use the polystyrene as a carving material direct. It can be sawn, filed, sandpapered and glued. It can also be cut with a heated wire—you can buy a special tool for the purpose at D.I.Y. shops.

Sculpture made in expanded polystyrene can be cast into aluminium directly by burying it in casting sand. The polystyrene burns away when the molten aluminium is poured onto it. The process is direct and relatively simple and cheap, but don't attempt it without expert guidance.

PAPIER-MÂCHÉ

Papier-mâché is a particularly suitable material in which to make

large sculpture. It is made of old paper (usually newspaper) and glue (as you will need a lot of glue it is sensible to use wallpaper glue such as Polycell or size). It is light, clean and inexpensive. It can be pretty strong and durable as well if you make it with good materials: strong paper or fabric and good glue. The ideal conditions for work are outside in the sun and wind, perhaps with some kind of tent or shelter to keep the rain off should the need arise. A fan heater will produce the same drying conditions indoors.

The main limitation with papier-mâché is the time it takes to dry. You must never put on too much thickness at a time or it may take months to dry out.

I demonstrate two different methods of making an armature for a papier-mâché figure. The method using chicken wire (pp. 106–7) is by far the best and the most permanent, and should be used if the figure is to remain in papier-mâché. It is quite possible to use some strong waterproof glue such as fibreglass and resin for the final coats. This will produce a sculpture strong enough to last for many years, particularly if it is well supported by the chicken wire.

Another possibility is to use papier-mâché as the beginning of a sculpture that is going to end up as a direct plaster. In this case you continue in plaster bandage after you have first established the main composition in papier-mâché. When you have got a strong skin of plaster it is best to empty out the paper and cardboard, which has no strength, and put in its place a back-up coat of plaster reinforced with scrim. The easier it is to remove the inside the better—for this method, therefore, the cardboard and tape foundation described here is the best choice.

A suitable armature for the cardboard and tape method is shown in the demonstration (fig. 23). The structure is designed to be

Fig. 23. A firm but flexible armature for use with papier-mâché, with a simplified cardboard silhouette tacked on. A piece of steel pipe is attached to the pieces of wood, either by drilling a hole through the wood (as in the shoulder piece) or by cutting a slot in it (as in the diagonal piece). I have driven nails into the slot to hold the wood in position and nailed the steel and wood together to stop the wood from sliding down the pipe. The head is supported by a third piece of wood, attached to a 'neck' made of expanded metal which is firmer than chicken wire but which still allows considerable movement.

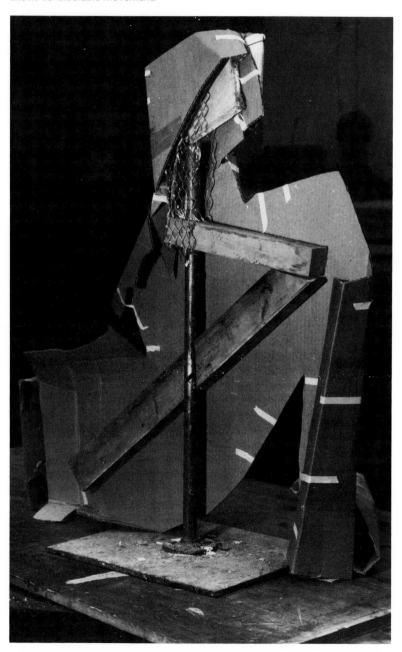

firm enough to support the cardboard that is attached to it with carpet tacks, but not so firm as to make difficulties when one comes to the moment of trying to remove it from the inside after the plaster bandage has been used outside. The simple skeleton is enough to support the torso of the reclining figure that I wish to make (*fig. 24*).

I will make the pelvis and legs at some future date, and these will be placed together, but not stuck together, until the work is more or less complete. This allows me the flexibility and manoeuvrability that I am looking for.

The idea is to produce a strong, crude, three-dimensional version of the form you want before you get into the papier-mâché, which should be reserved as far as possible for the skin only. If you have to build up bulk in papier-mâché it will take a hundred years to complete, because you can only put on a very thin skin before you have to stop work and allow time

Fig. 24. The cut-out cardboard silhouette is elaborated into three dimensions by the addition of more cardboard, held in place with tape.

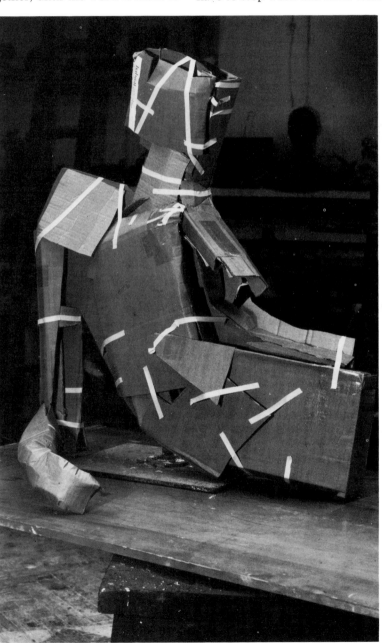

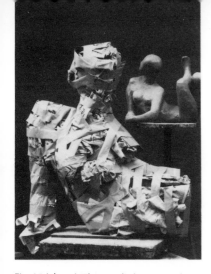

Fig. 25 (*above*). This crude form can then be worked over with papier-mâché or, as here, with screwed-up paper stuck on with brown paper tape. In the background you see the maquette.

for it to dry. Because I am working in winter and the figure has to be dried artificially with blown hot air, I have elaborated further by adding screwed-up paper held in place with brown paper tape, which involves less moisture and therefore less time with the blower (*fig. 25*).

After a few layers of the papier-mâché have been applied and been given time to dry, you will find that the sculpture begins to gain in strength and begins to resemble

the form you want (*fig. 26*). The way to shape it further is to break inwards the parts that protrude where they are not wanted, and to continue to build up in smaller and smaller pieces of paper until you have got what you want.

There is obviously a limit to the amount of detail and clarity that you can achieve in papier-mâché, and it is often desirable to use other materials in the finishing stages. The material you choose will depend on the purpose for

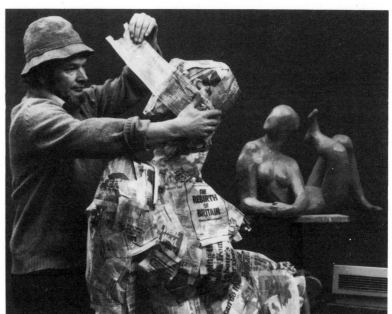

Fig. 26. Applying the first layer of papier-mâché.

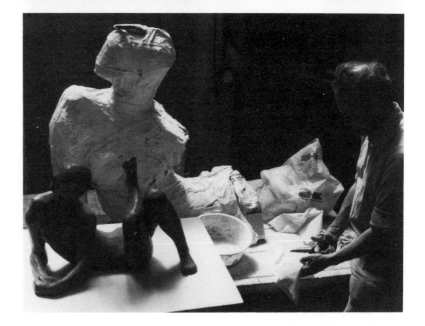

Fig. 27. Cutting up plaster bandage.

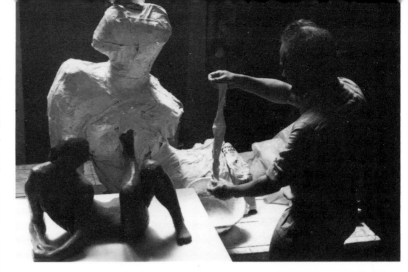

which the sculpture is intended. For things like carnival floats or theatrical props, where lightness and strength are required, it is not a bad idea to paint on a layer or two of polyester resin strengthened with plasterer's hessian, which is cheaper and finer than fibreglass fabric.

For a finish with less strength and more refinement of surface, oil paint or varnish can be used. The paint can be thickened with plaster or Polyfilla and sanded down to the final surface. This finish would be good for things like Christmas cribs which are displayed indoors and are moved rarely and with care.

Plaster bandage is a good idea if you wish to continue to work on the piece in a radical way. It can be sawn up and reassembled. You can also continue with builder's plasters, which are much easier to handle and more responsive than papier-mâché. And finally, of course, there is nothing to stop you from taking a mould from a papier-mâché figure and casting it into some completely different material.

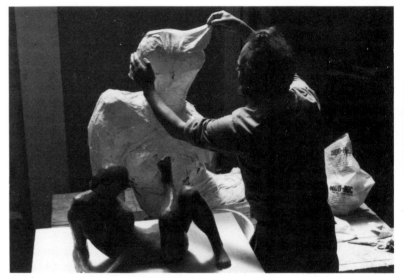

Figs. 28 and 29 (*top and middle right*). Applying plaster bandage.

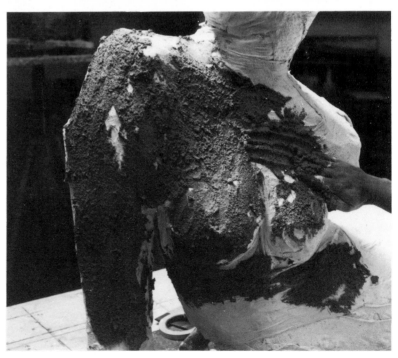

Figs. 30 and 31 (*right and opposite top*). Applying bonding plaster.

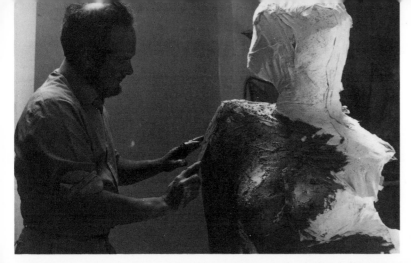

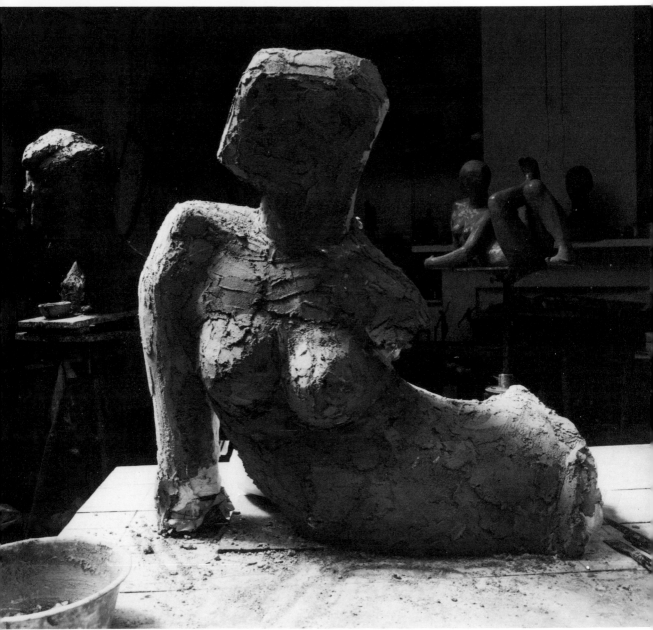

Fig. 32 (*below*). A later stage.

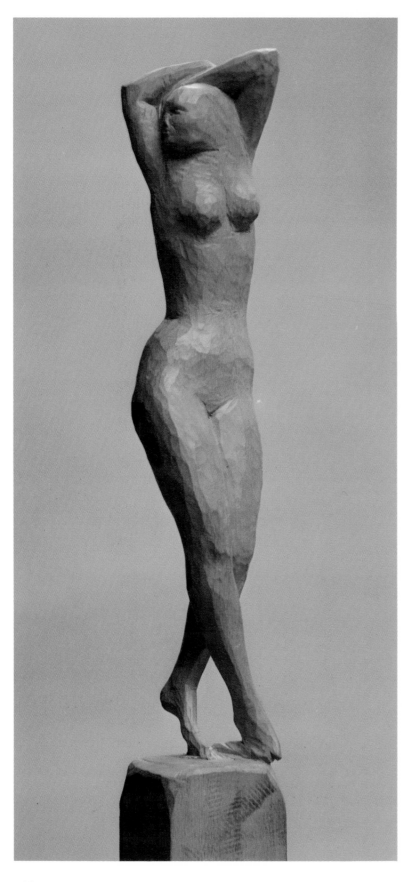

Final composition of *Wood Sprite* (see *pp. 126–32*)—height $10\frac{1}{2}$ inches (27 cm).

(*Opposite*) Annesley Tittensor, *Torso*, 1975 (artist's collection). This figure conveys something of the railway sleepers from which it was carved.

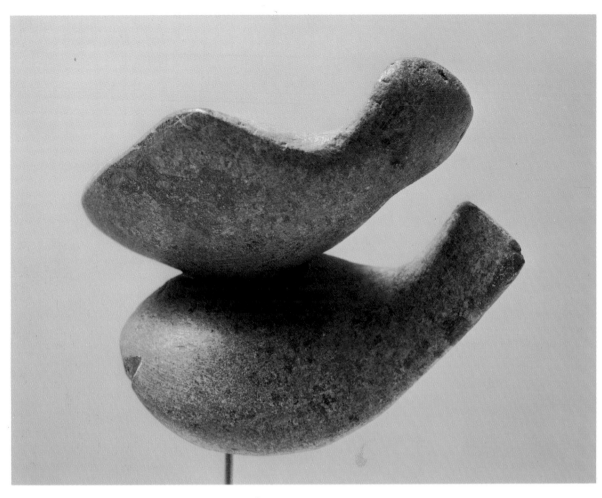

Final composition of *Fishes* (see *pp. 134–37*)—height $4\frac{1}{2}$ inches (12 cm).

(*Opposite*) Final composition of portrait modelling (see *pp. 148–55*)—height 14 inches (35 cm).

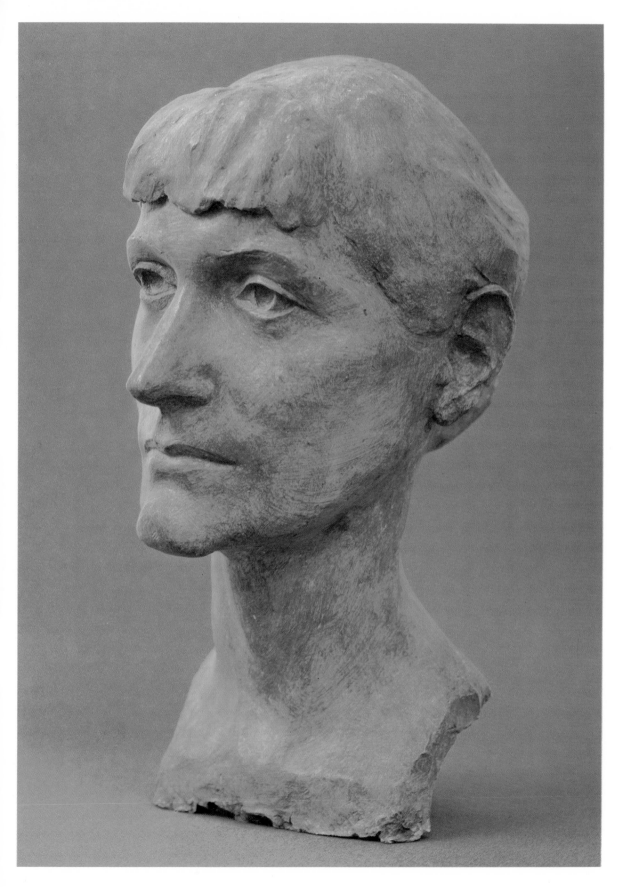

Nigel Konstam, *Knightsbridge Lady*, made in painted terra cotta—height 12 inches (30 cm).

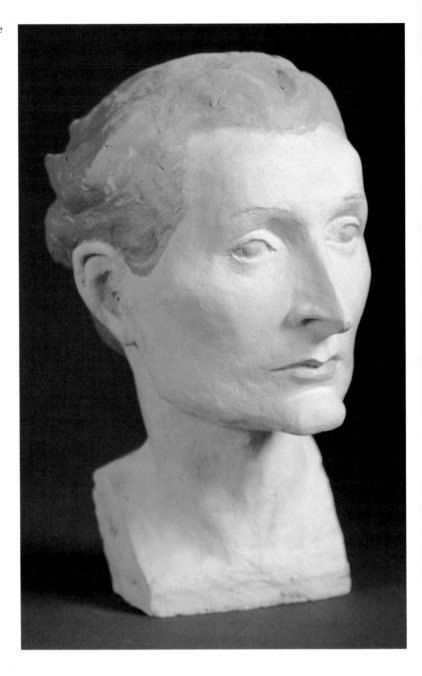

(*Opposite*) Final composition of the portrait of Klemperer (see *pp. 156–58*)—height 14 inches (35 cm).

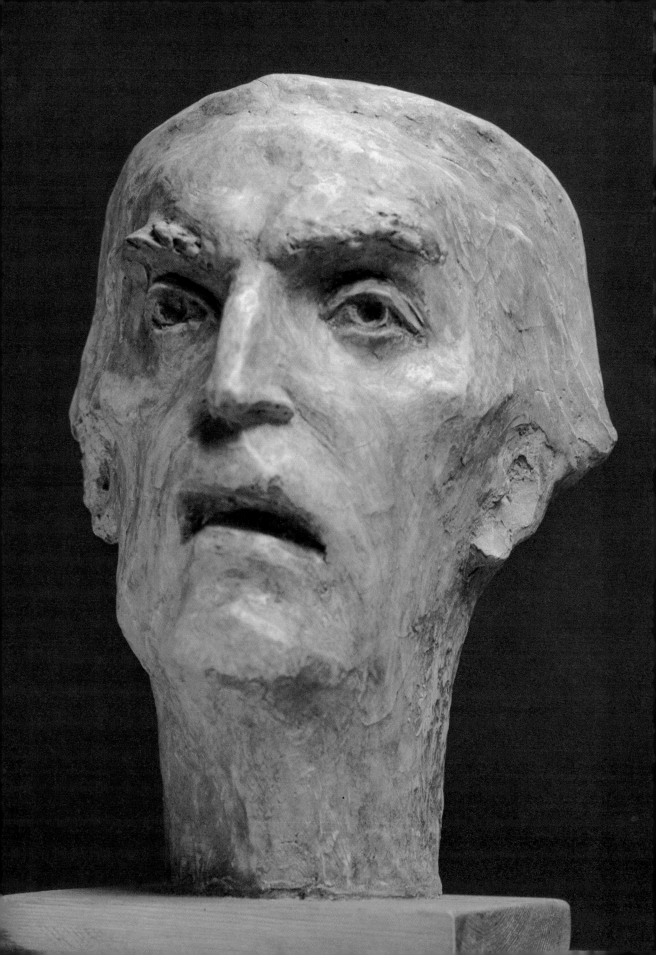

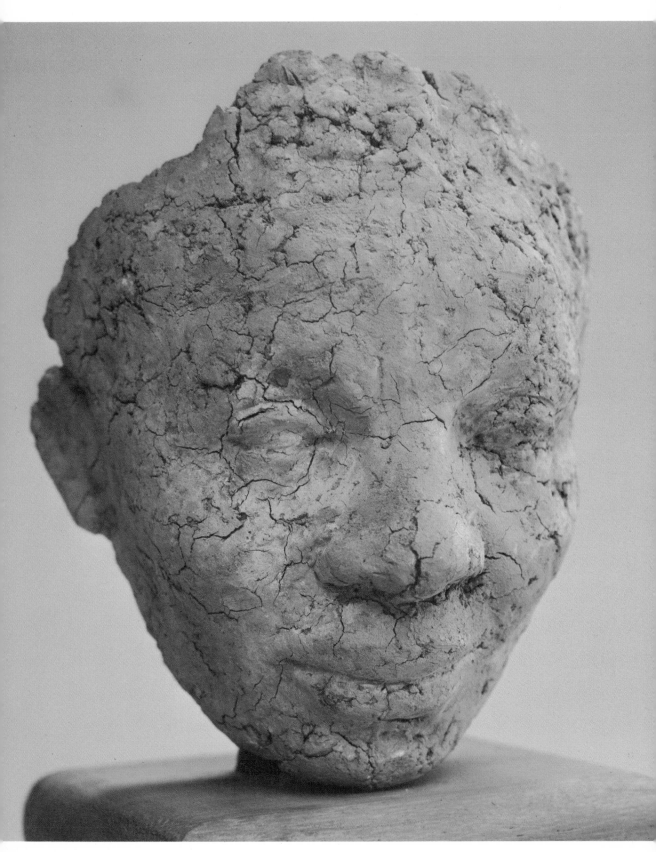

Nigel Konstam, *Mask of a Negress*. The 'antique' look comes from pressing clay out of the ground into a mould—height 5½ inches (1

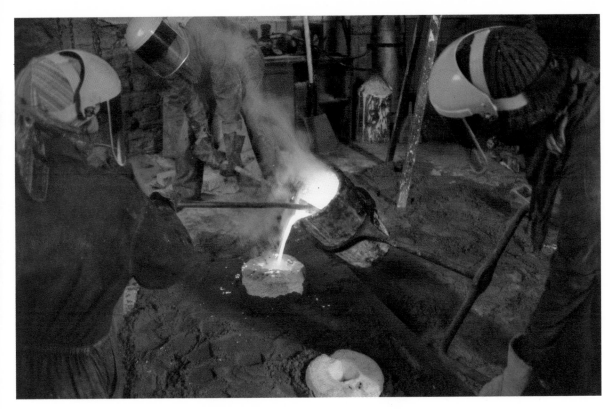

During bronze casting, the liquid bronze is poured at approximately 1150°C, while the dross is held back (see *p. 173*).

Elliot Offner, collection of bronzes, cleaned, chased and ready for patination.

Nigel Konstam, small figures made from *Regine*, cast in bronze (see *p. 171*)—height $3\frac{1}{2}$ inches (9 cm).

(*Opposite*) Nigel Konstam, *Dancing Figures*—height 7 inches (18 cm).

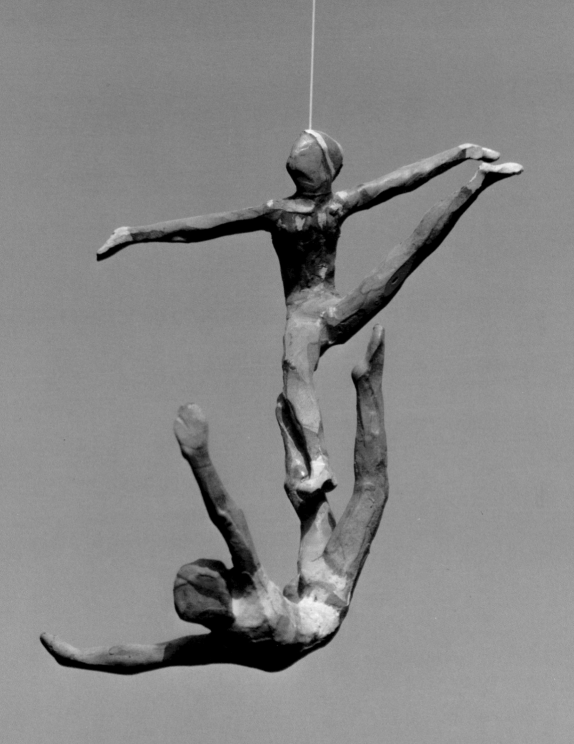

7. CARVING

wood, soapstone, expanded cement

I have shown how, in most types of artistic expression, form finally refers back to carving techniques. I hope that that will be enough to recommend the experience of carving to the student. It is not an activity that suits every temperament. I myself very seldom indulge in it, but I am extremely grateful that at one time I was obliged to carve. Without the experience of carving I certainly would not have written this book in this particular form nor would I make the sculpture I do. It has been quite crucial to my own development and I very strongly recommend it to all who have an interest in the fine arts, whether drawing, painting or sculpture.

I have spoken of my desire for flexibility of approach and method. Clearly carving does not answer that need. The carver is limited by the size and nature of the original block of material from which he starts. As carving progresses, so the possibilities for change recede. Once the main contours of the subject have been established, there is still plenty of flexibility in the way in which detail is executed, but major changes of mind are out. The carver has to be pragmatic. The modeller can, in theory at least, produce exactly what he wants—at a certain stage, the carver has to make the best of what he has got.

It is sensible to take the nature of the material into account when considering the design of a carving. Method and design develop together. Carvers in wood, for instance, have to consider the grain, the strength of the material and the method of manufacture, in much the same way as a furniture designer would have to consider

Pl. 1. Attributed to Michelangelo, maquette for a *Slave* (Victoria & Albert Museum). Note how the raised forearm and the knee come out to touch the front plane of the stone, and how the upper right arm and the thigh reflect the side. Michelangelo aimed to get the maximum movement from within each piece of stone. The maquette, though very tiny in relation to the final work, got the idea coming more clearly and was a necessary first step, even for Michelangelo. He frequently made much more elaborate anatomical studies of details, which he would doubtless have had by him as he carved. It is unwise to set about carving with fewer preparations than Michelangelo used, though many direct carvers make none.

them. Both wood and stone can produce unforeseen delights or difficulties which incline the artist to change course to a greater or less degree. The carver may have to be adaptable to the demands of his particular piece of material. Like any process that involves nature—whether farming, sailing or carving—the master is only in charge to a limited degree. The true master knows how to take advantage of the natural elements with which he works and when to bow to their demands.

The limitations are part of the fun. Poetry is more limited than prose and yet there are reasons to believe that the limitations actually enhance the expressive power of poetry. I certainly believe that to be true of sculpture. As a modeller I go so far as to invent limitations or adopt the limitations of carving in order to enhance the expressive power of the work.

Why this should be so is hard to explain, but easy to demonstrate. Michelangelo's *Slaves (pl. 1 and 2)* are designed to fit tightly each block of marble ordered from the quarry. We might describe Michelangelo as a sculptor who was determined to get the maximum out of each of his blocks. We can admire him for his economy and good sense, but beyond that he has married the idea of the block to the human figure in such a way that each figure seems to be struggling to free himself from the block or box which imprisons him. The story of slavery is coupled with the life story of the carving. By cramming the figure into the block, Michelangelo expresses both block and figure with great power.

A carving can start from the formality of a block of stone or the less formal but nonetheless distinctive shape of a horn, tusk or tooth, or from the natural form of a branch or tree trunk. Even some random piece of rock found in nature may well suggest the shape of the final sculpture.

Pl. 2. Michelangelo, *The Slave* (unfinished), c. 1514 (The Accademia, Florence). Note again how the planes of the original block of stone are echoed in the movement of the figure within.

Pl. 3. Warren whittling tool kit and knives with disposable blades, useful for all small-scale work.

Pl. 4. The tools for larger work. *Bottom left*: points, claw and chisels with ends to be used with a hammer. *Bottom right*: tools with rounded ends suitable for use with a mallet. *Top left*: a dummy hammer made of malleable iron for fine work, a stone carver's lump hammer and a Bouchard hammer for eroding stone. *Top right*: a hardwood mallet and a light wooden mallet (much worn).

WOOD

For carving in wood, I advise you to start with something on a small scale. Choose a good quality wood. Of the softer ones, pine is very beautifully grained but tends to split along the grain rather too easily; lime is a traditional wood for carving because it is very even in the grain and therefore easy to carve, but it is very dull to look at. The fruit woods are somewhat harder and good to carve—cherry and pear being the most frequently used. Of the more common woods, beech, birch, elm, chestnut, box, holly, laurel, laburnum, plane, sycamore, walnut and oak are all good in their various ways. So are many tropical woods, but they tend to be expensive.

It is important to get well-seasoned wood without any obvious cracks or knots. Some woods can be used unseasoned—they will be found to be much softer, but will certainly crack as they dry out. A good timber merchant should be able to show you samples of the way each wood looks when it is finished. You might be able to get some suitably sized off-cuts from a cabinet-maker for your first try. The harder the wood, the longer it takes to carve. My *Wood Sprite*, which is made of beech and is $10\frac{1}{2}$ inches (27 cm) high, took about two weeks to reach the state shown in the final stage; and I enjoyed every minute of it.

Before you start, consider how you are going to hold the work in place. If you start with a long piece, as I did, there are obvious advantages from this point of view. If you have a metal vice it is wise to fit the jaws with wood or leather gripping surfaces so that they do not bruise the wood. If you have not got a vice you should at least buy yourself a clamp. You can screw the work to a bench or to a large heavy piece of wood, but you really need to see it from many different angles, so a clamp or vice does make things easier. A tourniquet of rope can also serve very well.

A bench or worktop about a metre high makes life reasonably comfortable; you can both sit and stand at it. If you do not have one, try to get the use of one, at least for the first day of carving. Thereafter your needs for a bench will steadily diminish.

The tools you require will depend on the size of the work you undertake. If you start on a

Fig. 1. The wood is clamped to a good strong box filled with bricks—a good substitute for a bench if you have not got the use of one. You can sketch on the surface of the wood to help find your way into the mass.

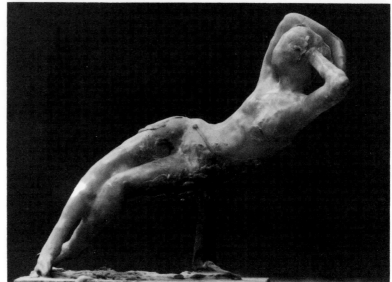

Fig. 2. It saves a great deal of time to have a three-dimensional model of the form you wish to carve even if, as in this case, it is incomplete and only roughly what you are aiming at.

small scale you will need no more than the Warren tool kit illustrated (*pl. 3*), a saw and a flat chisel. A mallet is optional, since for small work another piece of wood will serve very well. Knives with snap blades may prove useful but the Warren kit contains little blades specially designed for whittling (shown top left) which are better.

Wood-carving tools must always be kept very sharp. The best advice with sharp tools is to use them in such a way that if they slip—and however careful you may be they will inevitably slip sometime—they will bury themselves in the wood and not in your flesh. A wood-carving chisel should be kept so sharp that the merest nick will draw blood; if you inadvertently give yourself a stab, it could be a very deep

wound indeed.

For larger work you will need a full kit of carving tools plus a few flat chisels (see *pl. 4*). I also find a bricklayer's bolster which has been sharpened up very useful in the initial stages of a large carving. The Red Indians used axes for this purpose, but I find I have more control with a bolster and a stone carver's hammer. One advantage of working on a large scale is that you will not need a bench or clamps as the weight of the wood itself will hold it in place. If you are lucky you may be able to get hold of an old tree trunk for nothing.

The starting shape of my *Wood Sprite* was a length of beech with a section 2 inches (5 cm) square. I wanted to get the maximum movement out of this confined block. I had in the studio an unfinished

reclining figure which I used as a starting point for the idea (*fig. 2*). The arms folded behind the head were the widest dimension and fitted neatly into the diagonal. Having decided that, I sketched the position of the breasts, hips, etc. on the block and then set about the thing with a saw, cutting in as far as I dared and then removing the unwanted wood (*fig. 3*).

After this initial stage, when it is more or less necessary to have a clamp or vice, most of the work is of a sort that can be done in your lap. It is clean and noiseless, some woods even smell nice (but elm smells nasty), and only the chippings prevent one from doing it in a living room.

Your attitude to design will vary depending on whether you start with a raw tree trunk or a

piece of prepared timber. With my small piece of beech I felt quite confident that the wood itself would have no nasty surprises in store for me. On the other hand, it gave me none of the leads that come from the irregularities of a raw piece of timber. I have tried to maintain the feeling of the rectangle from which the figure was carved. For instance, large areas of the figure's back and her left side still touch the surface of the original block. I have also left the base untouched to emphasise this relationship between the starting and the finishing form. I make play between the organic movement of the figure and the static form from which it was derived—a very common sculptural game. It can be played the other way round: Picasso and Moore often start from some found object, such as a flint or a leaf, and incorporate it into a formal design. Many wood carvings are inspired by the shape of a branch or root.

In the soapstone carving which follows, the irregular shape of the original stone dictated the design; that is not to say that the same piece of stone might not have dictated something quite different to someone else. I hope I am conveying the sense of a partnership between the maker and the material that is the basis of most design that I admire. When choosing the subject matter it is wise to choose something you know about, but if you know nothing of the subject you can always do some research. The main thing is not to be frightened of beginning. It is better in my opinion just to launch out, take your piece of wood and explore its possibilities, than to sit and plan too much. You cannot make a carving without risking a good piece of wood. With experience you will learn to combine boldness with a modicum of caution, which will leave you plenty of room to manoeuvre—but you will only learn this through practice and experience.

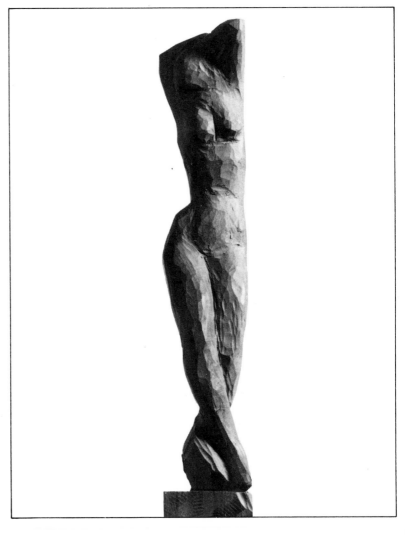

Fig. 3 (*opposite top*). Using a flat chisel and a mallet, I cut diagonally across the grain down to a saw-cut at the position of the waist. This is a very quick way to remove unwanted wood and should be used whenever possible.

Fig. 4 (*opposite below*). The original surface of the block can be seen on the base, the thigh, the chest and below the elbow. The lower parts are deliberately left on the heavy side at this stage to give added strength.

Fig. 5 (*below*). I have carved the lower left thigh with a very curved gouge chisel to try to get round the difficulty of carving along the grain of the wood.

Fig. 6 (*below right*). On the lower legs, I have cut from knee to ankle on the outside of the leg and from ankle to knee on the inside to avoid digging into the grain of the wood.

The carving I have produced is nothing like the figure I would have produced had I been modelling. Then I would have had more control over the result. My first saw cuts committed me to certain proportions; at one stage I did not like these but I had left little room for change. I still feel that the top quarter of the figure is too small to match nature, but I have tried to make this miscalculation into an asset by pursuing the particular rhythm suggested by this set of proportions. You will still see the sign of the saw under the figure's left breast and where the hip meets the waist. Some might say that I was over bold—I would say it was a close-run thing.

Many craftsmen would feel that caution and calculation are virtues to be fostered in the novice. I think you will make contact with the excitement of carving more quickly if you take risks (but not with the tools, please!). It is not a bad idea to make a toy for your first effort, where there is room for a little eccentricity or caricature. The human figure is a subject we all know a lot about, but it invites comparison with four thousand years of sculptural history and that can be a little daunting.

Another approach to composition suitable for the beginner is to make an adornment for a piece of furniture or a building—a decoration for the back of a chair, the pediment on a book-case or a local god or guardian angel for a summerhouse. This brings in an

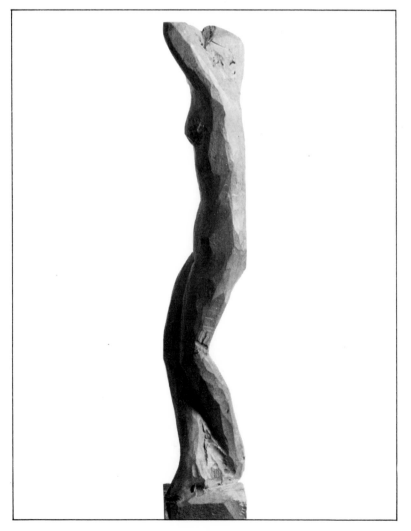

important consideration—that of appropriateness to the setting. The ornament on the back of a chair, for instance, must not dig into the spine of the sitter. The handle of a walking-stick—or a dagger (*pl. 5*)—must feel good in the hand. Architectural ornament should respect the modelling of the building that it is to adorn. In a word, it is often the artist's job to make his work *harmonise* with its surroundings or serve a specific function. Carved spoons, paper-knives, boxes, candelabras—all need to strike a balance between the requirement of the object, the material and the ornament. And such useful objects may be a good starting point since they are not too artistically ambitious.

When it comes to advice as to how to use your tools, very little can be said. Experience will teach you about the qualities of your particular piece of wood. If you have ever worked with wood in any way—carpentry, model-making or even splitting logs—that is a good start. The grain runs up and down the length of the branch or trunk. It is easier to cut across the grain with a saw than with a chisel. If you have to cut across the grain with a knife or chisel it must be extra sharp or it will tear the wood and look very nasty. If you try to cut along the length of the grain there will be a tendency to split the wood. It is inevitable that you will have to do both of these cuts and in the process you will learn just how much your wood will stand.

To avoid splitting, use a gouge chisel—that is, a chisel with a curved section. It will not get between two layers of wood, which causes splitting. Try also to use the gouge diagonally to the grain—this is the easiest cut to make clean and true because the edge of your blade has no chance to get between the layers.

Pl. 5 (*below left*). Ivory dagger handle, possibly Milanese, possibly 14th century (Victoria & Albert Museum).

Pl. 6 (*below*). Barbara Hepworth, *Pelagos*, 1946 (Tate Gallery). This work gives the impression of having been made by tying some springy substance together into a spherical form: in fact, it is carved from a sphere of wood.

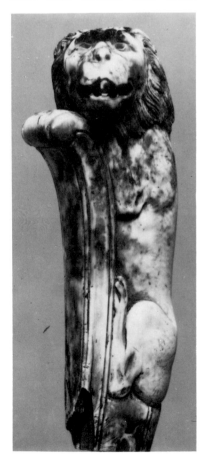

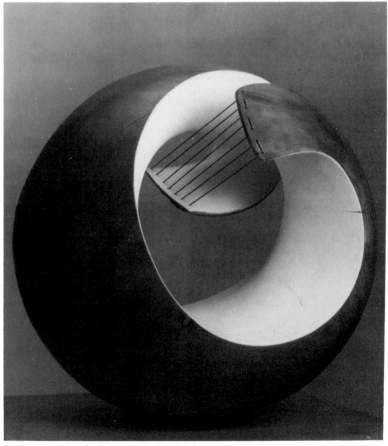

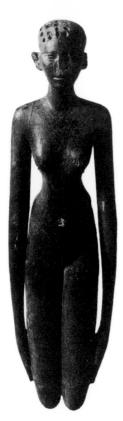

Pl. 7 (*above*). *Standing Girl*, Egyptian,
c. 1500 B.C. (British Museum). This is an
exquisite and utterly simple use of
wood. The ancient Egyptians produced
really lovely sculpture on a domestic
scale as well as the monumental works
for which they are best known.

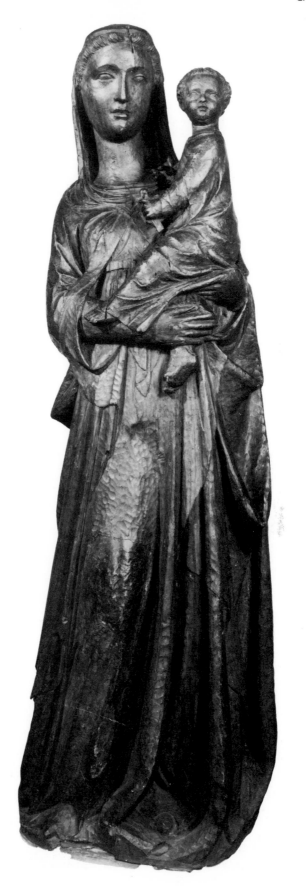

Pl. 8. *Madonna and Child*, Italian, early
15th century (Victoria & Albert
Museum). The vertical movements of
this piece, very subtly varied, give the
feeling of the tree trunk from which it
was carved.

On the forward leg of my *Wood Sprite* the front of the calf happens to be exactly parallel to the grain, and you will see that I have had difficulties with the grain lifting about half-way up. To cut across the grain (on the base) I used a saw, followed by a very sharp knife, removing wafer-thin slices. When you push by hand, it helps the passage of both chisel and knife if you can give a slight sideways action to the blade, like a saw. On a small carving like this one, all the fine work was done without the use of a mallet—one has more control by pushing. For safety, do make sure both hands are behind the blade. Push from the shoulder wherever possible, and push down onto a wooden worktop.

Pl. 9. Freda Skinner with limewood, sawn into planks, seasoned and assembled again in preparation for carving the figure of Christ.

Pl. 10. Freda Skinner's Christ figure in the process of being carved.

Pl. 11. Sharpening a gouge chisel, showing the 15-degree angle at which the tool must be held to the block.

Pl. 12. Cleaning off the burr from a gouge chisel with a slip stone.

Sharpening Tools

Sharpening tools is an art in itself. I give careful instructions below, but it will take six months of carving before you can do it really well. You will need:

A Washita oilstone.
An India slip and other small slip stones.
Cycle oil or, better, honing fluid.
A leather strop and emery paste.

To start, take a flat chisel about 1 inch wide (2.5 cm)—the easiest to sharpen. Place the oilstone in a prepared frame to hold it steady on the bench and put three drops of oil on it. Then place the bevelled side of the chisel on the stone, holding the tool at an angle of 15 degrees to the surface and the sharp edge parallel to the length of the stone, with the handle in your right hand. Place two fingers of your left hand firmly on the shaft of the blade and work the tool up and down the length of the stone with a firm, even pressure. You should be gently and evenly grinding the surface of the bevel. Keep checking to ensure that you are doing it evenly. When you feel you have done enough, turn the tool over and take off the burr with one or two gentle strokes. Wipe it clean—then strop it and test it for sharpness. If it is sharper than when you started you show real promise.

For the gouges the same action is needed, together with a rotating action with the right hand to bring each piece of the curved bevel into contact with the stone. This needs considerable practice; do it slowly but surely to begin with. Rotate the gouge anti-clockwise on the left-to-right stroke and clockwise on the right-to-left stroke. It is very important to keep the bevel at a constant 15 degrees and the shaft at right angles to the length of the stone throughout. Use the appropriate slip stone to clean off the burr inside the curve of the gouge. Emery paste can be used on the strop for the final touch.

STONE CARVING

Stone carving is not the neat and tidy process that wood carving is: even the carving of a small piece of soapstone or alabaster will make considerable dust. When it comes to anything large it should be done in an outhouse or garage. Stone dust can cause silicosis so be very careful in the way you sweep it up, and avoid using mechanical tools unless you are working in the open or are well protected by a mask. In the normal hand-tooling of stone there will be very little air-borne dust, but with a hard stone there will be chips flying about and it is wise to have a good pair of industrial goggles handy to protect your eyes.

For my demonstration I have selected a small piece of soapstone. It has the shape of two drops of water that have collided to form a simple rounded shape on one side and a concave on the other (fig. 7). Soapstone is found in natural nuggets. It has been exposed to the elements and the action of the weather will probably have softened the surface in places. It is in any case very fragile.

Fig. 7 (*above*). The original piece of soapstone.

Fig. 8. For carving, I find the Eclipse no. 660 an ideal general-purpose, disposable blade—it is heavy and fairly sturdy. You can use it in the handle designed for it, which can be adjusted to all angles: when set at right angles it is very useful for coarse scraping. When carving very small pieces, it is often easier—and safer—to put the saw in a vice and to move the stone: the blade is then at its most forceful and controlled. Held in the hand it is gentle and flexible.

The first thing to do is to investigate the surface by scratching it gently with a tool. The choice of tools is a matter of taste. The material is so soft that it can be carved with tools designed for wood or stone, or even with kitchen knives. I find that I use sturdy old saw blades the most. An ordinary hack-saw blade is also a very good all-purpose tool (*fig. 9*). After the initial roughing out all the work is done with blades, holding the stone in one's hands rather as if scraping a potato. The final finish is done with sandpaper.

With the particular piece of stone that I had, the use of stone-carving tools would have broken it up in no time. As it was, I managed to knock the tail off one of the fishes when I used the saw too roughly. Yes, the colliding drops turned into fishes: you can get more movement into fishes. I had gone quite a long way before I made this decision—at the beginning they might have become drops, fishes or birds. At a very early stage I abandoned the idea of a more complicated form; the stone simply was not up to it.

Fig. 9 (*above*). For more delicate work, a piece of a hack-saw blade is a good choice.

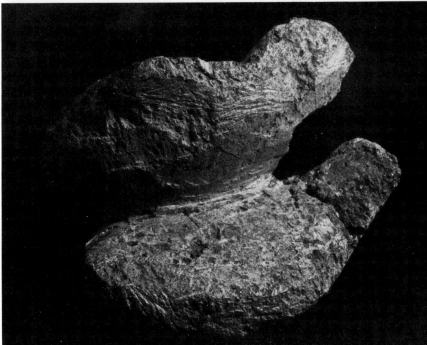

Fig. 10. The finished composition, roughed out.

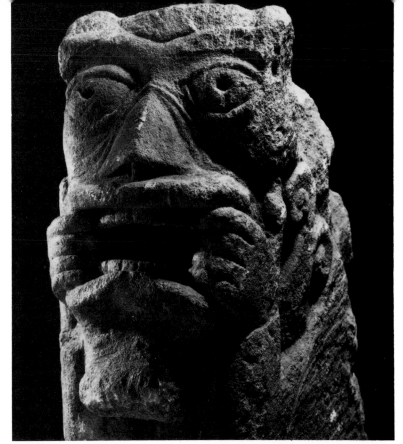

Pl. 13. Gargoyle, English, medieval (Victoria & Albert Museum). This is bold carving on a coarse stone.

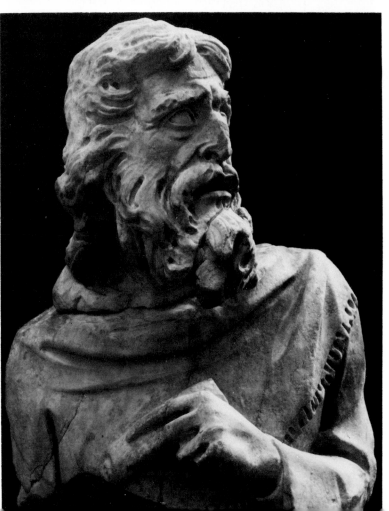

Pl. 14. Giovanni Pisano, *Haggai*, c. 1290 (Victoria & Albert Museum). The marks of the drill on the marble are very evident here in the beard and the hair. The work of this great sculptor is seen to best effect in Pisa and Siena.

This is ideal work for a day on the beach or in the garden. Indoors it can be done seated with a large apron or a sheet of plastic to catch the dust. The dust can be minimised by keeping the stone wet.

The form of this final sculpture is very much more like Eskimo work than like anything I have made before, for the simple reason that the nature of the material dictates the forms which can be conveniently carved. The composition is not one I imposed: it evolved as a result of the interaction of my sculptural preferences on the form and the material in my hand. I have always admired the sculptural quality of propellers—the two fishes reflect that taste. They are very much more rounded and easy-flowing than my usual work because they were made by a process of erosion and polishing similar to that used in classical Greece (see chapter 2).

These forms are agreeable to handle: I see the sculpture as one to be picked up and fondled rather than mounted in one particular orientation. The soft nature of the stone makes it easy to handle, even when it is quite rough.

I mended the broken tail with PVA. I also filled pock holes which appeared in the surface with a mixture of PVA and stone dust. Naturally it is better if you do not have to indulge in this kind of botching, but the faulty nature of many stones make it necessary. When you use a glue in this way do not be tempted to use the strongest possible. Choose one which is as near as possible to the strength of the rest of the stone, then there will be less difficulty in working over the repaired part.

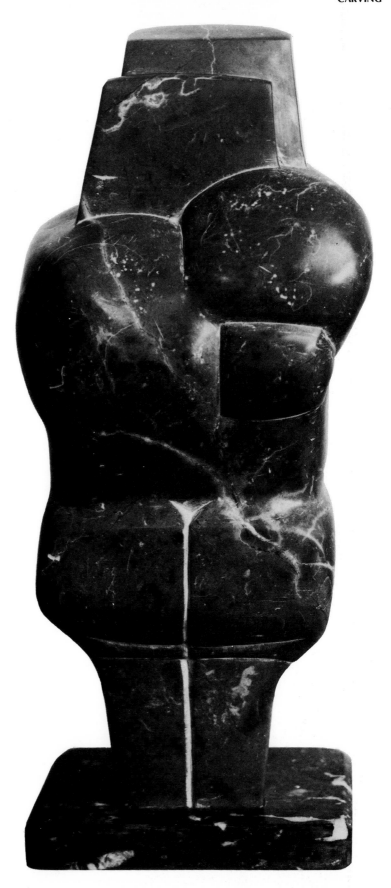

Pl. 15. Stephen Cohn, *Venus*, 1963 (artist's collection). The artist makes the most of the quality of marble in the contrasts between swelling curves and flat surfaces.

EXPANDED CEMENT

Expanded cement is a very good and inexpensive carving medium. It is very soft to carve but reliable in its strength—that is, it will not suddenly fracture as many natural stones will. It is so soft that it is not necessary to use stone-carving tools. On the other hand, it is a very satisfactory way of acquainting yourself with the mental skills required to find your way through a block of stone, and I strongly recommend it for the beginner. I use it myself to design work which I intend to cut in a more noble stone at a later date. My *Apocalyptic Horse* may end up twice its present size in marble. In the cement it is pleasant to look at, but needs to be handled with great care: it is weaker than plaster.

My first design was based on a real horse's skull that I admired in a friend's studio. As you see in the demonstration, the actual skull served as the armature on which to build a model. I used clay that was constantly drying out—it would probably have been more sensible to use plasticine or wax for the additions. The detailed process of carving from the block of expanded cement was done first with a saw, then with a saw-blade, then with a little pointed knife and, finally, with files and coarse sandpaper.

The initial starting point, or inspiration if you wish, was the skull itself. Skulls are by their nature a little menacing—most of them laugh at us at the same time as reminding us of our mortal condition. This horse's skull inevitably reminded me of a beautiful horse from the Parthenon that I visit nearly every time I go to the British Museum. The menacing element reminded me of Picasso (who has used animal skulls in his still-life paintings) and especially of his *Guernica*.

I did not actually refer to these other works in the course of making my horse's head, but I hope I have conveyed some of the horror of *Guernica*. If so, I acknowledge that it is because my half-memory of that work will awaken your half-memories of that or of similar horrors. Such references are the very stuff of visual communication. Artists rely on awakening the half-forgotten memories of their audiences—without them nothing serious can be communicated.

Art is riddled with cross-references, but not at all as the historians would have it—they have a way of tracing the iconography of a work that makes artists appear like witless tellers of third-hand stories, constantly having to run off to the library to check up on how so-and-so did it. I am sure that I am not the only artist who is too lazy to do any such thing. It is much easier, and more appropriate, to recreate the scene with materials that are to hand using one's own imaginative resources. I have yet to meet the artist who conforms to the historians' pattern-book. We worry about form; iconography comes as second nature. Artists take from each other what they admire in each other's work—this is the how, the why and the wherefore of artistic development for both the individual and for the school.

The artist constantly relies on memory. As one looks at a model one is reminded of the work of another artist; a particular pose may remind one of another work of art. As I work on my carving it may begin to remind me of the expression of a friend; I then choose to steer my carving towards or away from my memory. My own visual memory is not particularly sharp or accurate. I rate the *number* of memory links as more important than their accuracy.

These likenesses are not necessarily recognisable; they give a flavour, no more. The references that seem clear and obvious to the artist are often unseen by the onlooker, who may find instead the influence of someone who is

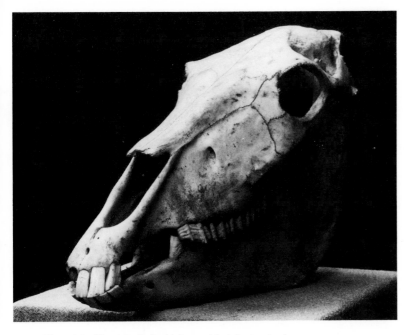

Fig. 11. The original horse's skull which provided the inspiration.

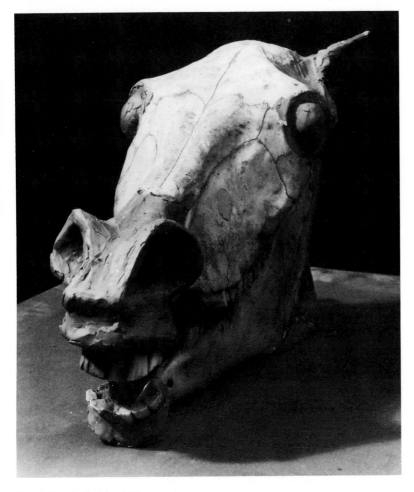

Fig. 12. The skull with additions in clay.

the artist's despised bête-noire. Works of art operate on the level of flavour or atmosphere, and the memories that come up in the course of work should be questioned for their atmospheric qualities: if pursued will they help create or destroy the effect you are looking for?

As I worked on my design I felt that the horse's nostrils and tongue reminded me of Picasso, though I could not name a particular work. It was just a feeling, and that feeling was good for the work that I had in mind so I pursued it. Having made the tongue it seemed necessary to carry it through to the roots, and the shapes I made were undoubtedly influenced by culinary experiences. As I worked on, vague memories of knights and caparisoned horses floated by and became incorporated. Once I made a study of a dead calf's head; on another occasion I was commissioned to make a portrait of a horse; drawings I had made of a sheep's skull had a very strong influence on the shapes I felt were appropriate. The sheep, in particular, had refinements of design that I was sorry not to find in the horse—so I incorporated them. The final horse could work for you without your following the origin of all these influences; and it could fail to work though I have told you of them. Whether it works for you or not depends upon the nature of the memories it awakens. Very many works of art are conceived and transmitted on memories.

There are also entirely practical considerations to be taken into account when designing for stone. Michelangelo required that a sculpture should be able to be rolled downhill without breaking; certainly his own were very robust from that point of view. So much classical stone sculpture has survived in a limbless state that we have come to regard that as the norm; it is nonetheless sensible to try to design forms that are not

too vulnerable to breakage. Even hard stones can be damaged by an inadvertent knock. Carvers try to design in a way that does not leave limbs sticking out on their own; drapery is often used to reinforce vulnerable parts. The ancients often included urns or even tree stumps to help hold their figures up; two ankles on their own do not stand a chance of supporting a complete figure in marble.

Weather can destroy sculpture that lives outdoors, particularly in countries where frost and rain succeed one another. One must be careful not to create hollows where puddles could form and freeze. It is also wise to consider where the rain will form rivulets because these will cause discoloration and streaking.

The starting shape of stone is usually a rectilinear block, and economy of the material is not just meanness—it is a virtue in itself to design to get the maximum out of the stone. The final size of my horse's head in every dimension is within a centimetre of the size of the original cement block from which it was carved. As I work on the original block, destroying it, I hope to replace it with a more complex geometrical shape which touches it at certain points—the ears touch the top plane, the jaw touches the bottom plane and the tip of the lip touches the front plane.

The economy of effort with which I have removed the unwanted stone with a saw (*fig. 13*) is, I hope, also felt in the final work. Using a material as soft as this, one is inclined to lose the clarity that results from cutting cleanly through stone, but I have tried to retain the clean, hard look which I like so much in carving. When stone carvers get too clever at imitating flesh they lose the nobility of the material in which they work. I want to find a balance between the soft lithe quality of a horse's tongue and the durability of the marble in which I hope one day to carve it.

Fig. 13. The roughed-out head, sawn from a block of expanded cement.

Fig. 14 (*below*). Using a small knife for carving the details. The Eclipse saw (see Fig. 8 of soapstone carving demonstration) is very useful as a scraper/rasp on this material.

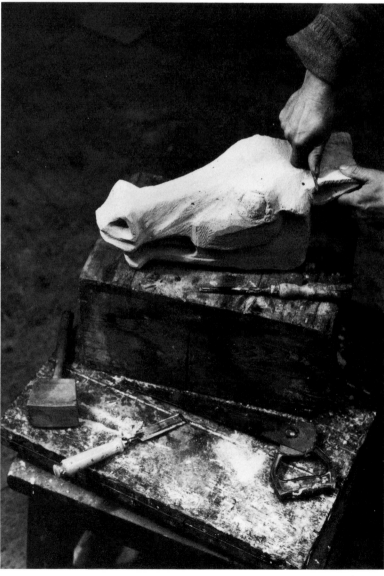

The decisions I took about shaping each detail are exceedingly difficult to describe, let alone give reasons for. It is a matter of responding to the various possibilities as they present themselves. If I leave the lips like that it looks as if he is sucking a sweet, so I try something else. A lovely spherical eye looks too healthy, so I sink it in its socket a little. The sense of speed and aggression are enhanced by creating links between the horizontal members— the shapes round the tongue and the roof of the mouth are linked with the space round the vertebrae. Had I been designing the same idea for bronze, I would almost certainly have made the mouth open right through to the front, with the tongue as a separate unit in the middle of the space. The arrangement that I have settled for is a concession to the fragility of stone—the tongue, the teeth and the lower jaw, all of which on their own would be weak, support each other. This is the kind of compromise that is necessary to consider when designing for stone. The precise shapes that I have used in the sculpture are more the result of ad hoc self-criticism than the fulfilment of any pre-ordained vision.

Fig. 15. The finished work—length 16 inches (41 cm).

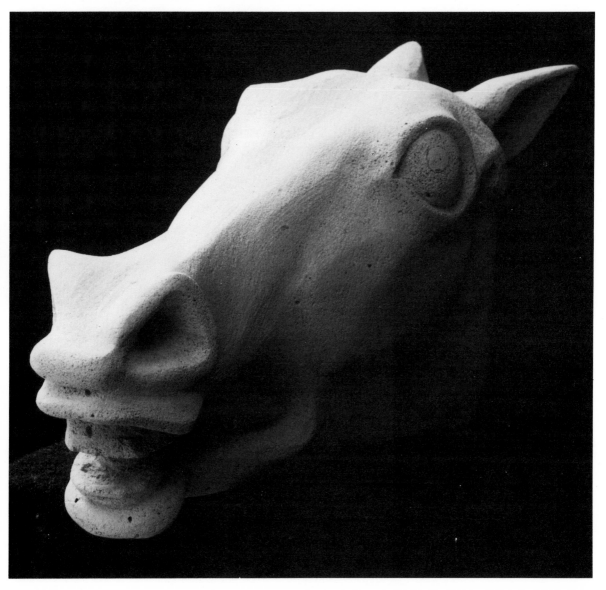

8. MODELLING A PORTRAIT

In chapter 2 I discussed the two traditions of form-making and the different types of portrait that they produce. My analysis of the sculpted portrait of Hadrian outlined for you the main thrust of the 'alternative' tradition; in this chapter I show you these ideas in practice by modelling a portrait.

DRAWING

In the normal course of events I would start a portrait by making at least three preparatory drawings: a profile, a full face and a three-quarter view. It is tactful to start with the profile, which is also the easiest. Few people are used to the intensive scrutiny that drawing entails: the eyeball-to-eyeball stare which is inevitable from time to time in the course of drawing the full face can be very disconcerting. Build up to it slowly. You will need to make your sitter feel relaxed.

It is a good idea to have a cup of tea or a drink together before you start—this will give you time to form a first idea of your sitter's personality, if it is not someone you already know. Put your sitters into the right frame of mind—this is a cooperative effort and you are going to need all the help you can get. Show them your studio. Curiosity is natural and, if you don't show it, they will be stealing surreptitious glances at it throughout the first sitting which will drive you mad. Observe them as they move around.

We respond to others at an instinctive, non-verbal level, which can teach us a great deal about personality. Practise receiving non-verbal communication. Exercise your instincts as you walk up the

Pl. 1. Charles Despiau, *Madame Schulte*, 1934 (Tate Gallery).

road and you will find that you can form an idea of people by the way they hold themselves, by the way they move and, of course, by their expressions. Ask yourself questions about them. Is this one trustworthy, bold or timid, generous or mean, organised or disorganised? It is highly desirable for an artist to have a lively instinctive response. You will be working without words—your work must speak in the same non-verbal

terms that instinct responds to. The messages are there; you have to learn to pick them up. Practising the visual arts sharpens the instinctive awareness and trains the powers of observation. It is a training for life itself, because you learn to see through camouflage, by-pass the surface and see what is really going on.

The manual skill required for drawing is rather less than that required to write legibly. Drawing

is as easy as switching on a light; the difficulty is in finding the switch. Once on, the light is constantly being cut off by a trip-switch in the brain, which wants to go back to automatic chatter. We may take it for granted that we all possess great potential powers of observation and a capacity to respond instinctively; our distant ancestors would not have survived long in the jungle without them. You must have them, though the chances are that they are buried beneath more recently acquired skills of speech.

Do not be afraid of changing your mind or your drawing. Great artists are often very clever at disguising the amount of labour that has gone into their work; they make it appear effortless. Michelangelo got his valet to destroy huge quantities of preliminary studies because, Vasari tells us, he did not want posterity to know the pains he had gone to. This kind of practice has led us into the mistaken belief that the great masters did not have the difficulties that we encounter. We tend to think that if only we had their magic touch, we too could create whatever we liked, instantly. Naturally practice and talent help, but in truth even among the great there are very few who get it right first time.

I regularly finish a portrait in less than one twentieth of the time taken by Despiau, or one quarter of the time Rodin usually needed. Alas, that does not mean that I am a better portraitist than they—the result is what counts. Despiau used to take one hundred and fifty to two hundred sittings to achieve a result that I greatly envy. I would willingly spend twice the time that he spent on *Madame Schulte*, but I lack his staying power: my work does not improve if I spend so long on it.

The method of drawing I will be showing you is a very efficient one, but the end result will depend on your powers of observation, judgement and sustained self-criticism. True creativity lies in a shifting balance between extreme self-confidence and rigorous self-criticism. An artist needs the ability to go on sacrificing work which he may regard as pretty good in order to create something better, until it is as good as it possibly can be in his own eyes. Even then he is likely to return a week or a month later to find that it has subtly changed for the worse. A fresh eye reveals the flaws in what wishful thinking had seemingly made good.

If you can always see what is needed and find the determination to put it right, you are a born genius. Physically, the time required to make a work of art is usually only a tiny part of the time actually spent. By far the greatest time is used in trying to see what to do. The creator's eye becomes accustomed to the flaws in his own work—he will need all the tricks of the trade and help from his friends to see what is necessary. My earnest advice is that you should gratefully accept any criticism that comes your way. Encourage your critics by trying out their ideas, even if they don't appear all that useful—you can always discard them later if they don't work out. Continuous creativity is dependent upon a willingness to destroy what has been created thus far. This attitude becomes progressively more difficult to maintain as the work goes forward. Despiau used to strengthen his resolve by taking moulds at various stages of his work so that if the new idea did not work out he could always return to an earlier stage without all being lost.

Your Subject

After these necessary cautions, you should be well prepared to enter the studio. Take your time in placing your subject in a good light. I say subject rather than sitter because if this is your first time you would be wise to start by working from some inanimate

object, so that your own frustrations will not be compounded with those of your sitter. A good piece of sculpture is a good substitute for a live model; indeed it has other advantages for the beginner besides keeping quiet and still that I will go into shortly. Plaster casts can often be found in junk shops; alternatively museums and galleries can usually supply a range of them, and they are often very reasonably priced. The skull of an animal, or even a well-made toy, can provide a good subject to work from. The artist's lay-figure has its uses here as well (see *p. 34*), but at this stage you should choose something with plenty of character.

Lighting

A sculptor's studio requires very little light. It is much more likely to suffer from too much light than too little. North light is traditional for an artist's studio but it is not essential. Direct sunlight is to be avoided: try to arrange for the light from a window or skylight to fall on a wall that is light in tone, so that directional light is broken up and reflected around the room. One of the most beautiful lights I have experienced was that at the Brera School in Milan: a huge barn of a building which was lit by three or four tiny windows very high up in one corner. The light was very diffuse but still had some kind of direction to it. There were shadows, but the contrast between light and dark was very gentle. A pair of strip lights at right angles to one another gives adequate light for a sculptor if there is no daylight available.

Put your subject in a good light—the light describes the form. Set yourself up comfortably to draw the profile. I suggest that you use A2 sized paper and charcoal to begin with. Charcoal is a wonderful medium—it is so flexible that it encourages flexibility of mind; it practically rubs itself out as you go along. With charcoal you will be

Fig. 1 (*above*). A box—or a handkerchief?

Fig. 1a (*above right*). We understand this to be a box seen from a particular point of view: we know that the axes **a** and **c** are horizontal in space although they are not horizontal on the page.

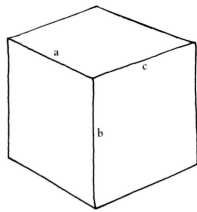

able to cover the ground quickly and then draw and redraw almost ad infinitum. You are likely to run out of critical steam long before you have exhausted the possibilities for change in this obedient medium.

Even so, start with care. Draw lines that you mean to stand the test of time, even though experience will teach you that they are unlikely to last for more than five minutes. Start by sketching the whole shape on the paper. In the initial stages of drawing or modelling, the desire to represent the subject in terms of its salient attributes—the features of eyes, nose and mouth—is likely to be so strong as to destroy the understanding of the whole. You must try consciously to direct your concentration towards the form *as a whole*. Always let your first few lines indicate the back, sides and bottom of the head, so that when you come to observe the features you start by relating them to the entire volume. From first to last train your eye to assess the subject as a whole. Hold your paper sufficiently far away so that you can see your work as a whole.

Don't think you can start with a perfect nose and just go on adding

bits and pieces until it is finished. Anyone can draw a perfect nose—the problem is to draw a nose so related to the rest of the head that the entire structure satisfies. Let the drawing develop on the page in much the same way as a photograph develops: be very delicate at first and then gradually give more definition. After ten minutes or a quarter of an hour you are likely to have come to the end of what you can see to do immediately. Put the drawing aside to be continued later. "Learn to sketch before you finish," as Michelangelo advised Giambologna.

Move round the subject so that you get a three-quarter view. This is the most difficult and the most important view and calls for some special advice. If we want to draw a box we could draw the shape at fig. 1 and say that that is a box. It is a perfectly correct drawing of a box seen straight on, but it is not very descriptive; it could easily be mistaken for a handkerchief. If we want to be certain that people are not misled, it is necessary to represent the three-dimensional aspect of the box as in fig. 1a. Here we see the top, side and front of the box. Ideally the three-quarter view of the head should show these three main planes.

From the technical point of view it does not matter whether the top or the bottom plane is chosen, but from the psychological viewpoint it may make a lot of difference whether you choose

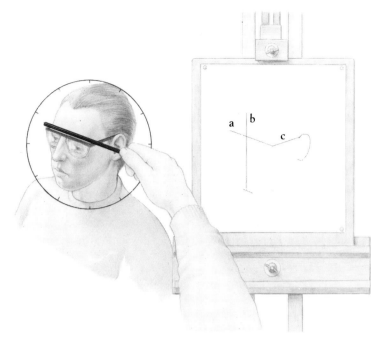

to look up or down on the head. I advise you to take a view that shows just a little of either top or bottom plane—which view you choose will depend on the salient characteristics of your model. Become aware of the viewpoint when you examine the works of the masters in future. Rembrandt, for instance, invariably chose a low viewpoint for his self-portraits, sometimes tipping his mirror by as much as 45 degrees from the vertical. In this way he maximised the three-dimensional aspect of his subject.

When you come to draw the three-quarter view of the head, be aware that by far the strongest clues about the three-dimensional nature of the subject received from a drawing come from our subconscious reading of the perspective planes shown in fig. 1a. If those do not make sense, you can build up the shading until your drawing looks like a Michelangelo, but it still won't work.

From the very first, establish the three dimensions of the head. Observe all the horizontals with special care—they are the most deceptive. When we look at the drawing of the box, for instance, the assumption is that the box

rests on a horizontal surface, and yet not one of the lines drawn is actually horizontal on the page. Watch out for this distorting effect of perspective.

It is a good idea to measure the angle between all actual horizontals and the verticals. Verticals are reliable: if they are vertical out there in space they are drawn vertical on the page. If you hold your pencil in line with the horizontal features, such as the eyes, you can measure the angle between the vertical and your pencil. A good way of doing this is to imagine the vertical as the 12–6 axis on a clock-face, and then tell the time as it would appear on a clock that is in a plane at right angles to your line of vision (called the 'picture' plane). In fig. 2, the angle of the eyes is approximately at 9.45. So sketch a line at that angle on the page to guide you when you come to place the eyes. When they are correctly placed, they will begin to establish the viewpoint that you have of the head in exactly the same way as the line a on the side of the box established the view of the box. The vertical axis of the features will establish the vertical axis as in line b. The placing of the ear is crucial

to the establishment of the axis c. Imagine your subject is wearing glasses—the front of the glasses is parallel to the a axis and the ear-piece is parallel to the c axis.

If, as you draw each feature or detail, you are aware that you are also making important statements about the nature of the head as a whole and your view of it, you need not be worried if you do not entirely understand the explanation above. Drawing is an instinctive process: make marks and respond to those marks critically. If you are able to read fig. 1a as a box you already have all the necessary technical training to become a draughtsman. Keep asking the right questions of your drawing and in time you will come up with the answer. The drawing process is simplicity itself; it is the continuous self-criticism that is difficult.

Let us look at the way a great master does it. You do not need me to tell you that Holbein succeeds in creating a clear and utterly convincing image of a particular individual. His drawings are so clear that I have been able to make sculpture from them. I therefore take him as the ideal example in draughtsmanship for the sculptor.

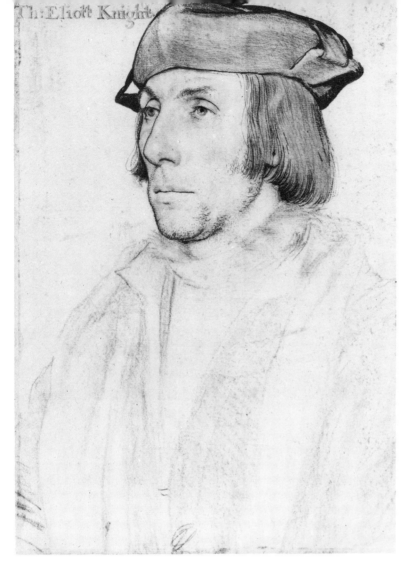

Th:Eliott Knight

Pl. 2 (*left*). Hans Holbein, *Sir Thomas Elyot*, c. 1535 (Royal Library, Windsor Castle).

Fig. 3 (*opposite*). A reconstruction of Holbein's method of drawing, based on a similar device known to have been used by Dürer. Holbein is seen here tracing the profile of his sitter on a clear sheet of glass, which acts as the picture plane. This is not as easy as it may appear. If you wish to try the method I advise the use of a felt pen to draw on the glass. Draw swiftly, and do not forget to fix your viewing point so that it does not shift about, and to close the other eye. To maximise the size of the drawing, put the greatest distance between your eye and the glass and the smallest distance between the glass and the subject. (This method is also very useful for drawing architectural subjects.)

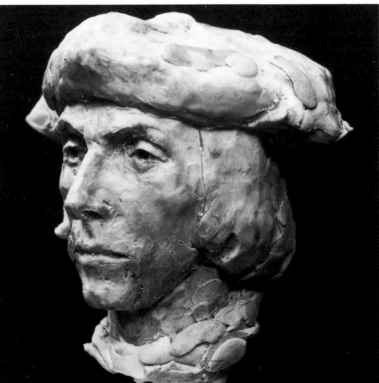

Pl. 3 (*below left*). Nigel Konstam, *Sir Thomas Elyot*, after Holbein. This work, not yet finished, is modelled in specially prepared french modelling wax (height 4 inches/10 cm).

The Drawing of Holbein

Holbein often uses hats to define the space in which he is going to deploy the structure of the head. In the case of Sir Thomas Elyot the four-square hat is like an inverted foundation stone. The differences in the areas of paper devoted to the two front surfaces of the hat (which we know to be identical in size in the actual world) tell us exactly how that hat is angled towards us. The silhouette of the third quarter takes us round to the back of the head.

One almost feels that Holbein then dropped a mason's plumb-line from the front corner of the hat to the chin, and could then carve Sir Thomas's profile with precisely calculated movements backwards and forwards about this axis. The front plane is

precisely conveyed by the corners of the mouth and by the axis of the eyes. Because of our certainty about the angle of this front plane we know exactly when the line that defines the chin leaves the front plane and moves up the far cheek. The width between the corner of the mouth and that line tells us of the heavy muscular quality of the face. With that single line of the mouth we know how the fullness in the middle of the upper lip rests on the lower; the differences in length of the lip on either side reinforce what we know already from the hat about our angle of view. From one single line, related to the rest of the structure with such cunning, we can even make an informed guess about the improvements an orthodontist might wish to make in Sir

Thomas's bite! The description of every detail is conveyed with a similar vividness and economy, not because of the 'quality' of the line but because of how convincingly each part relates to all the other parts.

To illustrate this last point, let us examine a part of the drawing that is less successful than the rest. The features are all constructed with uncanny skill in relation to the façade, but when we move round from the mouth on the front plane to the angle of the jaw on the near side we are disappointed. Holbein's sense of structure seems to have deserted him: the skirting of hair, the ear and the angle of the jaw do not relate to the façade as we would hope—there is a sudden loss of form. The quality of the lines with which these parts

are described is indistinguishable from any of the others in the drawing—a loss of concentration alone is responsible for Holbein's failing to put these lines in exactly the right place in the structure.

The result is a head whose face and top are entirely brilliant but whose side, bottom and neck disappoint. This is not an unusual feature of Holbein drawings but, as with all works of art, they should be judged by their successes, not their failings. There is enough of Sir Thomas to provide us with a record of his physical presence at least the equal of an excellent sculptural portrait of him. He appears to have been a rather cold and melancholic type, and this we read from the set of his features equated against our own experience of life.

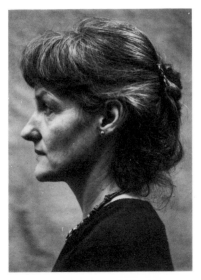

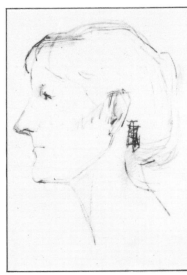

Figs. 4 and 5 (*left*). The profile is the easiest view to draw so it is a good one to start with. Notice how I have changed the shape of the head at least four times (this is particularly visible at the back). For me, the purpose of drawing is to try out many different possibilities. The drawing stops only when I cannot see how to change things for the better.

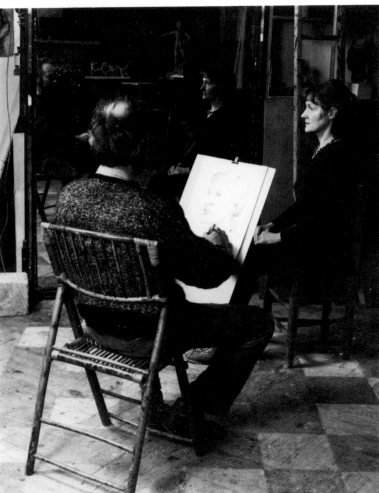

Fig. 6. Put your model in a good light and give him or her something reasonably interesting to look at—with children, this could be the television. It is not a good idea to encourage conversation at this stage—all your faculties will be needed for the job in hand.

Figs. 7 and 8 (*above*). The three-quarter view is the most difficult, and the most useful. After 20 minutes I am still undecided about the position of the ear.

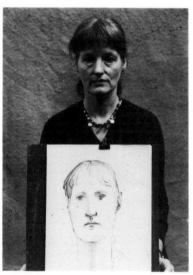

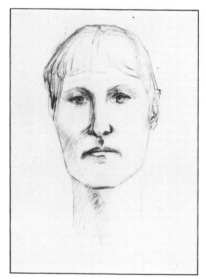

Figs. 9 and 10. Ten minutes later there is more mass to the head because the width of the brow has been defined by the eyebrows. After half an hour the way in which the brow moves under the hair has been more clearly defined and the way in which the fringe moves from the centre is more specific. The ear has taken up the position furthest from the eye, giving more breadth. I have added a fair amount of tone. The tone under the lower lip seems to define very well the point from which the chin grows out, but as a result the chin has grown too big.

Figs. 11 and 12. The front view is very tricky. The slightest shift in the view—if, for instance, the sitter drops her head through as little as 3 degrees—can throw the proportions out completely. After half an hour the tilt of the head is somewhat clearer.

Further Advice

Holbein's drawings demonstrate that he was one of the greatest portraitists ever. Yet it is a fact that he frequently used to trace his subjects on a sheet of glass to help himself on his way (see *fig. 3*). I tell you this not to make you change your mind about Holbein's greatness, but to show you that even the great are prepared to use any method that is available. You cannot cheat in art—any method is fair, so long as its aim is to assist you to *understand* your subject, and is not merely a mechanical aid. Holbein used a machine, but it is the quality of his understanding and of his decisions which raises his drawing to the pinnacle

of human achievement.

A useful trick to help you to spot the flaws in your drawing is to hold it up to a mirror. You will see the drawing as if for the first time and it may be quite a shock. It is also a good idea to give yourself a rest from time to time. Turn the drawing to the wall and return after a good interval. One of the advantages of an inanimate model is, of course, that the model will still be there after a week or more if necessary. A fresh eye will work wonders.

We all know that the nose is in the middle of the face: regardless of how much experience of drawing we have, we will try to put it there in the middle of the shape on

the page—even in a three-quarter view where it appears well over to one side of the shape we see. Knowledge tends to distort vision. In spite of my warning you are very likely to do the same. Take care!

Most heads are in any case asymmetrical, and the front face is the view for looking at the asymmetries. It is also useful for observing the pose of the head. The way in which we hold our heads is very closely connected with what is going on inside them. Observe well: the pose of the head can make or mar a portrait. In other respects, however, the front face is not a very satisfactory view. It is like the box in fig. 1: because you

only see one plane it is very difficult to make it read three-dimensionally.

While you have your model present you can move from one drawing to another as many times as you need to, thus getting the benefit of a relatively fresh eye with every move.

MEASURING

If you are aiming to make a life-size sculpture it is necessary to take some measurements at this stage (even if you are not it is nonetheless sensible to have them in reserve).

Taking measurements with callipers is a potentially hazardous business if you don't take the right precautions. Callipers should be a little stiff at the joint, so under no circumstances should you try to adjust the measurement while holding them up against your subject. Remove them to adjust them, and then try the measurement again. Better still, use your fingers as I do to extend the points, so making a soft pad to touch your sitter (fig. 13).

Measuring in three dimensions is a tricky business—you only have to shift your callipers a fraction to get an entirely different answer. Be as careful as you possibly can and then regard the result as a guide rather than as gospel. Measure large forms only, such as the distance between the point of the chin and the crown of the head, or between the cheek bones—it is no use thinking that you can measure the length of the nose, for instance. For small forms your eye, however untrained, will prove much more accurate than callipers. I suggest that you use measurements only when you get into difficulties. You are going to need a well-trained eye, so train yourself to see different proportions by comparing them with each other. If you measure, there is a tendency to regard the measured points as sacrosanct. Like hard points of

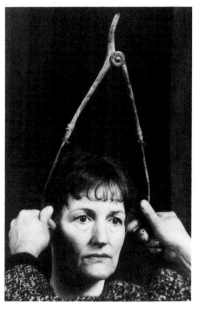

Fig. 13. To make sure that you do not stab your model with the callipers while measuring, always remove them before adjusting them. I extend them with the tips of my fingers so that the metal points never come into contact with the skin.

Fig. 14 (below). The armature showing the head-peg (1), aluminium frame (2), butterfly (3) and jubilee clip (4).

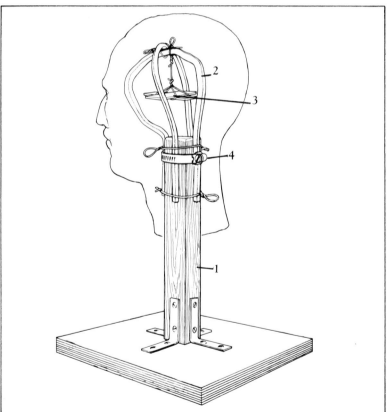

rock in an otherwise moving mass of clay, they somehow fail to become an integrated part of the whole.

When you have your three drawings and you are reasonably satisfied with them (you will always be able to go on with them), mark off the measurements on the side of them and end the session. There is no need to worry if your drawings are not going to rouse the jealousy of Michelangelo—they are working drawings and your only concern is that *you* can work from them. The

experience will teach you in time all you need to know about the art of drawing.

MODELLING

You will need:
An adjustable modelling stand.
A head peg.
Armature aluminium wire.
A hammer.
A pair of pliers.
A variety of modelling tools.
Callipers.
Approx. 25 lbs (12 kg) of clay.
A seat to hold your model at a comfortable height for you to work, about 32 inches (80 cm) high.

The Armature
The purpose of the armature is to support the weight of the clay. It is possible to do without one and make a terra cotta head as described in chapter 9, but I would not advise this here as it would add to your problems. A head armature is easily made. Essentially it is no more than a vertical about 1 foot (30 cm) high, very firmly fixed to a base about 10 inches (25 cm) square. It can be made of metal or wood. A metal one should be at least $\frac{1}{2}$-inch (13-mm) steel, preferably square in section and very well welded. A wooden one should be at least $1\frac{1}{2}$ inches (4 cm) square in section and fixed to the base with four brackets. Bear in mind that the head is likely to weigh 20 lbs (9 kg) and will need to be well supported. You can buy a head armature as an alternative to making your own.

When making the top of the armature, remember that the front of the head is well in front of the neck, so it is necessary to build supports for clay a good 4 inches (10 cm) out in front of the vertical—in fig. 15 the aluminium closest to my right hand will support the front of the head. The supports for the clay should be firm, but not so firm that they cannot be hammered in if they should obtrude in the wrong place.

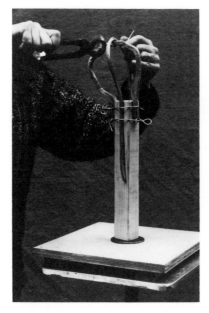

Fig. 15 (*above left*). Further flexible support is added to the vertical of the ready-made armature to give better support to the clay. Make sure that you build well forward of the vertical so that the profile can be well in front of the wooden support. It is a common mistake to start building the features too far back with the result that the armature protrudes in the region of the lower throat (see *fig. 14*).

Fig. 16 (*above right*). Put firm clay on the armature to begin with. If you have the opportunity, let it dry out a bit to gain strength.

Lead used to be used for this; aluminium of $\frac{3}{8}$-inch (9-mm) square section is even better; a mixture of $\frac{1}{4}$-inch (6-mm) mild steel and chicken wire will serve very well. To fix all this to the vertical post you can use plumber's jubilee clips, nails, screws, wire or fibreglass. If you use wire, bend it as shown in fig. 15—you stand less chance of breaking it when you tighten it, because you can take up the slack at both ends.

Putting on the Clay
To start with, it is sensible to use clay as hard as can reasonably be squeezed onto the armature. Ideally, this clay can be left overnight to become almost leatherhard: it will then make a perfect support for the softer clay that you will use for modelling. Tastes vary as to the best texture of clay to use; indeed you may find you want different textures at different times. To start with, use fairly firm clay for strength (fig. 16). If you

put on too much soft clay at once, its weight could pull it off the armature.

I start by making a profile in clay, making sure that the clay is very firmly stuck onto the armature. This is a direct copy of the drawn profile and should present no particular difficulty. Be aware as you do it that you are establishing at this early stage the scale of the final sculpture. Look out for the movement of the head on the neck; do not be tempted to follow too closely the movement of the vertical armature. Make sure that you go far enough forward with the brow or you will run into difficulties later when you want to take the neck back further than it can go. Take your time, because this is the foundation on which you are going to build. If you can afford the time, it is a good idea to let this stage stand overnight so that you can review the work with a fresh eye in the morning.

When you are content that

your foundations are reasonably secure you can proceed to the next stage, which is to draw in the sub-profiles. Sketch the position of the point of the jaw, the cheek bone, the ear and the eyeball in their right places in relation to the main profile. Then build out at right angles to the main profile so as to establish these reference points in their correct spatial position (fig. 17). Constantly move your sculpture round as you start to explore the third dimension, to view the space relationships that you are creating from every possible angle. Until you are used to it, working in three dimensions can be confusing. Again at this stage it is important to stick the clay firmly together. As you see in fig. 17 I have built whole planes at right angles to the profile to support the reference points. I lock these planes together for strength, as one might build a card house or a model aeroplane. After establishing a number of these points you will have created a framework for the head and it should begin to look a bit like the subject.

Do not hurry to complete the surface by filling in between these points. It is a good policy to postpone the moment when the head becomes a complete three-dimensional object: one's critical faculties work better on the abstract framework. Once you have a complete-looking object in front of you it is more difficult to find the necessary courage to change it, and this factor is progressive. The more finished the appearance, the more difficult it is to improve the work. Keep your work clear but sketchy in the sense that it invites further work on itself. The more you can prolong the sketch stage, the greater the likelihood of the final work proving worthwhile.

There is a strong tendency for the beginner to smooth and polish in the hope that polish will make good deficiencies in vision. If you can resist this temptation and maintain a rigorous critical attitude to your own work, you are

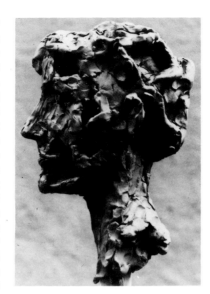

Fig. 17. First the main profile is sketched out in clay, then the sub-profiles are related to it. In this way the scale of the final work is established at a very early stage.

Fig. 18. This is the head as made from the working drawings, before the first sitting with the model.

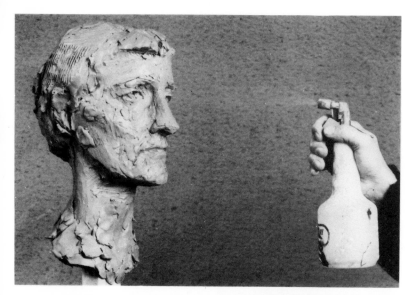

Fig. 19. I spray the head with water to keep it soft for working—in hot weather, this may have to be done as often as every 15 minutes. Working from drawings allows you as much time as you want for the initial build-up; in this case, the first stage was done over the course of a week.

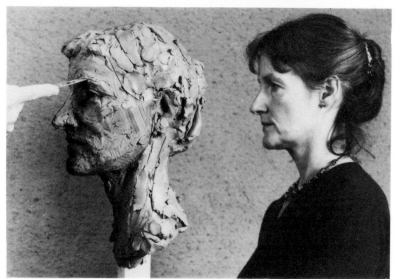

Fig. 20. When the model returns for the first sculpture sitting, use the advantage of a fresh eye to make sweeping changes wherever necessary. It is a good idea to spend the first 5 minutes just observing, until you are quite sure of what has to be done.

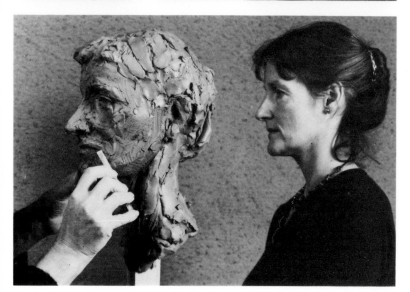

Fig. 21. The use of old hack-saw blades produces clearly defined planes, without giving any false idea that the result is final. The rough texture helps to reinforce the fact that all is still under review.

more than half-way to becoming an artist. The last drawings of Michelangelo maintain this sketch-like quality to the end, though there is every reason to believe that they are the result of much deliberation. Follow his example and work in such a way as to trick your psyche into believing that it could do yet better than the work so far achieved.

As you fill out the form, try always to see the detail in relation to the whole. If you cast your mind back to the analysis of Hadrian (chapter 2) you will remember how the head was chopped out of the simplified form, and how the final surface echoes both the simplified form of the head and the block from which it was carved. These references help to unify the head and give it a firm, clear, three-dimensional pattern.

Figs. 22 and 23 (*above and right*). A low viewpoint helps you to assess the asymmetries of the head and to understand the disposition of the features around the section of the head. It is a common fault among beginners to place all the features on one front plane, but note how the corners of the mouth and the eyes go round from the front to the side planes. Note also that the left side of this model's head is somewhat larger than the right and that the nose is slightly askew. Such asymmetries are to be expected and can be useful in the expression of different aspects of the character of your sitter.

The modeller starts from nothing and has to build up this sense of unity, clarity and completeness. It is very necessary to keep, consciously, a just balance between the parts. The eye, for example, is a very interesting and expressive feature but if you go too strongly for the excitement of its tone, colour and modelling you will inevitably detract from the bony structure that surrounds it. From the sculptural viewpoint the eye must first work as an eyeball in an eye socket. When you have established that prime physical fact, you can go on to express whatever psychological truth you see in your subject. Try to see the head in terms of clear-cut points that fit together so as to support one another. Do not allow the features so to dominate that they undermine a coherent sense of the whole head.

Fig. 24 (*above*). In the final stages it may be necessary to fiddle around with very minute changes.

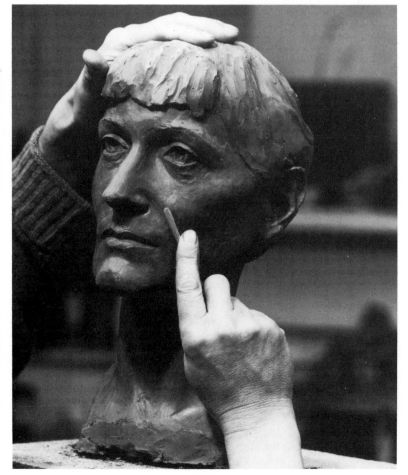

Fig. 25. If you are going to make a terra cotta (see chapter 9), you can bring about very tiny adjustments on leather-hard clay in the process of burnishing with a wooden tool (height $14\frac{1}{2}$ inches/ 37 cm).

9. MAKING A TERRA COTTA

Terra cotta means cooked earth. The colour known as terra cotta is the colour of a particular kind of fired clay containing iron oxide. In fact, however, fired clay can produce a wide range of colours from almost black through various browns and yellows to near-white, depending on the clay you start out with. You can modify the colour by adding different kinds of chemicals.

Clays fire at temperatures from 650°C to 1300°C. Ordinary domestic ovens will not go high enough so you will need a kiln. It is often possible to have your work fired in the kiln of a local potter, school or college of education. Some kilns are so simple that you can easily make one in a backyard from bricks and earth. For fuel, you can use wood, sawdust, coal, coke, charcoal, gas, oil or electricity.

The difference between modelling for terra cotta and modelling for casting (chapter 10) is partly practical and partly aesthetic. On the practical side the clay has to be thoroughly dried and then fired. You cannot do either of these things with an armature inside, so you are obliged either to remove an interior armature or to model without one (I demonstrate both methods in this chapter). The clay must also be free from any impurities, which would produce gases when it is fired—this could be dangerous and would certainly spoil your work.

It has to be borne in mind that clay shrinks when fired. One must not only model the sculpture about one-tenth larger than the intended size of the finished object but, on the aesthetic side, it is also advisable to model it somewhat

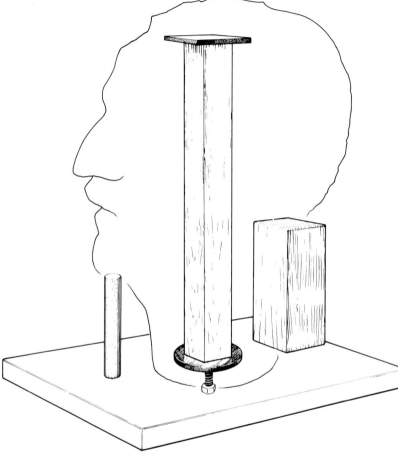

Fig. 1. In the early stages, it is necessary to support the weight of the clay with extra props.

broader—in the sense of bigger and simpler—than one might for casting.

Some clays have a nasty habit of sagging when they are fired. This is particularly true of clays that fire at high temperatures. It is normal practice to mix grog (crushed fired pottery) with the clay before you model something that you intend to fire. It reduces shrinking and sagging, and makes the body of the clay more porous, therefore allowing moisture and gases to escape in the course of firing. If the quality of the grog is good, it also functions as an aggregate which will strengthen the final product.

156

MODELLING A HEAD WITHOUT AN ARMATURE

For the demonstration, I have chosen to use a clay specially prepared for firing called marl. It has a very high grog content. This makes it rough and lacking in flexibility; on the other hand it has great compressive strength, even when it is wet. I have modelled very simple figures on a large scale with this material without any armature at all.

For your first try I advise the use of a simple support that can be removed without disturbing the sculpture. An absolutely straight and smooth vertical of steel or wood can be used in a figure and then withdrawn when the clay is leather-hard. For my head of Klemperer I have used a vertical of wood with a small piece of hardboard placed, not nailed, on top to spread the weight. In the initial stages I have also used an exterior prop behind the head to take the weight of the back; a prop under the chin can also help on occasion. The profiles are built up in exactly the same way as when making the portrait from life (chapter 8), but this time I use the base of the stand and the hardboard at the top to take the weight. The other props are put in as occasion demands.

I build down an extra $1\frac{1}{2}$ inches (4 cm) on the length of the neck; the extra will be removed at the same time as the supports when the clay is leather-hard (fig. 4). It is always better to err on the generous side—adding bits on is much more difficult than cutting them off. It is a general rule, if you are making a fragment like a bust or torso, always to make more of the form than you think you are going to need. For instance, if you intend to make a torso, model the thighs right down to the knee even if you think you only want a third as much. It seems that this is the only way to ensure that you do not unconsciously diminish the scale of the truncated part.

When making a terra cotta, you should aim to make the skin of clay about $\frac{1}{2}$ inch (13 mm) thick for strength; it can afford to be thinner in a small piece. It is unwise to make it more than 1 inch (2.5 cm) thick anywhere because this may lead to difficulties in firing. Trapped air or dampness can cause the piece to explode in the kiln. If, for strength, the clay has to be thicker, make sure that it is well grogged, dry it carefully and fire it very slowly.

For the modelling (also done in the same way as in the previous demonstration) I used soft ungrogged clay over the coarser clay. The grog produces a very rough surface, in which it is not possible to model features with any precision. When you add a layer of softer clay in this way, there is a risk that it will craze during drying or firing, and this indeed did happen. The cracks can be repaired with Polyfilla or plaster.

When the head is finished, allow it to dry slowly. When it is leather-hard, remove the supports and any structures you can get at through the neck. It is desirable to hollow a slit down the nose on the inside so that the clay is not too thick there. Sometimes it is also necessary to reduce the thickness of the clay from the inside before firing by hollowing out the head (see the section on modelling with an armature, pp. 159–61).

Clays with no grog in them have to be dried and fired very slowly. Never use clay with plaster or other impurities in it. Clays vary

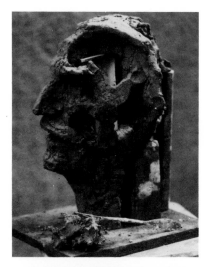

Fig. 2. The first stage of the build-up in sculpting marl. The head is supported by a simple armature and props that can be progressively withdrawn as the sculpture becomes self-supporting.

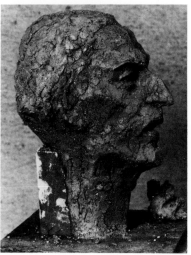

Fig. 3. Still at an early stage in the modelling, the vertical support has been removed from the back; a brick under the back of the skull supports the weight of the soft clay. The interior support is still in place.

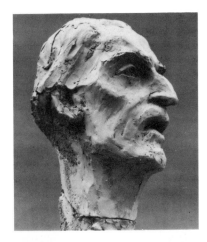

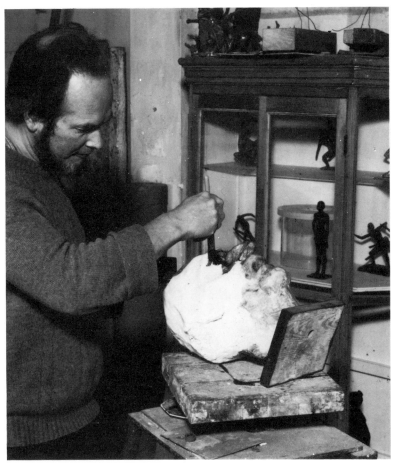

Fig. 4 (*top*). When the coarse marl has been worked over with a finer clay, trim the neck to the right length and clear out any clay from the inside that is no longer necessary.

Fig. 5 (*above*). The head after firing. If the fired clay is not pleasing in colour or texture it can be sandpapered or stained. Cracks or other imperfections can be mended with plaster or Polyfilla.

Fig. 6 (*above right*). Staining with a mixture of wax, turps and colour that is in oil or powder form. Applying the stain with a brush, allow the colour (Van Dyck Brown in this case) to run down into the deepest crevices and wipe it off the highlights. When the wax is quite dry you can polish it or add further coats of a lighter colour.

enormously in the way they behave during firing and in the temperatures they require. When you buy clay from a supplier the recommended firing temperature will be stated in the catalogue. I prefer fairly soft fired clay—it shrinks less and has the advantage that you can work over the fired sculpture with sandpaper or a file.

If you are unhappy with the colour of the final result you can always stain it or paint it (*fig. 6*). There is nothing to stop you applying pottery glazes if you wish, and then refiring to the correct temperature. Alternatively, a month in a good compost heap will put two thousand years on the apparent age of a terra cotta.

THE COILING METHOD

Another method of building up a terra cotta head is by coiling. Roll out long sausages of clay about $\frac{5}{8}$ inch (16 mm) in diameter. Starting at the base of the neck, coil them round in a spiral as you would a coil pot. Build the cylinder up the size and shape of the neck, but continue it right up to the height of the top of the head; it acts as the central column of support.

This type of terra cotta modelling is useful if you want to make a decorative head, but I do not advise it as a method of making a portrait from life unless you are very experienced. The technique requires the use of rather hard clay as a support, and there is great difficulty in making a structure out of clay strong enough to hold up a head but flexible enough to push around and modify as required. The method could be used if you are making a free copy of an earlier work, when you know exactly what you are doing from the start. But I would not use it to make a first-time portrait.

MAKING A TERRA COTTA HEAD USING AN ARMATURE

A more practical way of making a terra cotta head as a portrait is to use an armature as described in chapter 8 and then remove it before the clay is fired.

This is done when the clay is less than leather-hard but rather firmer than is desirable for modelling, by cutting off a small cap-sized shape in the hair (where it can easily be repaired afterwards). You then hollow out the inside of the cap and replace it on the head to see that it still fits (fig. 7).

If it has become distorted, the clay is too soft to continue. Push it back into shape and, very carefully, remove it to a safe place on a clean board and prop it up with pieces of dryish clay so that it does not sag out of shape. Allow the whole to dry a bit until there is no risk of the other parts distorting when they are worked on in a similar way. Then hollow out the head as far as you can from the hole you have made in the top.

When you cannot get any further, cut down from the hole behind the ears to the base of the neck and remove the entire back of the head and neck. Hollow this out in the same way as the cap then match it up again with the front of the head to ensure that it has not distorted.

Before hollowing out the front of the head and removing the armature (fig. 8), it is a wise precaution to support the front with supports under the chin which act as a cradle. The front section is by far the largest and most precious part. By placing a piece of wood close under the chin and building up props of clay on nails or clay and bricks, you will support the skin and keep it in shape when you remove the armature, ensuring maximum safety.

When all the parts are evenly hollowed to the thickness of $\frac{1}{2}$ to 1 inch (1.3 to 2.5 cm), dampen the edges to be rejoined by covering them with strips of wet rag for an hour—more if necessary. The edges should be soft enough to model without wetting the main

Fig. 8. When you can do no more through the cap opening, support the front of the head (the mask) with a cradle made of wood, bricks and clay and remove the back of the head. Continue to hollow out the clay to make an even skin all round and finally remove the armature. While you are working, support the cap with clay props and keep the edges moist with wet rags.

section, and you may have to wet the rags several times. When you have done this, offer up the back to the front, keeping the front supported under the chin. When the pieces are correctly positioned, support the back and then join the two wet edges by pinching them together with your fingers. Some people prefer to stick the pieces together with very soft clay, but this tends to get messy and does not make a very strong job. In difficult places I suggest you use a combination of the two methods.

When sticking the cap back in position it is often difficult to reach inside the head. You can make a tool to help you, such as the handle of a hammer. When the head is reassembled you will almost certainly have to retouch it to some extent, but if you have been careful during the hollowing out this should not present too much of a problem.

Fig. 7. When the clay is firm, cut off a cap-sized piece from the top of the head and hollow out the interior. You should aim at achieving a skin of $\frac{1}{2}$ to 1 inch (1.3 to 2.5 cm) all round, strengthening with clay on the inside any areas which are thinner than this. Do as much as you can through the cap opening.

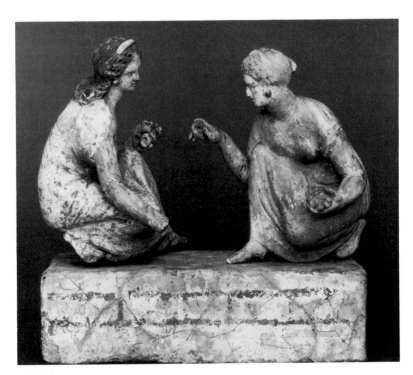

Pl. 1. *Knuckle-Bone Players from Tanagra*, Greek, c. 400 B.C. (British Museum). Tanagra figures were usually assembled individually from parts (such as arms, legs, heads, etc.) taken from moulds.

Pl. 2. Giambologna, *A River God*, Florentine, 16th century (Victoria & Albert Museum). The freshness of the surface handling shows this to be an original modelled terra cotta.

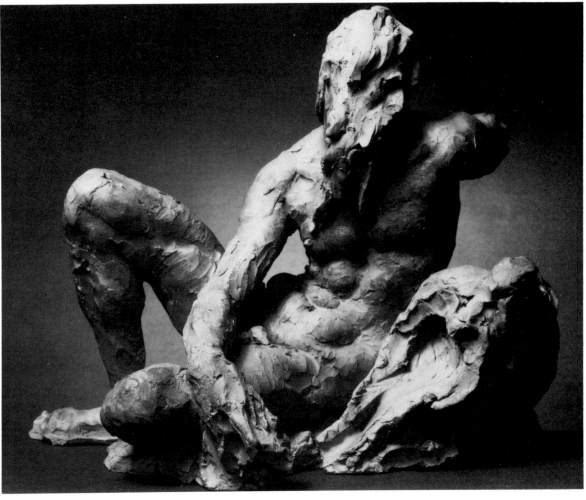

You can apply precisely these same principles to making a figure in terra cotta. One complication is that you must remember not to trap pockets of air—in the chest, for instance—without means of escape. If the air is unable to escape as it expands under heat, your sculpture will blow up in the kiln.

TERRA COTTA MOULDING

Terra cotta moulding is a cheap and simple means of reproduction much used in the ancient world and in potteries today. It can be done in two ways: slip moulding and press moulding.

Slip moulding is a process which can become so elaborate that I will only outline the principles here. Essentially it is the same as wax moulding (see chapter 10). Slip is the name given to clay and water mixed together to a thick custard-like consistency which can be poured into a mould. But complications arise because when it is leather-hard slip is very much more fragile and inflexible than wax or, for that matter, modelled clay that has hardened. If you are making a simple bowl shape it is fairly straightforward. But if your sculpture is complex or fragile it is necessary to make an elaborate mould that puts the least possible strain on the piece when it is being released. This process—called piece moulding—is a job for a skilled craftsman.

Press moulding is much simpler. One can often press a sculpture from a one- or two-piece mould. Because pressed clay is reasonably strong and flexible, the shape of a mask, for instance, can be pressed from a two-piece mould. A whole head can be pressed from the type of plaster mould that is used for wax, provided that the forms are not too complicated.

The method is straightforward. Place the mould in a cradle that is designed to hold the parts

firmly together—the plaster pieces should be reasonably dry. Convenience dictates whether one presses the clay into the individual plaster pieces before or after they are put together in the cradle. When the pieces are together, press soft clay into the seams to make the sculpture firm.

The plaster absorbs the moisture from the surface of the clay with which it is in contact, making the clay firmer and causing it to shrink. It will then separate from the plaster with ease. This drying process takes up to ten minutes. At the right moment, the plaster will lift away without any prising—before that moment the clay will be stuck fast; after it, the clay may become dry and brittle. The chances are that you will need to do a little final retouching when you have removed the mould.

You will find many examples in sculpture of minor variations on figures that have all originated from the same mould. Most of the terra cotta figures from Tanagra are moulded, sometimes in several pieces, and then assembled according to the whim of the artist. It saves a lot of time. In recent times sculptors have tended to make editions of identical pieces. The Greeks and Etruscans made many different pieces from the same moulds. So did Giambologna and Rodin.

Terra cotta is the cheapest and most convenient way of keeping a modelled sculpture. It is more permanent than plaster; it is also more agreeable to look at. A damaged plaster is painful to behold; a damaged terra cotta can be very acceptable. Like plaster, it eventually deteriorates if it is kept out of doors in a harsh climate without protection from damp. You can protect it with wax, paint or oil. Many of the outdoor sculptures at Versailles are made of plaster that has been boiled in linseed oil: this is also a very good method of preserving terra cotta from the elements.

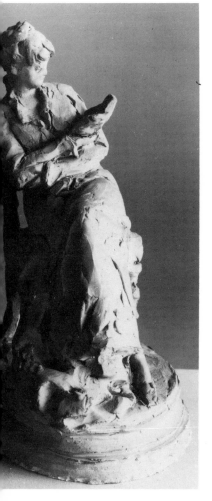

Pl. 3. Jules Legros, *Woman Reading*, 1876–79 (Victoria & Albert Museum). Again the sharp, fresh surface shows this to be modelled, not moulded.

161

10. CASTING

Casting is a method of changing a sculpture from one material to another, usually to make it more permanent or to make copies. It involves the making of an intermediate negative mould, usually of plaster but sometimes of a flexible substance such as rubber. The process is not difficult but it is best to gain experience under supervision if possible.

A SIMPLE RE-USABLE PLASTER MOULD

My first demonstration is of the simplest possible mould—the manikin used in the composition of *The Three Graces* in chapter 6. The manikin itself is specially designed to make it easy to get out of the mould: its forms are very simple, its surface smooth and it is made from wax which is firm and flexible (Plasticine would be good for this purpose also). So that it is convenient to mould, the feet are bent down and the head turned sideways: the figure then presents the appearance of a gingerbread man, with no inconvenient protrusions or undercuts. The mould is made in two halves.

The manikin is laid on its back in a bed of clay and a clay wall built up round the edge of the bed. The wall should be sufficiently well fixed to the bed so that it can withstand the pressure of liquid plaster being poured into it without giving way. Then with a tool cut a cone-shaped hole to make a 'key' in the bed which will hold the two parts of the mould in precise relationship when it is in plaster. A cone whose base is twice its height makes a good tool to cut the key.

Plaster, mixed to a custard-like consistency, is poured into the clay mould (fig. 3). It will begin to set within ten minutes and, when it is hard enough, the clay wall is removed (fig. 4). When you turn the mould over and remove the clay bed, the other side of the manikin will be exposed, backed now by plaster. A wash of clay over both the figure and the plaster creates a separation between the two pieces of plaster (fig. 7). You then repeat the process on the back.

Fig. 1. Lay the manikin in a bed of clay, then build up the surface of the bed so that it comes cleanly halfway up the manikin's depth, dividing it into two halves, front and back. If the original is wax, as here, give it a covering of soft clay so that the two parts of the mould will separate easily. Build up a wall of clay about $\frac{1}{2}$ inch (13 mm) high around the edge of the bed and about $\frac{1}{2}$ inch (13 mm) from the extremities of the manikin. Make a funnel in the clay from the wall to the top of the head.

Fig. 2. Put into a bowl the volume of water which you judge would fill the space around the manikin right up to the top of the clay wall. Sift in dry plaster through your fingers until small islands appear above the surface. Shake the bowl gently to get the plaster to submerge and allow it to stand for about a minute so that any air that may have been trapped in the liquid can get out. Then pass the mixture through your fingers, feeling for any lumps or pockets of dry plaster, which should be removed or dispersed. In a few minutes you will feel the plaster begin to thicken.

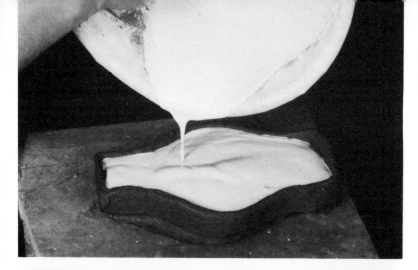

Fig. 3. When the plaster has thickened and is like thick, pourable custard, pour it into the clay mould.

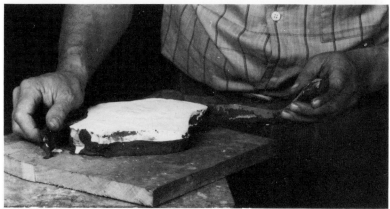

Fig. 4. When the plaster is set and begins to steam, remove the clay wall.

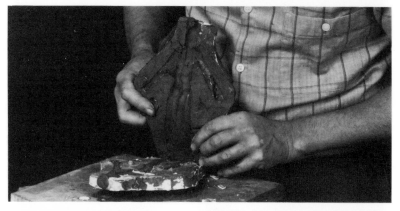

Fig. 5. Carefully remove the clay bed from the plaster.

Fig. 6 (*below left*). Cut away any plaster that has got behind the clay bed.

Fig. 7 (*below*). Paint a wash of clay on the surface of the plaster (and on the exposed surface of the manikin if you wish). Then build up the clay wall in the same way as before. Fill it with plaster and remove the clay when the plaster has set. You now have two separable halves of the plaster mould which may be fitted together.

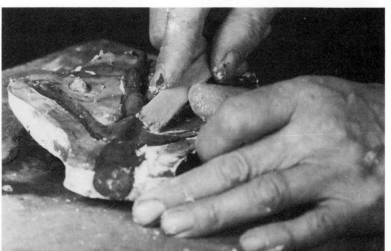

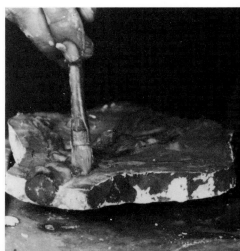

When this second piece has set, remove the clay wall and separate the two halves of the mould by inserting a knife or a chisel in the seam—they should separate with ease. Remove the manikin from the mould and clean the mould by soaking it in water and then brushing it with a stiffish paint brush. When this is done, tie the pieces together so that they do not distort: fresh plaster is inclined to warp and it is always wise to keep a mould of any age tied together as a whole. This very simple mould should serve to produce a hundred figures if required to do so.

To melt the wax, choose a container that is solidly made; wax shrinks as it cools and this will put a strain on the sides. The container shown in fig. 11 is ideal because it is wide and therefore less likely to get upset; it can also be used for catching spillage if you pour your moulds over it. It has two stout handles—one long in case you have to carry it when it is on fire. Your container should also have a lid or at least a fitted sheet of metal that can be put over it to quench fire and you should always have a fire extinguisher to hand in a workshop where wax is used.

There are two potential fire hazards. When you start heating a container full of solid wax, it is most important to heat the sides first to allow the expanding molten wax to escape through to the surface. If this does not happen, you will have a build-up of pressure at the bottom of the pot that will be explosive if not attended to. At worst your container could burst, spraying the studio with hot wax that could catch fire; at best a spout of wax will hit the ceiling. Second, if a pot of wax is left unattended on too high a flame it will heat up to the point when it is giving off inflammable gases and you get the equivalent of a chip-pan fire. Neither of these misfortunes is likely if you take proper precau-

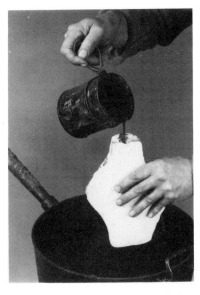

Fig. 8. To ensure the least wear on the mould, soak it well in warm water before use. Wax will not stick to wet plaster and the warmth will ensure that the wax has the best opportunity to take the shape of the mould before it sets or 'freezes'. You should soak the mould thoroughly but sponge off any surplus moisture on the inner surfaces before you pour in the hot wax.

Fig. 9 (above). After a few minutes, with the wax still warm, open the mould. The manikin will lift out easily and will be flexible enough to be moved about and posed.

Fig. 10. Trim the seams neatly with a sharp blade.

tions, but be prepared—you could get called away at the crucial moment. It is always best to warm wax on a low flame which, if forgotten, will cause no hazard.

When you have got the wax molten, remember that it can be hot enough to give a bad burn. It is sensible to wet your hands thoroughly before handling it, and have a bowl of water handy in case of trouble. Hot wax will not stick to wet skin, and you can at least cool the wax with water if it does get somewhere awkward, such as in your shoes.

The correct temperature at which to pour wax varies according to circumstance. If you have a fairly large finished piece to be cast for bronze, it should be hot but not smoking hot. For a small piece such as this that you intend to work on, it can afford to be just warm—a few degrees above melting point. The wax shown in fig. 11 is the coolest that can be poured— it is just beginning to form a skin, which is too cool for this job. The surface would be very rough and unlike that of the original piece.

Do not try to pour from too large a container—it is unwieldy and therefore dangerous. I use an old paint tin with a hole pierced in the side just below the top rim. This kind of 'ladle' ensures that you get a thin controlled stream of wax when you pour. The wire handle allows you to hang the ladle up on a nail after use—it should not be put down on the bench when it is covered in wax, as it will pick up dust and other rubbish that will inevitably find its way back into the wax pot. It is important to keep wax clean, and this is particularly so when you are making a wax for bronze. My ladle keeps back floating debris, but to clean wax properly you should pass it through a sieve. Never decant the last dregs—it is amazing how many tools get lost in the bottom of a wax pot!

For a small mould like this, it is enough simply to hold the two parts together with your hands when you are pouring. With larger, more complicated moulds it may be necessary to tie them or plaster them together. Immediately you have poured the wax, you can immerse the mould in cold water for a few seconds, holding it upright. Then put it down to cool more slowly for a minute or two. After that it can be opened and the figure withdrawn (fig. 9). While it cools you can trim the seams (fig. 10) and when you judge the wax on the inside to be firm enough, you can pose the figure.

It is unwise to leave wax inside the mould until it is completely cooled: it will be harder to get out and therefore more likely to damage the mould or itself in the process. If you do allow the wax to stay in the mould inadvertently, soak the mould in warm water for ten minutes before trying to open it: wax that is left inside a mould long enough for the mould to dry will start to adhere to the surface.

Fig. 11. This wax is just on the point of 'freezing', as you can see from the pattern on its surface. To pour a small mould, the wax should be a few degrees hotter, but this is the ideal temperature for the second, back-up coat when you are making a large mould.

Fig. 12. Cold shock marks like these are the result of pouring wax that is too cool.

MAKING A 'WASTE' MOULD

These same principles are applied in different ways according to the size and complexity of the piece, and its materials before and after casting. The simple mould that I have just shown you is re-usable. For a more complex original sculpture, to make a re-usable mould is time-consuming and expensive. The simple thing to do is to make a 'waste' mould—that is, one that can only be used once.

The figure is again divided into pieces but this time you do not have to divide each form in half because a waste mould will be removed from the final figure by being broken away. It is only necessary to divide it sufficiently so that you can: 1) remove the clay and the armature from inside; 2) clean the surface completely; 3) apply a separator if this is necessary, and 4) fill the mould with the new material. For my demonstration, however, I have chosen to divide each form because I am making a mould which is a compromise between a waste mould and a re-usable mould.

It is not possible to lay complex sculptures down in a bed of clay as I did for the manikin, so the mould is divided in a different way—either by a clay wall built onto the sculpture as it stands or with shims. I use brass shims where I wish to divide the mould (*fig. 13*)—I have cut them to a convenient size with a pair of scissors. For a figure of this size, I want the shims to stand out about $\frac{1}{2}$ inch (13 mm) from the surface. This means that the mould will be $\frac{1}{2}$ inch (13 mm) thick round the edges. For a bigger figure I would want the mould to be thicker, depending on the size of the pieces that need to be handled. For a life-size figure, I would make the shims stand out nearly 1 inch (2.5 cm). When I have completed the mould I do not expect it to be an equal $\frac{1}{2}$ inch (13 mm) thick all over; it will be strong enough if it

Fig. 13. Putting brass shims into the clay figure, *Regine*, in preparation for plaster moulding.

Fig. 14 (*below*). Throwing on the first coat of plaster. Pick the plaster up by lowering your hand palm down onto the surface and closing your fingers. Then take your filled fist, wrist uppermost and fingers down, so that the back of your hand is about 8 inches (20 cm) from the figure. Flick your wrist and at the same time open your fingers with a flicking motion. The plaster should fly gently to its destination, but it takes a little practice.

is that thick at the seams and $\frac{1}{4}$ inch (6 mm) in the thinnest places.

With this particular figure, I must make special provision for getting the steel of the armature away from the mould without damaging it. I am therefore dividing the mould across the figure's hips along the line of the diameter of the strut so that the legs will pull off downwards and the top half will pull off upwards. When the shims are in place you should review them to check that all the pieces are likely to come off as you want them to.

Your plaster should be the same consistency as before, but of course you will need more of it. When it begins to thicken slightly (after about 1 minute), you can begin to throw the first coat onto the lower part of the figure (fig. 14). Build the mould from the bottom upwards and don't put on more than about $\frac{1}{8}$ inch (3 mm) of plaster for the first coat. If you have used shims you can do front and back at the same time; if you have built a clay wall out from the figure, you need to do the two halves separately.

While the first coat is setting you must clean off the edges of the shims so that you can always see the seams (fig. 15). When the first coat is set, you can mix rather more plaster for the second coat. Apply this when the plaster is somewhat thicker than before and therefore more manageable. Starting with the seams, build up methodically so that you are aware of the thickness in all places. Go on adding more coats as necessary until you are satisfied that there is $\frac{1}{2}$ inch (13 mm) at the seams and a minimum of $\frac{1}{4}$ inch (6 mm) all over. Remember to clean off the shims after each coat.

When the mould is complete and set (fig. 16) you should wet the clay inside by totally immersing it in water. If that is impracticable, pour water liberally over it. It will then expand and the seams will begin to open. Ease off the pieces as gently as you can, using a knife

Fig. 15. Between each coat of plaster the edge of the shims must be cleaned off. Build up the thickness of the mould with three or more coats of plaster if necessary. When the plaster is quite set, wet the mould thoroughly then prise each section off carefully with a knife or a chisel along the shims.

Fig. 16. The completed plaster mould is carefully cleaned, reassembled and stuck together with plaster. Check that it does not leak by filling it with warm water. This will also warm the mould prior to filling it with hot wax.

or a chisel if necessary. Remove the clay and the armature and then thoroughly wash out the mould.

It then has to be re-assembled. I have used plaster to stick the mould together; for a size larger I would use scrim as well for strength. But do not use scrim unless it is necessary, as it makes the eventual chopping away of the mould more difficult. Test the mould for strength and leaks by filling it with warm water. Allow it time to soak, then pour the water out and give the surface water five minutes to be absorbed into the plaster.

Fill the mould with hottish wax and immediately pour it out again. Have the wax for your second, back-up coat ready, just above melting point, as shown in fig. 11.

It is best to have a second wax pot for this. The back-up coat can be diluted with some paraffin or earth wax to save money. You can sometimes get a mixture of waxes from the ceramic shell caster's that is also cheap and, I think, better. Pour the back-up coat as soon after the surface coat as you can—this will ensure the maximum adhesion between the two coats. Even if you use a back-up coat of the same wax as the first, the coats are prone to separate as you work, particularly if there is a long gap between applying them.

When making a wax that you intend to cast as a hollow bronze, it is important to get the skin of wax of an even thickness everywhere of about $\frac{1}{8}$ inch (3 mm)—though different founders may

use anything from $\frac{1}{16}$ inch (1.5 mm) up to a $\frac{1}{4}$ inch (6 mm) according to the temperature at which they pour the bronze. Watching the build-up of wax as it cools in the place where you poured it in, judge the right moment to pour the excess molten wax out.

There are several points to watch. First, if you have peninsulars of mould between areas of hot wax—such as the plaster between the figure's legs in this instance—it is likely that the plaster will heat up more quickly there than in the rest of the mould. Therefore its surface will attract less solidifying ('freezing') wax and be thinner than the rest of the figure. At this stage there is nothing you can do about it, but the problem can be alleviated by pouring in the wax cool. You may have to cut out a section of the figure and paint more wax into this part when you have removed the mould.

Another thing that can happen is that the leg that you empty the wax through is likely to become thin because the setting wax will be washed from its surface. A third problem may be created by the wax in the legs setting solid and therefore preventing the emptying of the mould. If this does happen you may have to consider the possibility of making a new hole in the head end to allow the wax out. A fourth and final problem may be caused if the wax comes glugging out, causing suction in the mould which, if you are unlucky, may pull the soft surface of the sculpture in at some point. If that happens, you have to make a different hole through which to pour, and try again.

When the excess wax has all been poured out, and the skin of the wax is cooling inside the mould, you can begin to rediscover the seams by chipping away at the plaster that is holding the mould together. When the seams are all exposed and the wax is thoroughly solidified, you can start to lever off the mould, start-

ing at the high extremities—the figure's right hand in this case. If the mould does not come away easily you can break it with a sharp blow from a mallet and chisel. Gradually work down towards the feet (fig. 17).

This kind of mould is designed to produce one good wax cast and leave you with a jigsaw puzzle of broken plaster pieces to which you can return if the bronze cast subsequently goes disastrously wrong. Micro-crystalline wax is particularly suitable for this kind of moulding because it goes through a stage in cooling when it is remarkably strong and elastic at about blood heat. When it is cold, however (say 10°C), it is very brittle indeed and it would be very difficult to chip it out of the mould without shattering it.

The quality of your wax will be

very apparent when you first try to break it up to get it into lumps small enough to fit your melting pot. Most waxes are brittle when cold and can be broken easily with a sharp blow from a hammer, but on a warm day micro-crystalline remains very tough.

The hollow wax figure taken from this mould is very convenient to work on, being light and flexible. I can work on it very much better than the same figure in clay. In very warm weather it is wise to keep it in a tank under water, but in mild weather it need only be kept out of direct sunlight and propped in the correct pose when you are not actually working on it. When you have got it to look as you want—by the same means as the small wax manikins in chapter 6—you can go on to the next stage: casting it into bronze.

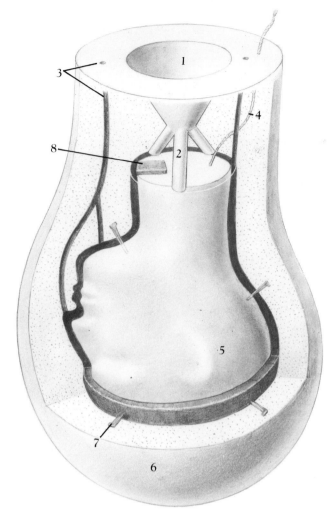

you give it in some other material they will safeguard you against total loss by making a mould to which they can return if disaster should strike, but this is more work for them and more expense for you. The sensible thing to do as a safeguard is to make your own mould, if you could not bear to lose your work.

The principles are remarkably simple and effective (see *fig. 18*). To put it at its simplest, a hollow wax object is embedded in a mould, which is most often made of plaster and grog—the grog is to make it porous and strong when fired. The mould, with the wax in it, is then fired in a kiln to a temperature of at least 600°C, more usually to about 650°C. At this temperature not only is the wax entirely vaporised, but the water of crystallisation is driven out of the plaster (if clay was used it would become terra cotta).

There is now a cavity in the mould where there was once wax (the shaded area in the diagram). Bronze is poured into that cavity so that the surface that was once wax is now bronze. After the casting, the mould is broken up and the bronze revealed. The refinement of surface that can be achieved in this way is staggering, but it is a very exceptional cast that needs no repair or redefinition at all. Finishing—called chasing or fettling—is done with files, chisels and matting tools.

It is also possible to use other combustible material to shape the cavity in the mould: leaves, twigs, teasles, waxed thread, dead insects and small animals have all been used, often to startling effect. Anything that will burn away leaving little or no residue can be tried, and these substances can also be used in combination with wax.

There are various problems that should be borne in mind when you are preparing a wax that is destined to be cast into bronze. First, use very clean wax—impurities in the wax that do not burn

Fig. 17 (*opposite above*). After the wax has been poured in and cooled, the plaster mould is broken away with sharp blows from a light piece of wood. Do not allow the wax to get cold or it will be brittle—ideally it should be about blood heat.

Fig. 18 (*above*). A cross-section through the mould of a head suitable for casting into metal, showing the following features: (1) the cup into which the molten metal will be poured; (2) the runners to take the metal down to the mould; (3) the airs, risers or vents which allow the air to escape from the mould as the metal runs in; (4) the core vent to allow the gases which are contained in the porous core to escape after they have been heated by the metal; (5) the core, made of the same material as the mould; (6) the mould; (7) nails to hold the core in the correct position in relation to the outer mould after the wax has been burnt out; (8) the plate for mounting the final bronze.

CASTING BRONZE OR OTHER METALS BY THE LOST WAX METHOD

Lost wax casting is a method used by the ancients and still used today for most refined art casting. It is hard work and hazardous, particularly for the beginner. There are many things that can go wrong and the best advice I can give is not to attempt it on your own until you have considerable experience. The following is not intended as an adequate guide to practice—it is simply a description to acquaint you with the principles.

The method is called 'lost wax' for the good reason that in the attempt to get a bronze you lose a wax. So if you give a cherished work in wax even to the most experienced foundry you are taking a risk, albeit a small one. If

away will show up as holes in the bronze. Second, the thickness of the bronze should not exceed 1 inch (2.5 cm) in section, otherwise shrinkage as it cools will cause distortion. Third, the bronze will shrink by about 10 per cent and this should be taken into account if it has to marry up with existing material. Fourth, if the bronze is big enough to need a core (see diagram), the shape of the core should be considered from the point of view of strength and of the gases that will expand in it after the bronze has heated it by 1000°C. These gases will have to be provided with a means of escape. If they are not they will make their own way through the hot bronze, leaving a hole usually where you least want it. Fifth, the core will have to be supported in its correct position relative to the outer mould once the wax has been burnt out. It is safest to leave these considerations about the core to the foundryman as the

choices made will be dictated by his techniques and these can vary widely. If at all feasible, give him a wax without a core. He can then see the thickness of the wax and make appropriate arrangements for the runners and the core.

The Principles of Running a Bronze

To get the bronze into the mould you will need a funnel, called the 'cup' or 'sprue'. This is attached to 'runners' that take the molten bronze down to the actual sculpture. As the bronze rises in the mould it will heat up the air inside and displace a large volume of gas (gases expand greatly when heated). It is necessary therefore to provide an escape route for these gases. Normally one attaches 'airs' or 'risers' to all those points where pockets of gas might get trapped. These are then taken up to the top of the mould and usually attached to the rim of the cup. Both runners and airs are

normally made of wax that burns away with the rest, but they can also be made more economically of marsh rushes or newspaper rolled round a pipe which has then had wax poured over it.

Cellini used clay pipes packed in sand for both runners and airs. His method was wonderfully economic in the firing of the mould because his mould was no more than a jacket of terra cotta with holes in appropriate places to which the clay pipes were attached after firing. His method reduced the size of the mould that had to be fired by about half its girth. A modern mould to take the whole of his *Perseus* would probably take about ten days to fire; Cellini took two days. In fact no modern foundry would attempt to cast the whole of *Perseus* at one go; it is too risky. Joints are very quick with modern welding. Cellini would have taken a week on a joint that modern methods finish in an hour.

Pl. 1 and 2 (*opposite far left*). Stephen Cohn, *Black Idol*, 1965 and *Large Sunburst*, 1964. For both these sculptures, sheets of wax were cut and reassembled and then cast directly into bronze by lost-wax casting.

Pl. 3 (*opposite*). Benvenuto Cellini, *Perseus*, 1546 (Florence).

Fig. 19 (*right*). The figure of Regine in wax (height 21 inches/53 cm).

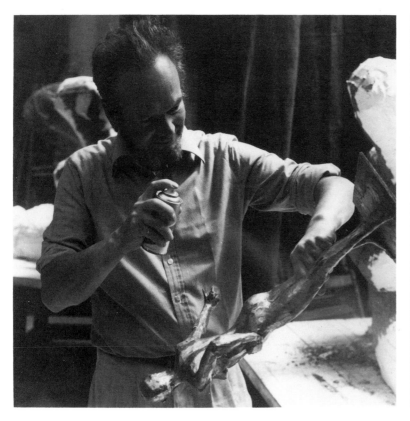

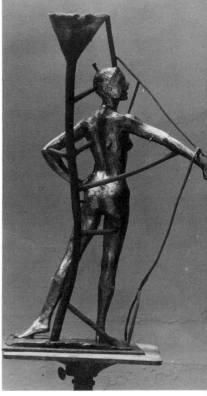

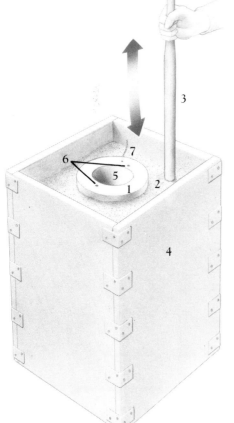

Fig. 20 (*above*). Gold spray shows up imperfections in the wax.

Fig. 21 (*above right*). The hollowed wax prepared for moulding. The runners (for the bronze to enter) and the airs or risers (for the air to escape) are attached in wax. When the wax is entirely covered with the mould, only the cup at the top with the air attached to the rim will show. The nails are to hold the core or inner mould in the correct relationship to the outer mould when the wax is burnt out. All that is solid in this picture will become space inside the mould when the mould is fired; the bronze is poured into that space through the cup.

Fig. 22. Ramming the mould. The mould (1) is buried in slightly dampened sand (2) which has been very carefully rammed with the rammer (3). The sand is in a strong box (4) which will contain the pressure of the molten metal. It is sensible to cover the top cup (5), airs (6) and core vent, i.e. the hole left by the string when it is burnt away (7), to prevent any sand from getting into the mould during ramming.

The risk multiplies as the height of the mould increases, because the pressure of molten bronze builds up very quickly and becomes very difficult to contain. It is unusual nowadays to run a bronze that is more than 4 feet (1.2 m) high. Large sculptures are cut up and joined after casting.

The Firing of the Mould

The mould has to be fired in a kiln with a long and steady heat. The time of firing varies with the girth of the mould. A life-size head will take at least fifteen hours; a life-size figure about a week. As the shapes of different sculptures vary hugely, it is traditional practice to build a new kiln to measure for each firing and to fire with coke. This is enormously wasteful of manpower as the kiln has to be attended at least every two hours. Modern foundries tend to use very large gas- or oil-fired kilns that are not rebuilt for each case. Instead they try to make each mould conform to a standard size by cutting large sculptures up and

putting many small ones together into one mould.

To be sure that a mould is properly fired it is necessary to see the final gases from the wax burn away, while keeping the temperature up in the kiln. The kiln is then allowed to cool slowly and completely—this may take a day. It can then be opened and the moulds examined. If there is a trace of blackness in the cup, the mould is under-fired and should not under any circumstances have bronze poured into it as there is a big risk of it exploding. Even if it only bubbles or splutters, the cast will be useless. Lead and aluminium are more tolerant of wax in underfired moulds, but woe betide the caster who has so under-fired his moulds that there is still moisture in them!

Pouring the Metal

Pouring the metal requires experience and care: it is potentially very dangerous. Bronze and aluminium require a crucible and a purpose-built furnace. Lead and its alloys are the only metals that you can melt on a gas ring. They are the most dangerous because they are very heavy and therefore build up pressure very quickly. Lead also remains liquid for very much longer than bronze. If you have a mould about 3 feet (1 metre) high you will have to contain pressures of over one atmosphere at the bottom. With a bronze of similar height you would expect the metal at the bottom to freeze within a second or two, and therefore be no longer capable of breaking out. With lead it might remain liquid for several minutes, so breakouts are more likely.

The traditional mould that has been fired is very weak. On its own it is quite incapable of standing up to such pressures. It is absolutely imperative to ram it in a sand box before pouring; the box and the sand contain the pressure—the mould is only required to maintain the shape of the original (see *fig. 22*). The sand is

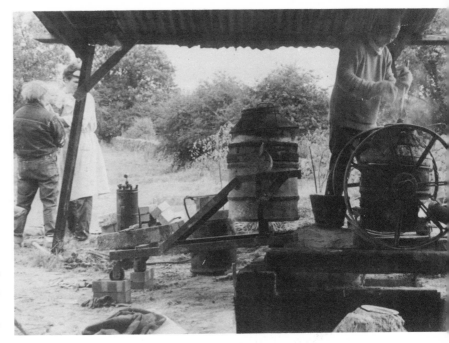

Pl. 4. Two primitive but effective tipping furnaces designed by the author. They are fired by paraffin and compressed air and can deliver 250 lbs (120 kg) of molten metal. Railway sleepers and sand are used to contain the pressure in a large mould.

kept very slightly damp so it will pack firmly, but it is dangerous to leave small moulds packed but not poured for more than an hour—the mould is porous and will gradually absorb moisture from the sand. Dampness and molten metal are an explosive mixture. I usually wrap moulds in very light polythene to get round this danger. The ramming of the moulds has to be done with very great care. A life-size figure, for example, will take three men several hours to ram.

Pl. 5. An example of a rubber mould in which a soft rubber or jelly is used to make the negative. This has the advantage that it can be pulled off the cast without difficulty and is the most practical method of making editions. The rubber has to have the support of an outer plaster case to keep it in shape. In the centre you see the figure, behind it is one half of the black rubber mould, and behind that the plaster case. On the left is the other half of the case with the mould inside.

The Metals

Of the metals commonly used for sculpture, bronze is the most expensive and the most rewarding for most forms. It is capable of receiving a wide variety of finishes, from polished through to very many shades of green, brown, red and black. There are many alloys of bronze and brass. Their main constituent is copper, with white metals—such as zinc, tin and lead—in varying proportions. Gunmetal, a bronze once used for cannon, is the most popular for sculpture: it lasts forever. Silicon bronze is becoming increasingly popular because it is best for welding.

Lead is little used nowadays—perhaps because sculpture made from it is very difficult to transport, being soft and heavy—but it is very beautiful for garden sculpture.

Casting aluminium is cheap. It is light and strong for transporting. Its melting point is nothing like as high as that of bronze, but it still needs a proper furnace to melt it. One of the main attractions of aluminium for me is for lost wax casting of waxes that are too thick for bronze. It also is capable of looking very good, though you cannot patinate it in the same way as you can bronze. It is not recommended for siting out of doors as it is prone to rot away with alarming speed, though if properly cared for it does well—the statue of Eros by Gilbert in Piccadilly Circus, London, has lasted 100 years. Aluminium is frequently used for lost polystyrene casting, which is incredibly quick and easy, but it is difficult to achieve a really good cast surface. In my opinion aluminium needs to be worked cold with files, chisels and hammers before it is worth looking at.

My own method with aluminium is to cast works that are near completion and then finish them by working the metal cold, whereas with bronze I complete down to the finest detail before casting. Lead, like aluminium, is also best

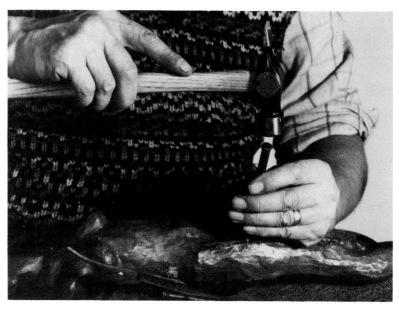

worked over after casting. It looks wonderful when sandpapered but remember that it is poisonous—and your hands will be blackened with it if you don't wear gloves.

Chasing or Fettling

When a bronze or other metal cast is knocked out of the mould it will still have the runners and risers on, and these have to be cut off. Their stumps have to be shaped to form a part of the surface of the sculpture—this process is known as chasing or fettling. You will be lucky if this is all the chasing that you will have to do—in the normal course of events you will also have to deal with some blemishes in the casting. If the sculpture has a core, the core pins that have kept the core in place during the casting process will have to be removed and the holes they leave plugged with bronze. Many of these repairs are now done with a weld which is then ground down and finally matted with a matting tool to give it a surface that resembles the cast surface. In the more traditional foundries small holes are drilled out and 'tapped' and then plugged with pieces of the runners or risers that have been threaded. The ancients used to inlay rectangles of bronze over bad areas of casting.

Many antique pieces look like victims of a shooting accident that have been treated with sticking plaster—the result of the loss of the inlays.

The process of chasing is good to experience, whether you do the casting yourself or not. (It will save you money and give you a much deeper appreciation of Donatello's bronzes.) Many foundries are used to sculptors who wish to do their own chasing and patinating. The task is not all that agreeable—it is noisy, dusty and rough on your hands. But if you do perform this delicate task, you will be so dazzled by the subtle transformations that take place in the material under your hands that it will henceforth be unthinkable for you not to supervise the work very thoroughly, if not actually to do it yourself. Bronze is capable of taking a subtle variety of finishes—all in the space of a few square centimetres. It can be sanded and polished, burnished, beaten or matted before you even start to think of the patina. All these processes have an effect on the way the sculpture is read.

A craftsman's attitude to chasing must be different from that of the sculptor. The craftsman rightly sees it as his job not to obtrude. His work as a chaser of bronze

Fig. 23 (*opposite*). Using a matting tool to blend in the cut metal with that which has an unworked cast surface.

must not be seen; it is the work of the artist on the clay or wax which must come through on the finished sculpture. A sculptor who works on his own bronzes, however, may choose to follow Donatello's example and allow the metalwork its rightful place in the result. I personally love to see the way in which the metal has been pushed, hammered or chiselled into shape. The sculptor who does his own chasing produces a different, fresher result—closer to the workshop, and perhaps less appealing in the salon.

Patinas

New clean lead can be artificially aged with milk. Aluminium can-

Fig. 24 (*below*). Heating the bronze with a gas flame and applying liver of sulphur with a paintbrush to the hot metal.

not be patinated with chemicals. It can be anodised, but it does not look very good that way—it is best polished and waxed with blackened wax or graphite and varnish, in my opinion. Bronze patination is an art in itself. Books are available which give directions, but you must be very precise in following the instructions. Simple green patinas can be obtained by using sal ammoniac (NH_4Cl) and vinegar. Many shades of brown to black can be got from liver of sulphur (KSO_2). A more transparent brown and a reddish-brown can be got from ferric nitrate ($Fe(NO_3)_3$). Use plenty of distilled water to dilute the chemicals. All sorts of surprises can be obtained by using natural substances such as sour milk, sawdust, grass cuttings, soil, dung and urine.

Before attempting to patinate a bronze it is important to clean it thoroughly. After you have worked on a bronze it is likely to be parti-coloured because the metal which has been in contact with the mould is never exactly the same colour as that which has been worked. In order to get uniformity of colour it is necessary to treat it with an acid, or mechanically with sand blasting, glass-bead blasting or with a very fine grade of sandpaper. Unless you follow one of these courses the patina will always show the difference between the parts of the piece that have been worked and those that have not.

Once you are happy with the colour it is necessary to fix the patina, either with beeswax or with a varnish if it is to go in the open. It is good to apply the wax when the metal is fairly hot so that the wax really penetrates into the depths of the patina and into all the crevices of the bronze. It will enhance the colour if you keep the bronze in a low oven for an hour or two.

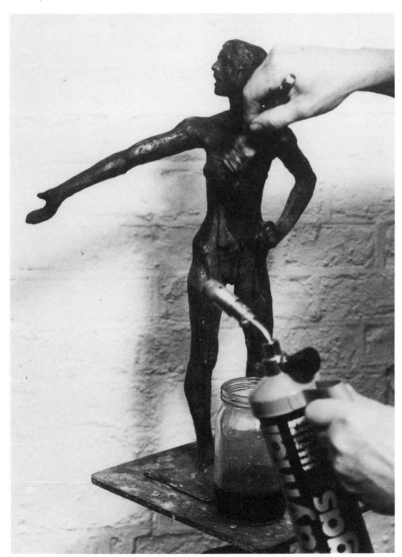

11. OBSERVING THE FIGURE

modelling from life

Whatever the standing may be today of art based on the observation of nature, there can be little doubt that, viewed historically, such observation is the central act of the artist. My own training consisted of little else and, in retrospect at least, I would not wish it otherwise. And of all the subjects that a sculptor may be called upon to observe, the figure standing against the pull of gravity is the task most difficult to complete convincingly; by comparison my dancers (*p. 123*) are child's play.

It would be understandable if you regarded the study of the nude as old hat. It has after all been the focus of attention in academies of art for five hundred years, and for two thousand years before that in the most glorious days of Greek and Roman art. Has not all that could have been done, been done, you may ask? The quick answer to that is 'no', nor will the subject ever be exhausted. As long as man exists, his primary study is likely to remain himself. He may not have evolved physically since Phaidias but his view of himself psychologically has changed dramatically and doubtless will continue to change.

As far as I am concerned, if art is a serious business at all it is because it conducts a dialogue between ourselves and our complete environment in a medium that can touch the shape of thought itself: it can be as clear and abstract as geometry or as fleeting and ambiguous as a half-remembered image on the retina. There is no other discipline that can keep us in touch with so diverse a sensing of reality. It touches our understanding of both the sensing mechanism and reality.

As we know so much about the general condition of man, both through our own experience and through the work of artists over thousands of years, the figure is likely to call forth the most adamant criticism. No one likes to have received knowledge put to the test; the general expectation is to look at art to confirm prejudices, not to upset them. Be prepared for this if you are going to take on the figure. Abstract sculpture is safer.

The standing figure must have a sense of balance. It must also contain a sense of structure: how does this complex tissue of muscle and bone stand against that universal force of gravity? Sculpture may say something about physical beauty and, if you believe as I do

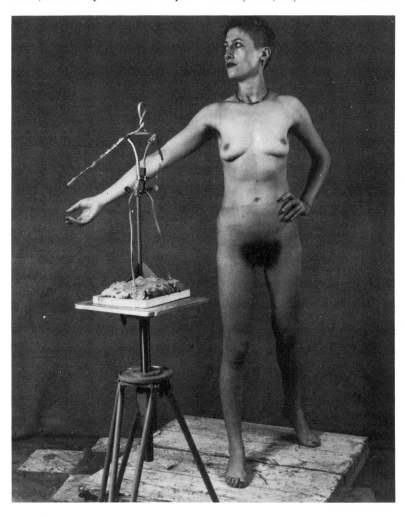

Fig. 1. The model in position and the basic armature. Spend as much time as necessary getting the movement to come in the armature—it should convey a real sense of the movement you want in the finished piece.

that the spirit of a person expresses itself in the body, then of course the psyche of the subject can also be made visible in art.

Narrative and drama have frequently been an important part of the figurative tradition, but the most exciting thing as I see it is the tradition itself. As a figurative sculptor you cannot escape comparison with the endeavours of five hundred generations of sculptors before you; daunting as this prospect may appear at first sight, it has great advantages. A figure made today automatically creates its own ancestry: it forms with the past a series of links, connections and cross-references that gives it another dimension of expressive power. Every work of art worthy of the name is an act of criticism; it chooses to endorse and to extend certain currents of thought in art and to ignore others. It conducts a dialogue with the accumulated sculptural experience of mankind, and the most serious ambition of the sculptor is to try to extend that experience. A sculptor may do this by weaving together strands that had not previously been connected, or by cutting away extraneous detail and exposing the 'true essence' of some admired work or school.

A great deal of art is about art. It is about extending and revitalising the language of expression. Musicians, writers, dancers, artists are all concerned in this continual act of purification. Language deteriorates without this attention; usage creates cliché and cliché creates emptiness. Artists do not look for novelty so much as for power—power of expression. Abstract art has become so obsessed by the act of purifying the language that it has all but lost sight of the end towards which we all struggle—expression.

It is my personal credo that the model provides the inspiration and I am there to respond, not to impose. My ambition is to see the true character of the person before me, whether I am making a

portrait or a figure. But my attitude is by no means a general one. A sculptor like Maillol, for instance, makes a 'Maillol' figure which scarcely changes in character throughout his life as a sculptor. Though it started out full of vigour it became in the end a bit stale. I take this as a warning and try to approach each new model as if I had never seen such a thing before in my life.

I tend to look for character in a model and I have been accused of making females who are either too fat or too thin to appeal to anyone; that does not bother me. It is not part of my aim to provide pin-ups or some ideal of modern beauty; I would prefer to devote myself to life's variety. The two aims are not compatible and you may well choose to search for beauty.

What I am saying here about sculpting the figure from life is not intended to frighten you off the whole idea. It is the most challenging and rewarding of all aspects of sculpture, and you are not obliged to be certain that you have something splendid to add to the sum total of sculptural experience before you thrust your fingers into the clay. You make sculpture for your own experience—it is your own search for meaning.

MAKING THE ARMATURE

If you make things easy to change, you are more likely to find the courage to change them. It is very important to use a material that is easy to alter, and to make a flexible armature. For the demonstration, I have made a very simple armature out of $\frac{1}{4}$-inch (6-mm) aluminium mounted on an adjustable armature support (fig. 2). To make it, cut a piece of material—aluminium, wire, lead or mild steel according to availability and the required strength—of a length at least one and a third times the height of the intended figure when folded double. Twist a loop in the top to form the head and neck.

Fig. 2. Close-up of the basic armature, showing the clips and wire used to hold the aluminium in position on the support.

Then form the shoulder, waist, hips and legs from the same piece. Attach this to the armature by means of a jubilee clip or with much well-bound wire. On the whole I do not favour welding as it does not allow flexibility, but it can be used (on over life-size figures, for example, it is sensible to use it). Next attach the arms. It is advisable to bind a spiral of fine wire around the arms and legs to help the clay to cling to the armature. On large-scale figures it is necessary to knit loops into this spiral of wire so that it will support the greater weight of clay.

The bigger the figure the more armature you will need. The armature illustrated is sufficient, if made in stronger material, for up to five-eighths life size. After that it is highly advisable to add strength by adding to the number of supporting members rather than to the strength of any one member. Mild steel which is more than $\frac{1}{4}$ inch (6 mm) in diameter or aluminium more than $\frac{1}{2}$ inch (13 mm) is difficult to bend in situ and should be avoided in places where flexibility may be needed.

Spend plenty of time adjusting the armature to express the movement, and try to combine strength and flexibility with visibility. An

ability to support the weight and texture of the material in use is the practical requirement, but in order to respond to the armature as a potential work of art it is necessary for it to be a visible embodiment of that potential.

A leg that is represented by a single piece of armature can express the direction of the leg, but not its volume. For large works it is highly desirable to represent the volume as well, as far as possible, before putting on the modelling material. Ideas of how that can best be achieved are contained in the section on building a large figure (chapter 6). The use of chicken wire can reduce the weight of a life-size figure by more than half, and it will make the volumes much more manoeuvrable. In small figures I would advise the use of the minimum armature necessary.

THE USE OF MEASUREMENT AND A CAUTION AGAINST RIGIDITY

It is always sensible to have measurements of the model available in case you need them at a later date. I would advise the use of a plumb-line to start with (6 feet/2 metres of string with a symmetrical weight on the end such as Plasticine will do). By holding the plumb up against the model (fig. 3). I find out that her cheekbone, stomach and the joint of her big toe fall more or less on a vertical axis. But when working from life one must expect very considerable variation in the movement—learn to welcome this as a sequence of choices of pose, otherwise you will become very frustrated.

When I make a piece of sculpture I do not see myself as inventing or imagining the end result; rather it is a matter of observing and choosing from a continuous parade of possibilities. The living model provides such a parade, and the work in progress provides

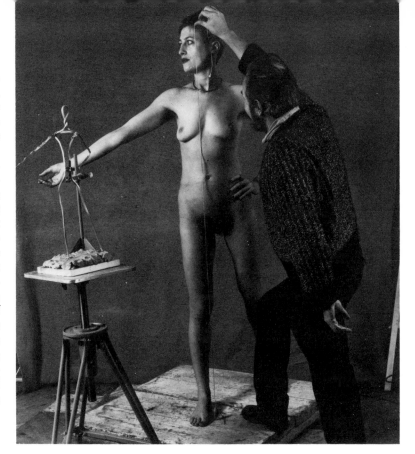

Fig. 3. Assessing the vertical axis using a plumb-line.

Fig. 4. Marking off height measurements against a vertical.

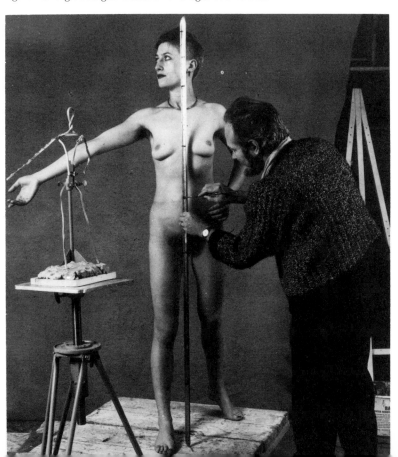

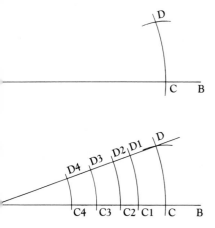

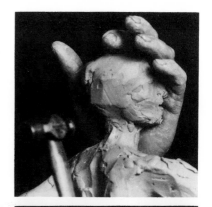

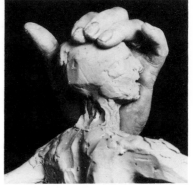

Figs. 5 and 6 (*right*). If you get into trouble with the armature protruding where it is a nuisance, deal with it forcefully; if you don't it will annoy you to the end. If the armature protrudes at the back of the neck, as in this case, support the head with your hand and strike one swift blow with a hammer to put the armature back where you want it. With bigger armatures, use bigger hammers. It is essential to build your armature in a flexible material so that it can be modified in this way during the course of work.

Method of converting measurements into different scales (*above*). First take an actual measurement of your model—say, from floor to navel for a standing figure. Draw a line **AB** longer than the actual measurement (first diagram). Strike an arc, intersecting line **AB** at **C**, with a radius equal to the measurement. Decide what measurement you want your final figure to be from floor to navel. Putting the point of the compass at **C**, strike an arc of the projected measurement to intersect the first arc at **D**. Make a line connecting **A** and **D** (second diagram). You now have a basic scale diagram which will enable you to read off any measurement conversions you want. The distance from **A** to **C1**, for example, on the real model will be represented by the distance from **C1** to **D1** on your sculpture. The points **C2**, **D2** etc. on the diagram work in exactly the same way.

another parallel parade. Every mark, every action produces some result which either helps or hinders the result I wish for. I use the expression 'wish for' in preference to 'have in mind', because the latter might suggest too clear an image in my head. I embark on a work with fairly clear-cut wishes but only the vaguest image of the final result.

I am inventive (sometimes my technique may appear to the craftsman to be much too improvised) but I do not consider inventive capacity as necessary or even important to the artist. It is more important to be able to sustain the original impetus by remembering your first intentions in the face of the continuous parade of counter-attractions. After that, I counsel living dangerously so as to keep the parade moving. Do not leave your imagination at home when you work from life.

I make a note of the heights of various key points (*fig. 4*); widths can be measured with callipers as described in the section on portraits (see *p. 150*). I would advise

here, however, that you don't actually use these measurements unless you get stuck in the course of work, when they may be useful. They are likely to prove a hindrance if you try to use them as a substitute for vision. The diagrams above describe a method for the conversion of measurements from one scale to another.

It is customary to pose the model on a revolving dais. If you use one it is sensible to mark the position of the feet so that the pose can be resumed as accurately as possible after each break. A piece of paper that is moved round on the floor, similarly marked, is an adequate substitute.

BUILDING UP THE FIGURE

When you are convinced that you have done all you can to make the armature conform to the pose you want, you can begin to put on the clay. Start by pressing clay into the armature of the torso, paying particular attention to the axis of the hips and shoulders which should

be very clearly defined, possibly even exaggerated to begin with. If the model is standing with the weight firmly on one leg, for instance, it is very probable that the other hip will drop and the head will move over the axis of the weight-bearing leg to maintain the balance of the figure. The consequence of this will be that the shoulders will take up an axis opposite to that of the hips, leading to the 'controposto' that has been used by sculptors since classical times. The delicate balance of this pose—giving rise to a compression of the forms on one side and a relaxed elongation on the other—is the equivalent of sonata form to the sculptor: it has been done a thousand and one times before, but it is still new every time.

My model on this occasion is a singer, and I have chosen to use that as an excuse for a little drama. I wish to make a figure that conveys the satisfied feeling that comes with the final bars of a song well performed. I do not expect Regine to maintain the excitement

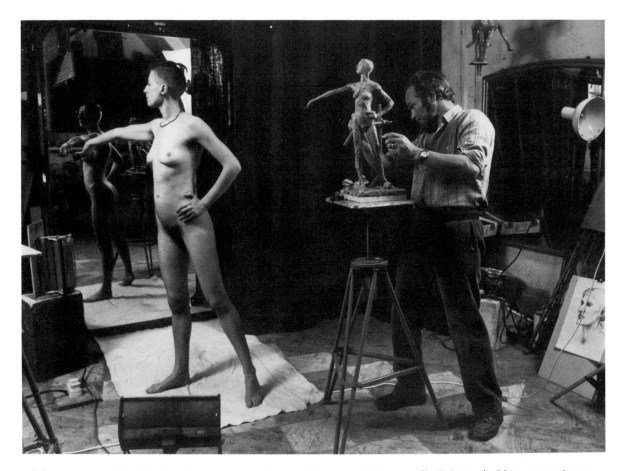

Fig. 7. As you build up your sculpture, make clarity of movement your top priority.

of that moment for the duration of the pose—I will be more than happy if she can revive it once a day. As I work, I shall endeavour to keep that aim in mind and see which of the variety of movements that she will inevitably pass through help me in this ambition, always bearing in mind that something even more interesting may well appear which will change my intention.

Let me give you a few final hints on building up the figure. As with portraiture, if you can postpone the moment when the figure takes on the full roundness of life by dealing with it as an abstract structure for as long as possible, this will create a good basis as it will help to keep your critical faculties alive. It is also a good idea to make many drawings before you start to clarify your ideas. Ideally you should not work from life unless or until you have a clear idea of what you are going to try to ex-

press with your figure, and I hope that expression will emanate from the model. I say ideally, because working in a group as one often does (to share the expense of a model) it is not always possible to find a pose that is equally satisfying to all parties. Nonetheless, excitement in your work is the best guarantee of success.

Try to concentrate on the disposition of the large masses; try to find a structural principle that holds them up. (You might wish to look back to where I have previously dealt with structure, particularly chapters 2 and 4.) Detail is something that gets to fascinate the novice too soon—usually long before the large masses have been properly understood in relation to one another. Many great sculptures seem to manage very well without detail at all; if you use it, make sure that it is seen as a part of the whole.

Students of today's generation

Fig. 8. Try to make the whole movement express the feeling you want.

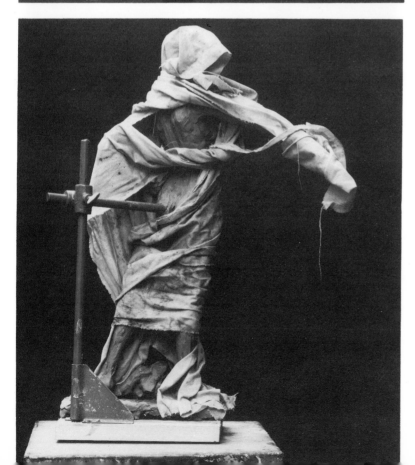

Fig. 9. At the end of each session it is sensible to cover the clay with wet rags to keep it moist (plastic on top will keep the moisture in). The dampness penetrates the clay more evenly in this way than if water were sprayed on. At normal humidity, this figure will keep moist for 3 or 4 days.

By this stage in the work I found that having the armature blocking my view was too much of a hindrance. It was a good moment to cast the figure into wax—my preferred medium—so that it would stand up without an armature. It was eventually cast into bronze (see chapter 10).

181

are frequently called upon to defend their desire to work from life: though it is sad that this is so, I hope that I may have provided some further ammunition for the defence of this time-honoured practice. If I were to summarise them, I would put top of the list the exercise of that nearly moribund but essential faculty of observation. Coupled with observation, the practice of art has a considerable contribution to make to the evolution of the mental process by which we digest or assimilate the world about us. This role is best exercised in direct confrontation with the real world we are trying to understand, and nothing shows up so well our failure to understand what we see than working from life. It keeps us in direct touch with the great achievements of the past in a way that art history cannot begin to rival; art history only observes, while the figurative artist is a part of the tradition, whether he likes it or not. The language of human feeling, conveyed through body language, gesture and facial expression, is a large part of the language of art itself—indeed, without it abstract art could never have come into existence.

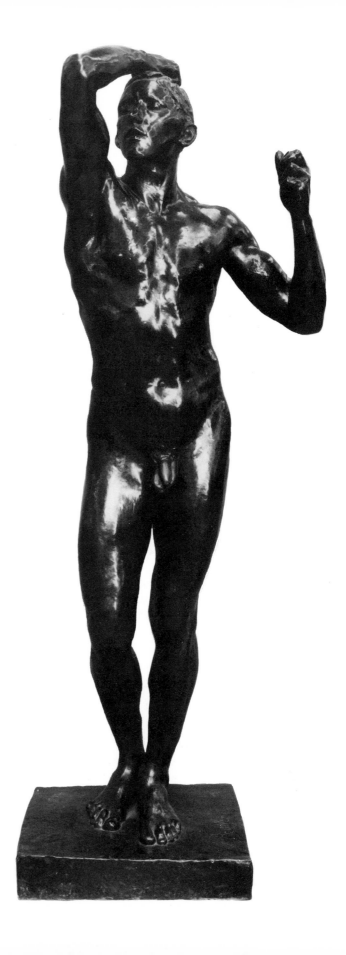

Pl. 1. Auguste Rodin, *The Age of Bronze*, 1875 (Victoria & Albert Museum). When this early work was first exhibited, Rodin was accused of casting it from life. In fact it is very much more life-like than any life cast I have seen. The controposto is slightly interrupted by the raised left hand which originally held a spear. This brilliant virtuoso work was soon to be superseded by Rodin's dynamic sense of structure (see *The Prodigal Son, p. 72*).

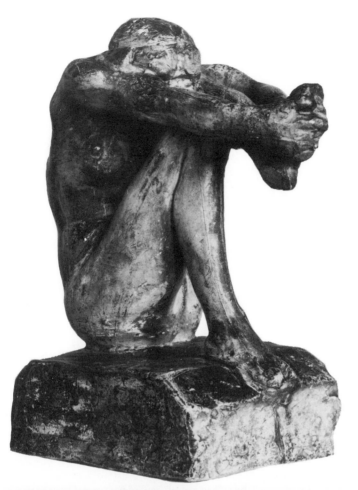

Pl. 2. Auguste Rodin, *Despair*, 1890
(Victoria & Albert Museum). I have
always been impressed by the simplified
architectural arrangement of this
figure—the arms, head and left calf are
seen in one plane, like a roof, propped
up by the buttress of the right leg.

Pl. 3. Giacomo Manzu, *Susanna*, 1942
(Tate Gallery). This is a very successful
modern version of a figure seen in the
classical mode. The large, simple shapes
of the back, head and buttocks are
contrasted with the small scale of the
fingers and the folds. The folds
themselves draw section after section
round the torso, helping to define the
movement.

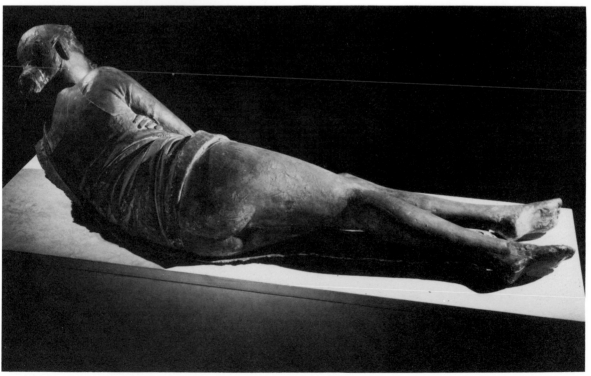

The study of life brings a new, unpredictable element into a practice that can all too easily degenerate into a dull and lifeless routine—it is literally revitalising. Abstract art is not self-renewing in the same way. Its primary interest lies in its relationship to the forms evolved in the history of sculpture—that is, in the figurative tradition. This may be why the first generation of abstract artists were so much more interesting than the second and third generation, whose grasp of that tradition is more tenuous.

Another defence of the practice of working from life that is frequently put forward is that it provides students with the knowledge of the figure necessary to enable them to depict narrative scenes. While this may be true, I think that that sort of knowledge can be learnt just as well from anatomy books. Work in the life-room should be devoted to the much more important and rewarding business of sharpening perception.

CONCLUSION

I would like to repeat a few of the most important points I have made in this book which I hope will take root in the mind of the reader and flourish there as a result of experience. One's powers of observation have to be cultivated: we may all see, but to *experience* what is there in front of our eyes is quite another matter.

The history of art is not just an amusing fashion parade—it presents the creative observer with a number of evolving patterns of thought which artists have chosen to pursue in their efforts to experience more. Do not be frightened of putting on someone else's spectacles for a time: the great masters are so called because they have something to teach us. The pathway to new experience can be long and tortuous, but it is also deeply rewarding. And remember —you do not have to go it alone all the way.

Pl. 4. Alberto Giacometti, group of sculpture, mainly 1950s (Tate Gallery). Giacometti has none of the mass one expects to find in sculpture. His work is an example of extreme economy: he spans the maximum space with the minimum of material. Because he focuses so exclusively on space, he has taught me very valuable lessons about the importance of spatial position when reading form in art. The way I read Rembrandt, for example, was learnt as a result of visiting a Giacometti exhibition in 1956; for this reason I feel a real debt of gratitude to him, though I don't actually enjoy his sculpture. The portrait at the top right of this group could be cited as an example of the card-house structure I describe in connection with Verrocchio (see p. 72ff.).

Pl. 5 (*opposite*). Aristide Maillol, *Torso of the Monument to Blanqui*, 1905 (Tate Gallery). At his best, as here, Maillol can be magnificent, but viewed as a whole his life's work constitutes strong support for the case I have been making against the use of classical form. I find his later work lifeless.

GLOSSARY

AIR also called riser or vent. In metal casting, tube for allowing the air to escape from a mould as the metal runs in.

ARMATURE support for materials such as soft clay, plaster etc.

ASSEMBLAGE sculptural collage.

BISCUIT terra cotta, clay that has been fired but not glazed.

BURLAP see scrim.

BUTTERFLY support for soft clay on an armature, usually made in the form of a cross of wood.

CAP piece of a mould which may be removed for the purpose of emptying or filling the main mould.

CAST sculpture from a mould in any material.

CHASING also called fettling. The process of cleaning the surface of metal after casting, cutting off runners and risers, removing flash and making good faults.

CLAW stone-carving tool with a serrated edge.

COLD CAST METAL term sometimes used to describe a plastic with a powdered metal surface. It can often look like real metal.

COLLAGE work of art made by glueing together or otherwise assembling disparate elements.

CORE the inner mould for a hollow metal casting.

CRUCIBLE a ceramic pot in which to melt metal.

CUP also called sprue. In metal casting, the funnel through which the metal gets to the runners.

DAS trade name for a modelling material containing glass fibres.

EDITION term used when more than one cast is made from an original work of art.

EXPANDED METAL reinforcing material for plaster or cement; stronger than chicken wire.

EXPANDED POLYSTYRENE very lightweight thermoplastic material which can be cut, glued or sandpapered in simple shapes.

FETTLING see chasing.

FIBREGLASS spun glass fibres used as a reinforcing material, often with resin. It should not be used with cement.

FIRING the process of baking in a kiln.

FLASH also called feathers. Bronze that has run into cracks in a mould which has to be cleaned off during chasing.

GROG crushed fired clay.

KEY locating device used in plaster moulds.

KILN high-temperature oven for firing moulds or terra cottas.

MAQUETTE also called bozzetto. Small sculpture made in preparation for a larger piece.

MOULD three-dimensional negative from which a cast is made.

PATINA colour produced on bronze, usually by ageing but also induced artificially with chemicals.

PLAS DUR trade name of a modelling material.

PLASTICINE trade name of a modelling material.

POINT also called punch. Stone-carving tool used for roughing out work.

PUNCH see point.

PVA polyvinyl acetate, synthetic glue which can be used as a separator between plaster and resin.

RELIEF the sculptural equivalent of a picture, in which the depth dimension is greatly reduced.

RESIN usually polyester or epoxy. Two-part plastic used in conjunction with fibreglass.

RISER see air.

RUNNER in metal casting, tube for taking the molten metal to the cast.

SAND CASTING method of casting metal against rammed sand which can be cheap for simple shapes.

SCRIM also called burlap. Open-weave hessian used for reinforcing plaster.

SETTING hardening, of plaster etc., by chemical reaction.

SHELLAC varnish usually dissolved in methylated spirit.

SHIM thin sheet, usually brass, used to separate the pieces in plaster casting.

SLIP clay thinned down with water to make it pourable.

STONEWARE high-fired clay that has vitrified.

TERRA COTTA fired earth or clay.

VENT see air. Also, a hole in the core for letting gases escape.

WASTE MOULD mould from which only one cast can be taken because it is designed to be removed from the cast by being broken away.

WEDGING preparing clay by kneading.

WELDING the process of joining materials, usually metals, by fusing under heat.

LIST OF SUPPLIERS

GENERAL

Tiranti, Alec Ltd 21 Goodge Place, London W1 (01-636 8565) *and* 70 High Street, Theale, Berkshire (0734-302775). For tools, materials and equipment for the sculptor.

CLAY, PLASTER

Fulham Pottery Ltd 184 New King's Road, London SW6 (01-731 2167). For pottery equipment, clay and plaster.

Pottery Crafts Ltd Campbell Road, Stoke-on-Trent, Staffordshire ST4 4ET (0782-272444) *and* 105 Minet Road, London SW9 (01-737 3636) *and* 75 Silver Street, London N18. For pottery materials and equipment.

Potclays Ltd Brickkiln Lane, Stoke-on-Trent, Staffordshire (0782-29816). For clay, grog, etc.

WAX, RESIN

Poth Hille & Co Ltd 37 High Street, London E15 (01-534 7091). For wax.

FIBREGLASS

Strand Glassfibre Ltd Brentway Trading Estate, 109 High Street, Brentwood, Essex *and* 524 High Road, Ilford, Essex (01-599 8228). For everything necessary for fibreglass moulding.

STONE, WOOD

Consolidated Stone Ltd 1a Harpenden Road, London SE27 (01-761 3055). For marble and slate.

Mallinson, William & Sons 130 Hackney Road, London E2 (01-739 7654). For hard woods.

The Timber Trade Federation 47 Whitcomb Street, London WC2 (01-839 1891). For help and information about wood.

FURTHER READING

AESTHETIC

Carl Bluemel, *Greek Sculptors at Work* (Phaidon) 1955 (original German edition, 1927).
Adolf Hildebrand, *The Problem of Form in Painting and Sculpture* (Garland, N.Y.) 1979.
Erle Loran, *Cézanne's Composition* (University of California Press) 1970.
William Tucker, *The Language of Sculpture* (Thames & Hudson) 1977.
W. R. Valentiner, *Studies of Italian Renaissance Sculpture* (Phaidon) 1950.
Rudolf Wittkower, *Sculpture: Processes and Principles* (Penguin) 1979.

PRACTICAL

G. Clarke and S. Cornock, eds., *A Sculptor's Manual* (Studio Vista) rev. 1970.
Malvina Hoffmann, *Sculpture Inside and Out* (Bonanza, USA) 1939.
Barry Midgley, ed., *The Complete Guide to Sculpture, Modelling and Ceramics: Techniques and Materials* (Phaidon) 1982.

Nathan Cabot Hale, *Welded Sculpture* (David & Charles) 1974.
C. C. Carstenston, *The Art and Creation of Wood Sculpture* (Dent).
Robert Dawson, *Practical Sculpture* (Studio Vista) 1970.
R. Hughes and M. Rowe, *The Colouring, Bronzing and Patination of Metals* (Crafts Council) 1982.
John W. Mills and M. Gillespie, *Studio Bronze Casting* (Maclaren) 1969.
Daniel Rhodes, *Kilns: Design, Construction and Operation* (Pitman) 1969.
Carson I. A. Ritchie, *Soft Stone Carving* (Scopas) 1973.
F. Skinner and P. Mills, *Wood Carving* (Granada, USA) 1961.

There are very many other books on specific techniques, too many to mention individually here. Those by John W. Mills, published by Batsford, are clear and reliable; the one listed above on bronze casting is excellent. Scopas and Tiranti also put out a large number of good, practical handbooks covering a wide range of sculptural techniques.

INDEX

Page numbers in *italic* refer to the illustrations.